# COLOR
## IN CONTEMPORARY
## PAINTING

# COLOR
## IN CONTEMPORARY
## PAINTING Charles Le Clair

WATSON-GUPTILL PUBLICATIONS/NEW YORK

## ACKNOWLEDGMENTS

I am deeply indebted to each of the artists, galleries, and private collectors who have contributed ideas and visual material for this book on color; to Mary Beth Brewer, who encouraged me to undertake it; and to my wife, Margaret, who, as "in-house" editor and adviser, has shared the daily challenges of a lengthy writing project.

Above all, I want to thank Marian Appellof for her creative suggestions and expert editing of the manuscript for publication, and Areta Buk for the book's handsome design.

**PICTURE CREDITS**

Numbers correspond to page numbers.

John Broderick, 26, 27; Wayne Cozzolino, 10, 14 (bottom), 56, 65, 71, 102, 103, 116, 122, 124, 172, 173, 214 (bottom); eeva-inkeri, 105; Lisa Kahane, 150; Eric Mitchell, 218, 219 (top); Joseph Szaszfai, 60; Ellen Page Wilson, 198; Zindman/Fremont, 30, 72, 206.

Cover front:
RICHARD DIEBENKORN, detail, *Ocean Park #140* (page 34).
Collection of the Douglas S. Cramer Foundation, Calif.
Courtesy M. Knoedler & Co., New York.

Art on title page:
WAYNE THIEBAUD, detail, *Seven Suckers* (page 84).
Courtesy Allan Stone Gallery, New York.

Text set in 12 pt. Goudy Oldstyle
Edited by Marian Appellof
Designed by Areta Buk
Graphic production by Hector Campbell

All artworks in this book are in private collections unless stated otherwise.

First published in 1991 in the United States by Watson-Guptill Publications, a division of BPI Communications, Inc., 770 Broadway, New York, NY 10003

**Library of Congress Cataloging-in Publication Data**

Le Clair, Charles.
    Color in contemporary painting / Charles Le Clair. Pbk. ed.
       p.              cm.
    Includes Index.
    ISBN 0-8230-0741-3
    1. Color in art.   2. Painting, Modern—20th century.   I. Title.
ND1489.L4    1991
752—dc20                                    90-23573
                                                  CIP

Manufactured in Hong Kong

Paperback edition, first printing, 1997

3  4  5  6  7  8  9  10 / 07  06  05  04  03  02  01

*For Margaret*

# CONTENTS

# PREFACE

The content of this book is unique. There are many books on color theory and countless "how to" manuals about colorful painting techniques. My book, on the other hand, integrates theory and practice. It shows how color relationships actually function in picture-making. Optical theories are examined from the standpoint of their usefulness for the practicing artist or interested gallery goer; and emphasis throughout the book is on pictorial structure rather than rendering techniques.

My method is that of a slide talk. We shall be looking at about 150 paintings, drawings, and prints by nearly seventy artists. Discussions of these individual works are related both to universal color principles and to the strategies of such specific movements as realism, impressionism, minimalism, and abstract expressionism. Special attention is also given to changing attitudes of the last decade as the century-old values of modern art have been challenged by postmodernism.

Beyond these specifics, the pages ahead are designed as a tribute to the richness and variety of contemporary American painting. I have traveled from New England to Florida and from the East Coast to California in search of exciting visual material. The roster of painters includes national and international stars as well as emerging artists from around the country. There is a balance of figurative and abstract art, and although work on shaped canvases isn't covered here, other currently vital idioms are well represented.

Finally, this book is written with many audiences in mind. Art students and painters working at home will find extensive practical and theoretical information. Professional artists will find discussions of unusual techniques and avant-garde ideas. And there is substantial material here for art teachers—a chapter on color theory, notes on historical backgrounds, and numerous topics that can be translated into studio exercises.

I also envision another, very important reader—the person who simply enjoys art and wants to learn more about it. Very often this is an individual who responds to paintings but finds "art talk" about their abstract qualities rather puzzling. A particular emphasis of my book, therefore, is to lift this veil of mystery with a straightforward text, clearly defined terminology, and graphic illustrations of the way artists actually use esthetic concepts in their work.

FRANK HYDER, detail, *Night Spirit*
(page 190)

# 1 THE COLOR EXPERIENCE

*A palette nowadays is absolutely colorful: sky-blue, pink, orange, vermilion, strong yellow, clear green, pure wine red, purple.*

—*Vincent van Gogh*

Color is the most exciting of visual elements. Used with imagination, color can be just about anything—brilliant, somber, serene, explosive, jaunty, down to earth, or gloriously out of this world.

Anyone who has sketched in oils or watercolors, played with a child's crayons, or had fun with jazzy Magic Markers will identify with the delight artists take in working with color. And if color is a "turn on" for artists, it has an equally strong impact on the public. Colorists like van Gogh and Monet are far and away the most popular modern artists. Collectors buy ten colorful paintings or prints for every monochrome drawing. Merchants invest millions in full-color advertising because color pages have a stronger "pull" than black-and-white images. And despite the outcry against colorized movies, they have had higher TV ratings than reruns of the black-and-white originals. Ted Turner's venture may be a setback for cinema art, but it is a vivid demonstration of the world's fascination with color.

## THE JOY OF COLOR

When looking at art or choosing pictures to live with, we are attracted not only to color but also to work that conveys the artist's own pleasure in using it. This joyousness can manifest itself in all sorts of ways. It is self-evident, for instance, in the exuberant "gestural" style of painters like Joseph Raffael and Bill Scott. Raffael's *Untitled* oil was inspired by the view of a flower garden with a vermilion blossom at the top, dusky blue flowers on the lower left, and a field of bright buds in the background. Yet the treatment is so abstract that the image is all but lost. And the color is so exploded by whirling brushstrokes that it takes on the brilliance of night

CHARLES LE CLAIR, detail,
*Pomegranate and Prickly Pear*
(page 14)

fireworks. Bill Scott conveys an equal exuberance with the dynamic
scribble-scrabble of his pastel *Bloomington*. Here we can almost see the
artist's hand swinging across the page—creating sunshine with a yellow
smudge, putting in a river of turquoise marks, making a thicket of
blooming plant life with red, rust, and purple chalkstrokes.

There's a similar color excitement in the work of the so-called painterly
painters—artists in the tradition of Oskar Kokoschka and Willem de
Kooning who delight in blobs, slashes, and gooey slabs of paint. During his
1960s pop art phase, Wayne Thiebaud used this approach in paintings of
cakes, pies, ice cream, cookies, and lollipops that equate the joy of color
with the joy of eating. Or perhaps I should say *Joy of Cooking*, in deference

to the popular gourmet guide. At any rate, a painting like *Cheesecakes* is a perfect metaphor for the idea of color as pleasure. Thiebaud is famous for cake paintings frosted with buttery swirls of pigment that imitate real topping, and in this tribute to plain and chocolate cheesecakes, he gives each triangular wedge a gelatinously painted top with a thick, gooey "lip" to suggest a knife cut.

Finally, let me say that the joys of color can be just as intense, if not always so obvious, for those of us who paint more deliberately. The preparatory drawing for a watercolor like my *Pomegranate and Prickly Pear*, for instance, involves tedious days of adjustments, erasures, and problem solving. So you can imagine the thrill of finally being able to turn to color. Furthermore, the rationale for the elaborately patterned background is a color game involving clusters of interrelated hues that are like harmonic

BILL SCOTT, *Bloomington*, 1987. Pastel, 25 × 19″ (63.5 × 48.3 cm), collection of Mary Nomecos and Arthur W. Jones, Philadelphia.

WAYNE THIEBAUD, *Cheesecakes*, 1961. Oil on canvas, 20 × 24″ (50.8 × 61.0 cm), courtesy Allan Stone Gallery, New York.

CHARLES LE CLAIR, *Pomegranate and Prickly Pear*, 1988. Watercolor, 35 × 29½″ (88.9 × 74.9 cm), collection of Mr. and Mrs. Anthony Richards, South Orange, N.J.

chords on the piano. I have always loved to mix colors, and here there are hundreds of stripes to be painted in tones that match hues in the still life and, at the same time, reflect changes occasioned by light, shadow, and distance. Thus there is both logic and improvisation in this color game, and where another artist might play it with eight or ten standard colors, the fun for me lies in making each mixture fresh, new, and alive.

## LOOKING AT COLOR: FIVE LEVELS OF PERCEPTION

From these examples, you will see that our study of color relationships in painting must start with an awareness of the artist's intentions. But we must also be sensitive to the variousness of the color experience. You can't look at Rembrandt, Monet, Picasso, or any of our contemporary artists in precisely the same way. Color functions on many levels, each with its own logic. It can be perceptual, realistic, theoretical, emotional, or symbolic. It can create moods, atmospheres, and even suggest historical periods, as in a "Victorian" or "art deco" color scheme. And though one or another of these functions may be uppermost in the artist's mind, you will often find several color systems at work in the same picture.

**Abstract Relationships.** By definition, the first, or root, level of color usage is the purely abstract manipulation of the element of color for its own sake.

You will find this most direct approach to color in both nonobjective painting and in certain decorative arts like quiltmaking, in which subject matter is subordinate to design. It is also the dominant impulse in children's artwork, and on a more sophisticated plane, in Matisse's wonderfully spontaneous paper cutouts. Since the days of Seurat's divisionism and Mondrian's neoplasticism, however, the goal of a more scientific approach to abstract color relationships has excited painters. And at various stages in their careers, Jasper Johns, Ellsworth Kelly, Kenneth Noland, Al Held, Sol Le Witt, Frank Stella, and others have worked with theoretical optical schemes.

Stella's 1978 canvas *Double Scramble: Value Scales, Yellow & Spectrum* is a case in point. As the elaborate title suggests, the artist's scheme involves a double image and a plan like that of the board game Scrabble (a sound-alike for "scramble"), in which moves in two directions have to be correlated. Here the moves are *in* and *out* from sides to center, with the value scales, or shifts from light to dark, reversed on the two squares. On the left, the darkest colored stripes are in the center; on the right, they are on the outside edge. And in each case the yellow background is shaded to heighten contrast, so that as the stripes get darker, the yellow areas in between them get lighter. Meanwhile, despite their flatness, these images create an optical illusion of spatial depth. Look closely and the left square

Frank Stella, *Double Scramble: Value Scales, Yellow & Spectrum*, 1978. Acrylic on canvas, 81 × 162″ (205.7 × 411.4 cm), collection of Dr. and Mrs. Robert C. Magoon, Miami Beach, Fla.

suddenly becomes a pyramid projecting outward. Look again, and the right square is a tunnel shooting inward toward a distant spot of light.

Light/dark contrasts are just one aspect of this color game, however. Stella also creates a chromatic puzzle that pits yellows against the other hues of the spectrum. The progression within each square follows a harmonious sequence of neighboring, or analogous, hues—yellow, orange, red, and violet on the right side and, moving in the other direction around the color wheel, yellow, green, and blue on the left. Meanwhile, dramatic contrast between the two faces of this mirror image is created by the dominance of red in one and its spectrum opposite, green, in the other. Stella's neatest trick is to present us with squares that seem to be on entirely different backgrounds—one on an orangish-yellow tone, the other on bright lemon yellow. Yet upon close examination, we discover that the outside band of yellow in each square is an exact match for the innermost yellow in the other.

In contrast to this intellectual approach, Hans Hofmann shows us how the same color principles can be employed in a more sensuous, painterly way. Hofmann (1880–1966) was a German émigré who became one of our most widely influential modernist teachers after establishing studios in New York and Provincetown in the thirties. He also received major, though somewhat delayed, recognition as a painter during the last decade of his life.

Like most abstract artists, Hofmann saw color relationships as a balancing of opposing forces—hence the title of his canvas *Equipoise*. Where Stella relies on suave gradations, however, Hofmann was obsessed with color dynamics—the juxtaposition of colors in a system of vehement

attractions and repulsions he called "push/pull." Hofmann was also both a vigorous action painter and an artist whose abstractions were drawn from visual experience rather than from purely nonobjective ideas. His students were taught to work from life, paint with kinetic energy, and reduce what they saw to simplified color planes.

Hence, though Hofmann's *Equipoise* poses a "symmetrical" color equation not unlike Stella's in *Double Scramble*, it is a more dimensional and emotionally involving composition. Instead of Stella's twin squares, Hofmann balances four large rectangles, and in place of a flat yellow ground color, he gives us the loosely brushed greens of a landscape with small blocks of contrasting hues that might be houses scattered in the distance. Meanwhile, the foreground arrangement of four large color blocks is cleverly designed to convey the duality of the pictorial experience— surface design versus depth illusion. Three of these rectangles are positioned like posters in a shop window to "close off" the view, but the fourth, on the upper right, is raised up and turned around in such a way as to "open" a path toward the horizon.

"Opening and closing the picture plane" is a basic modernist strategy, and no one does it more boldly than Hofmann. His famous pushes and pulls depend on three variables: aggressiveness of color, weight of paint, and the overlapping of shapes. Here, each large rectangle takes a different position in space. A green block blends into the thinly painted background, while immediately above it, a thick lemon-yellow block snaps forward like a kite in the wind. At the same time, a neighboring orange-yellow rectangle is pushed back a notch by virtue of its deeper tonality and placement behind an overlapping swatch of blue. And in the lower left, a block of fire-engine red is the springboard for a whole series of depthward movements. Unlike the other rectangles, it is attached to the frame, with smaller pink, yellow, and orange shapes tucked in behind like houses and cars marching up the street.

**Representation.** If abstract color relationships are a primary consideration in painting, many artists also work with a second, more pragmatic level of color logic that is based on observation and representation.

In John Moore's *San Francisco View*, for instance, the sky is a "realistic" blue, and the buildings, softened by layers of atmosphere, become paler in the distance rather than jumping from pink to orange and bright blue as in Hofmann's abstract landscape. There is also a sense of urban grittiness in the choice of ochres, umbers, and steel grays for the foreground. Clearly, the artist has spent long hours observing the scene, distilling shapes and colors into an expressive but truthful record of his subject.

Yet forget about realism, and you will find amazing similarities between the Moore and Hofmann paintings. Both are composed symmetrically with

HANS HOFMANN, *Equipoise*, 1958.
Oil on canvas, 60 × 52″
(152.4 × 132.1 cm), Marcia Simon
Weisman Collection, Beverly
Hills, Calif.

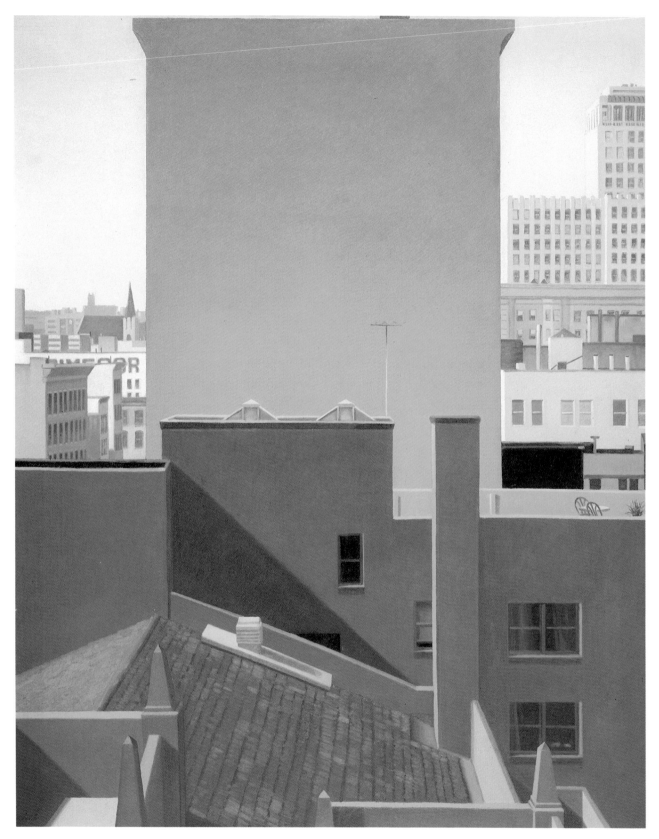

JOHN MOORE, *San Francisco View*,
1982. Oil on board, 30 × 24″
(76.2 × 61.0 cm), courtesy Hirschl
& Adler Modern, New York.

large rectangular blocks tied together by active smaller shapes. In both, the foreground is a pervasive neutral tone accented by percussive darks and lights, while the upper region is dominated by two bright rectangles—yellow in one, sky blue in the other.

This similarity is neither superficial nor accidental. Instead, it reflects Moore's concern with a contemporary visual vocabulary. People think of realism as the opposite of abstraction, but today's "new" realists carefully avoid old-style illusionistic devices like "center of interest" and railroad-track perspective in favor of simplified design. Here, the artist chooses the side view of a blank, featureless building whose shapes register as pure geometry. He emphasizes the flatness of the picture plane by pushing the foreground back with dark, neutral browns while pulling the recessive side panels forward with brighter color and eye-catching architectural details.

Virtually all the realists whose work we shall be looking at in this book are committed to a similar balance of verisimilitude and formal design. It is a difficult equation, however, since subject matter tends to limit abstract possibilities. Where Hofmann could be totally uninhibited in choosing colors for an abstraction, Moore's cityscapes are bound by the specifics of time and place—the view from a particular window, the light of a certain season or hour. Moore's solution is to portray urban facades and the topography of industrial sprawl as a kind of cubist pattern in muted colors. Brick reds and grass greens provide flashes of brilliance, but his palette is most notable for subtle harmonies dominated by either the softly pervasive light of *San Francisco View* or, more recently, by velvet-black shadows.

Because still life is the most flexible of the figurative genres, many contemporary realists prefer it as a format for their ideas. Obviously, it presents an ideal situation for recording precisely what one sees. Models move, skies cloud over, but studio setups don't change. On another level, however, still life can also be thought of as an essentially abstract art form. The subject need not be "important." Objects can be arranged arbitrarily like shapes in a collage. And as in an abstraction, there are no color restrictions. One has preconceptions about the color of an evening sky or a model's skin, but drapes, bowls, and boxes can be any color of the rainbow.

Nancy Hagin is a past master of this idiom. A watercolor like *Three Red Cloths* has enormous appeal as a poster-bright abstract pattern of primary reds and angular shapes. Yet we are equally attracted by the immediacy of the image—the realism of a shiny white enameled pitcher, the illusion of reflections in a folding mirror. Hagin achieves these effects with a directness that owes much to the close-up perspective of the still-life format. There is no foreground, middle ground, or distance, just a flat view of the studio floor, with everything Hagin could find that was red thrown down on it—a bandanna, a floral cloth, a fabric bearing a design of abstract birds, and a bunch of artificial lilies and poppies. And in contrast

NANCY HAGIN, *Three Red Cloths*, 1982. Watercolor, 29½ × 42″ (74.9 × 106.7 cm), courtesy Fischbach Gallery, New York.

to the fixed relationships in a landscape or figure composition, these still-life objects have been scattered in a centrifugal pattern like that of crystals turning in a kaleidoscope.

**Material Concerns.** A third level of color perception has to do with texture and material. Pastelists find color ideas in dry-as-dust chalks, watercolorists in wet washes, collagists in substances like wood and cloth, and the viewer's perception of color, in turn, is strongly affected by this choice of medium.

You see, we don't usually relate to colors as isolated hues, like sample chips in a paint store. The *lustrous blue* of velvet, the *misty blue* of chiffon, and the *crisp blue* of linen strike us as distinctive colors, even when they are from the same dye vat. The same thing is true in painting. Critics have always acknowledged differences of color quality in traditional mediums like oil and watercolor, and the physical aspect of color has an even greater importance in contemporary art, where standard materials are often replaced by mixed media and experimental substances like velvet, linoleum, Day-Glow pigments, aluminum, and lead.

Until recently, for instance, who would have thought of painting on broken crockery or worn-out tarpaulins, as Julian Schnabel does? And who

TONY VEVERS, *Mexican Series #4*,
1986. Collage and sand on canvas,
35½ × 20″ (90.2 × 50.8 cm),
courtesy Long Point Gallery,
Provincetown, Mass.

could have imagined the subtleties of tone Provincetown's Tony Vevers has discovered in working with sand? In *Mexican Series #4* we are immediately struck by the distinctive color quality of his materials—the overall "ceramic" feeling and the contrasts of dull versus bright and natural versus painted surfaces. The moon is painted white, but over a delicately textured surface of pasted-on confetti. The sky is natural black volcanic sand from Martinique sifted onto canvas and glued down with acrylic medium. And the beige landmass below is layered with brown, tan, and gray Mexican river sands over which a collage of bright paper strips has been laid to suggest moonlight.

Vevers's color has distinctive textural qualities, and it is effective on other levels as well. In abstract terms, his picture is virtually a textbook chart of optical laws. The concept of light is expressed diagrammatically by a white circle on a black field—white being the color that combines all others, black, the symbol for absence of color. The image can also be seen representationally as a white moon casting a path of light that has been broken into the rainbow hues of the spectrum. Not a precise spectrum, to be sure, but a Mexican version reminiscent of the stripes in a native serape.

**Connotation and Symbolism.** The thought that colors can suggest a particular locale like Mexico brings us to a fourth level of color usage, one based on associative meanings and symbolism.

We all know that roses are red and violets are violet (rather than blue, as the poem says). Indeed, most of the world's flora and fauna are associated with specific colors—lemon, orchid, tangerine, avocado, flamingo, to name a few. Certain color combinations are also associated with events like Christmas or the Fourth of July, with historical periods, and with specific places, such as Scandinavia, India, or Alaska.

In representational art, one's subject is almost always identified with certain obvious colors—the pink of a model's skin tones, the oranges and yellows of autumn foliage, and so on. The artist must then decide whether to heighten the normal color chord, as van Gogh does in painting *Sunflowers* of an overpowering yellowness, or to play against it and surprise us, as Monet does in the famous series of grainstacks that are forever changing color.

Color associations are important in abstract art, too, since in the absence of representational imagery, they are often the only clue to a picture's "meaning." This can be helpful or disadvantageous, depending on the artist's point of view. Nonobjective purists, for instance, must work hard to avoid inadvertent figurative references—a blue area that reads as sky, a green triangle shaped too much like a tree, an orange circle that might be taken for a setting sun. On the other hand, there are many artists

like Tony Vevers who see abstract art as a multilevel experience in which
thematic overtones are a poetic enrichment. In fact, Vevers says his
Mexican series was directly inspired, during a visit to San Miguel de
Allende, by the idea of using gaudily colored street scraps as found objects
that might impart "a sense of place and mood."[1]

Frances Gialamas shares Vevers's interest in unusual materials. Her
satirical collage *Glitz* is an inventive assemblage of visual and tactile
elements—silk-screen prints of the American flag, Xerox copies of fifty-
dollar bills, artificial gold coins and stars, rhinestones, advertisements for
"fabulous Las Vegas," and Christmas-tree lights—the whole arrangement
fastened to Plexiglas with grommets and dusted with glitter.

As her ironic title suggests, however, this Pittsburgh artist takes a more
conceptual approach. Like much recent avant-garde work, *Glitz* makes a
social comment with words as well as visual elements, and with found
objects chosen for meaning rather than purely formal design. Gialamas's
color is also more symbolic than Vevers's. That is to say, it represents ideas
instead of places and things. It isn't the look of Las Vegas she is after so
much as an indictment of the values of a high-rolling city. Coins,
greenbacks, and electric lights are obvious physical symbols, while the
color gold traditionally stands for wealth, and her red, white, and blue
scheme could mean anything from Old Glory to red-blooded Americanism
to smug, self-righteous flag-waving. When it comes to symbolism, however,
everything depends on context, and here, in a setting of flashing lights and
fifty-dollar bills, Gialamas's flag reference is clearly satiric.

**Emotional Expression.** Finally, we take note of an important, fifth level of color usage, which is based on emotional intent. If red is a spectrum hue for the abstractionist and the color of apples and cherries for a realist, it can be the fiery color of passion for the painter of inner emotions. Such artists are generally spoken of as expressionists, and they tend to choose colors for their psychological impact—purple to convey horror, perhaps, or pink for joy and green for envy.

There are two main expressionist modes: the Germanic/Scandinavian idiom of darkly passionate imagery, which dates from Gothic times, and the ideal of childlike or primitive innocence nurtured by nineteenth-century romanticism and later by Freudian psychology. Frank Hyder's huge panel painting *On the Beach* is a stunning contemporary reaffirmation of the first tradition. Its somber tonality is reminiscent of Käthe Kollwitz; its stylized poses, of Edvard Munch. In addition, the unusual technique—in which ink-stained plywood is carved with hand tools, painted, and then recarved and repainted—provides the kind of textural energy currently exalted by Anselm Kiefer and the German neo-expressionists. Above all, we see a freely emotional approach to color here as Hyder shrouds his scene

FRANK HYDER, *On the Beach*, 1987. Oil on carved wood panel, 72 × 96″ (182.9 × 243.8 cm), courtesy More Gallery, Philadelphia.

SOCRATES PERAKIS, *Yellow House*, 1988. Pastel on canvas, 30 × 36″ (76.2 × 91.4 cm), collection of Mrs. John T. Dorrance, Jr., Gladwyne, Pa.

SOCRATES PERAKIS, *Red House*, 1988. Pastel on canvas, 33 × 44″ (83.8 × 111.8 cm), collection of Mr. David N. Pincus, Philadelphia.

in blackness, smears the ocean floor with streaks of molten yellow, and edges the fingers of a giant hand with blue and gold phosphorescence.

The second, more cheerful mode of expressionism has cropped up frequently in modern art, beginning with Gauguin's search for "primitive" simplicity in the South Seas. Later there were the childlike Fauves (or "wild beasts"), the irrational dadaists, and fantasists like Klee, Miró, and Calder. Essentially, this vein of expressionism represents an anti-academic, anti-intellectual approach to art, and as such, it is a rallying point even now for artists who are turned off by the supersophistication of today's art world. In contrast to the large-scale conceptual and high-tech work featured in major exhibitions, smaller galleries everywhere are showing paintings in a lighter, more intimate and personally expressive vein.

As in Socrates Perakis's *Yellow House* and *Red House*, quirky humor, "primitive" drawing, and narrative imagery are very much the order of the day. Actually, these pastels tell a serious story about color theory, but in the lighthearted style of a child's picture book in which skies are drawn with scribbles and houses have faces with window-eyes that smile or frown. To follow the plot, we must also see *Yellow House* and *Red House* as sequential images in an animated cartoon about the way colors move forward and backward in space. In the first picture, two "shots" of Yellow House show it moving confidently from mid-distance to center stage as wicked Red House hides almost invisibly on the far right. Then in the second painting, Red House comes to the fore, while Yellow House is banished to distant hills and the heavens rain teardrops.

You will no doubt recognize this as the Mother Goose version of Hans Hofmann's push/pull theory of color dynamics. But though the treatment is lighthearted, Perakis takes these principles seriously. A brilliant colorist, he loves to make colors push forward aggressively by surrounding them with their spectrum opposites. In *Red House*, for instance, the central crimson building is outlined in electric violet-blue. The surrounding green shrubbery is dotted in red. And areas of intense yellow—an arc at the left and a little house on the right—are set against complementary violets and purples.

None of this is done "scientifically," of course, but with the abandon of a free spirit that is a reminder of the joyousness of the color experience and the variety of splendors it offers.

1. *Tony Vevers: A Retrospective of Thirty-five Years' Work* (Lafayette, Ind.: Greater Lafayette Museum of Art, 1986, exhibition catalogue), 15.

# 2 COLOR AS VISUAL IDEA

*When I had every choice open to me . . . I used the same five or six color combinations. . . . Having imposed a system on the construction of an image, I found myself making shapes and colors I had never made before.*

*—Chuck Close*

Before turning to color theory, we should take a look at the way today's painters think about color and the other visual elements they work with.

The traditional view of art has been one of esthetic harmony—an ordering of line, form, and color according to principles of unity, variety, rhythm, and balance. In this respect, Ruskin's Victorian ideal of beauty and Roger Fry's modernist ideal of esthetic form aren't all that different. But nowadays, although these principles still underlie much of the work we see, artists don't talk about them. Instead, they talk about their "concepts," "ideas," and painting "strategies."

## ART IN A CONCEPTUAL AGE

Since World War II, universities and degree-granting art colleges have largely replaced the traditional fine arts academies as the training ground for artists. In this intellectual environment, art history professors chart the triumphs of avant-garde movements, studio teachers talk of art "on the cutting edge," and foundation courses, far from stressing traditional skills, challenge the student with conceptual "problems." Thus within their first year, students come to understand that, in contrast to nineteenth-century figurative art and early twentieth-century abstraction, theirs is an age of conceptual concerns.

One has only to pick up a current art magazine to recognize this. As I write, for example, the news is that Lucas Samaras has moved from abstract chairs and stitched quilts to Dürer-like portrait drawings and surrealist jewel boxes. Sam Francis is reported to have found a new way to apply color by walking on his canvases in paint-soaked stockings. And David

JANET FISH, detail, *Raspberries and Goldfish* (page 40)

Hockney's latest show is advertised by a painting called *Van Gogh Chair*, which re-creates Vincent's famous yellow bedroom chair in a distorted, reverse perspective. Presumably, the exhibit will include other famous furniture—perhaps a Braque taboret or Matisse love seat—and one assumes that Hockney will come up with something new again next year.

It is in this perspective, then, that we shall be looking at color here. Although artists always have sought new ideas, it has usually been within the framework of a naturally evolving style. Today, on the other hand, they think in terms of painting "strategies." *Strategy* is an "in" term at the moment that implies both a more arbitrary stance and a more detailed game plan designed to produce an unforeseen and, hence, new and original outcome. John Cage's experiments with a "prepared" piano introduced me to this tactic some years ago. Each time the composer inserted a pencil, eraser, coin, or bit of string between the wires, the keys produced sounds

PHILIP PEARLSTEIN, *Nude with Griffin*, 1988. Oil on canvas, 72 × 60″ (182.9 × 152.4 cm), courtesy Hirschl & Adler Modern, New York.

that, quite literally, hadn't been heard before. And the beauty of Cage's strategy was that it could be repeated with seemingly endless variations.

In the field of painting, the most thoroughgoing strategy I know is that of the distinguished realist Philip Pearlstein. Agatha Christie fans will recognize it immediately as a "locked room" strategy. Not that Pearlstein's studio is actually locked; rather, it is psychologically sealed off—an arena no larger than a wrestling ring, with the window wall bricked up and the artist and his models locked in a close encounter under harsh spotlights.

Like Cage's piano, Pearlstein's "prepared" studio has been the vehicle for significant discoveries. By standing tall over a setup of sprawling bodies, rugs, mirrors, and bizarre furniture, his brush a mere six inches from the model's foreshortened elbow or foot and the head sometimes cut off from view entirely, the artist has been able to remake realism in the image of cubism. That is to say, his compositions function primarily as abstract patterning, despite their clinically observed subject matter. In *Nude with Griffin*, for instance, spatial compression and figural distortions are so extreme as to suggest a painting torn apart and reassembled as a collage.

Pearlstein's most significant innovation, however, is his handling of color and light. Back in the 1870s, the realists moved from the "brown gravy" of studio shadows into the sunshine. Now, a century later, Pearlstein's "new" realism reverses things, not only by a return to the studio but also by a total reliance on artificial light. In Pearlstein's studio there are no windows, no skylights, just six 150-watt spotlights—three on either side, shining from high, fixed positions so that the setup below is struck by crisscross shadows. As a "direct" painter, Pearlstein records precisely what he sees, but in this light-flooded space, the vivid hues of patterned rugs and costumes have a posterlike boldness, while flesh tones take on the pallor of plaster figures.

Meanwhile, space is created by the artist's famous triple shadows— stylized repetitions of an edge in tones of gray or beige, as in the shadows cast by a weathervane and an African mask in *Nude with Griffin*. This is a vision as unique to our own age of electric light as Monet's open-air landscapes and Toulouse-Lautrec's gaslit cabarets were in theirs. I often think of Pearlstein when visiting a museum where both old masters and modern artists are shown with track lighting that casts nests of multiple shadows around each picture.

## COLOR STRATEGIES

In even the most crowded exhibition one identifies a Matisse or Picasso from across the room. It isn't easy to achieve a truly distinctive style, but like Pearlstein, most of today's stars have done so by developing a clearly focused painting strategy. There are countless variations, of course, but the

WILLIAM BAILEY, *Still Life Verona*, 1988. Oil on canvas, 40 × 50″ (101.6 × 127.0 cm), courtesy Robert Schoelkopf Gallery, New York.

artists we shall look at next suggest a range of possibilities. William Bailey paints quietly poetic still lifes, Richard Diebenkorn paints austere but radiant abstractions, and Peter Saul is a maverick satirist whose own strategy is to mock the styles of other artists.

Bailey's paintings are a particularly interesting contrast to Pearlstein's because they employ a similar concept—the arrangement of forms in a narrowly restricted space—but with diametrically opposed results. Where Pearlstein portrays dynamic life-size figures in aggressively patterned surroundings, Bailey paints orderly arrangements of jugs and vases in the hermetic setting of a shallow shadow box.

*Still Life Verona* is typical of the latter artist's rather severe and unvarying compositional strategy. In almost all of Bailey's still lifes, ceramic pieces of vaguely antique character are arranged as here—lined up along a shelf in the lower half of the canvas, always at eye level, and always with a spacious, but featureless, wall behind them. In this frontal view, bowls and jars are seen in profile, so that their decorative stripes appear as elegantly flattened bands of color. What sets Bailey apart, though, is the exquisite refinement with which he has reduced a standard realist "mantelpiece" format to a purely formal statement. He conceives of his objects as "fictions" to be arranged in the mind rather than observed in real life. And he renders them with dreamlike perfection—their contours drawn with Mondrian-like severity, their forms rounded like Greek columns, and the modeling of shadows and open spaces as smooth as silk.

Color plays a decisive role in creating this classical tone. There is a sense of time gone by in Bailey's Italianate palette of umbers, siennas, and ochres. Faded backgrounds like the lovely pinkish terra-cotta wall in *Still Life Verona* also contribute to an air of old-world richness. At the same time, Bailey's colors sing out with extraordinary clarity. Each object is assigned a distinct local color. Gradations from dark to light are perfectly calculated. And despite a sumptuous paint surface, one has the sense of a severe, almost minimalist, underlying design.

Where Bailey paints real objects abstractly, Diebenkorn takes the opposite approach of painting abstractions with overtones of real-life experience. Thus the more than 140 works in his Ocean Park series are to be understood as abstract interpretations of the extraordinary light and spatial vastness of the California coast. In this context, his color is understandably as bright and fresh as Bailey's is muted. And in contrast to the self-contained harmonies of much abstract art, Diebenkorn uses color referentially. In *Ocean Park #140*, for instance, the color chord of ultramarine blue, aquamarine green, and yellow functions both as formal design and as a vision of sunlight and sea.

We also see here how Diebenkorn translates the sensation of infinite space into the flattened idiom of an abstraction. Instead of pushing inward toward a distant horizon, as in a realistic seascape, areas of green and blue stretch outward toward the edges of the canvas, squeezing a sunlit sky at the top and echoes of buildings at the sides into narrow, pressurized strips of color.

In addition, the artist uses a technique of transparent planes to suggest a layering of spatial distances. We see this most clearly in a cluster of overlapping shapes in the upper left corner. Though colors are poster-flat elsewhere, here they move in front of or behind one another like boats and harbor pilings seen against the sky. The vagueness of extreme distance is created by a thin lavender wash painted underneath the other colors. A middle distance is established by the firmer tone of the large blue rectangle. And the green shape is pushed forward, in turn, by a shadow thrown on it by the edge of the blue rectangle. Thus, even though *Ocean Park #140* is an abstraction, it would seem to be lighted from behind in this top left corner. There is even a suggestion of realistic perspective here in the dramatic diagonal line that sweeps upward as if to a distant vanishing point.

In talking about color, we must inevitably consider esthetic relationships. The Texas painter Peter Saul, however, is one of a growing number of artists who are more interested in social and political comment than in formal nuances. Over a long career, he has satirized everything from Ronald Reagan's politics to junk food and capital punishment. As a leader of the new wave of issue-oriented artists, Saul has especially caustic things

RICHARD DIEBENKORN, *Ocean Park
#140*, 1985. Oil on canvas,
100×81″ (254.0×205.7 cm),
collection of the Douglas S.
Cramer Foundation, Calif.;
courtesy M. Knoedler & Co.,
New York.

PETER SAUL, *New York Painter*, 1987. Oil and acrylic on canvas, 72 × 108″ (182.9 × 274.3 cm), courtesy Frumkin/Adams Gallery, New York.

to say about the cult of modern art, which he sees as "a long list of exaggerations: exaggerated thick paint, exaggerated size of canvas, exaggerated emptiness, etc. etc."[1]

Executed in a style that is part Mad Max and part Marx Brothers, his 1970s pictures of Francis Bacon descending a Marcel Duchamp staircase or Donald Duck as a de Kooning "Woman" are screamingly funny. And in a later work called *New York Painter*, Saul portrays today's with-it artist as a macho type with double-barreled pipe between yellowed teeth, a pimple on his nose, hair in a combination ponytail/flattop style, and a T-shirt proclaiming his YAIL university connection. The object of this creature's attention is a shaped canvas that he attacks with a housepainter's brush and the straight-from-the-tube squiggles of a would-be Jackson Pollock.

Thus Saul takes aim at precisely the kind of picture-making strategies this chapter is about. Yet we note that his own style is as exaggerated as anything he might attack. The billboard scale of a canvas like *New York Painter*, with its six-foot portrait head and nine-foot span, is very much in the current mode, as is its hopped-up color. More to the point, however, is the fact that, although Saul prides himself on using unfashionable, in his words, "slick" and "cartoonish" color, his palette of overheated spectrum hues serves his purpose well.

In short, this is color that "works." Despite popular notions to the contrary, color doesn't have to be harmonious to be effective, and in a satirical context like this, comic or even crude effects are in order. Accordingly, Saul's New York artist works on a gaudy chartreuse canvas, and his studio is a symphony of bad-taste decor, its canary ceiling shining above pink-and-red and blue-and-orange plaid wallpapers.

# REINVENTING A PERSONAL STYLE

Painters who emerge as "new talent" during their twenties or thirties soon face the problem of adapting youthful ideas to the challenges of a continuing career. Having found an original, and sufficiently involving, strategy, many tend to stick to their last. Bailey's ceramic still lifes, for instance, have undergone a process of development and refinement, but within a certain mold. And for more than twenty-five years, Pearlstein has composed variations on a single theme. Exotic costumes and furnishings have varied his poses, but the underlying strategy has remained the same.

A slide talk by Janet Fish reminded me that there is also another kind of painter—the person who thrives on change. When we think of Picasso, it is of the "pink," "blue," "cubist," and "neoclassic" periods, and many of today's artists are known for similar stylistic shifts. Frank Stella, for instance, has kept nonobjective painting in the news with strategies ranging from minimalist austerity to baroque extravagance. Fish has a similar position among the realists. I can think of no better illustration of the conceptual or, if you will, "strategic" use of color in contemporary painting than the creative changes that have taken place in her work over the past twenty years.

Let me say at the outset that these changes have to do with theme and style rather than philosophy. Like Pearlstein, Jack Beal, Neil Welliver, and other leaders of the 1970s new realist movement, Janet Fish has maintained her belief in painting from direct observation. Unlike the others, however, she has changed her subject matter and radically altered her approach to color and space along the way. So much so, in fact, that the early and late paintings have quite opposite virtues—structural severity in her youthful phase, opulence in her latest style.

Representative examples of the artist's work over a period of twenty years show how she has consistently reinvented her art by introducing new themes and picture-making strategies:

**1969.** Janet Fish first captured attention with an innovative still-life format consisting of giant frontal views of plastic-wrapped supermarket produce. In *Oranges*, for instance, each piece of fruit is some thirty inches high, and—like her paintings of peppers, apples, bananas, tomatoes, and broccoli—it is shown in a bright tray that fills the picture space. I remember the stir her work created at the time, because this combination of pop-art color and extreme spatial compression hadn't been seen before. Fish's most significant contribution, however, was the use of realistic technique as a vehicle for abstract design. Her rendering of studio windows as highlights on plastic wrap is a virtuoso representational effect. But as you can see in the convoluted reflections in the upper corners, this realistic device also creates thoroughly abstract patterning.

**1974.** After the pictures of wrapped produce, Fish turned to shelf arrangements of glass containers filled with liquids like vinegar, salad oil, honey, or liquor. *Tequila* is typical of the period. This time the view is frontal rather than from above. And although there is continuing interest in reflections, they are achieved now with backlighting that creates an interplay between reflections *on* the bottles and the see-through movement of liquids *within* them. The new approach makes for a more complex image than the studies of solid supermarket produce. Here, reflections and transparent effects are conveyed by separate, fragmented spots of light and color, and this sense of a fractured image is amplified by the use of mirrored shelving under the objects.

Tequila is most notable, however, for its color. Unlike many realists, who favor a muted or selective palette, Janet Fish likes to use, as she says, "Every color! Any color! Every color in the book!"[2] Look again at her *Oranges*, for example, and you will find the full spectrum—yellow, orange, red, and violet, plus a green label and a pale blue background. In *Tequila* the artist plays new color games, this time with the manufacturer's labels, as she alternates columns of rainbow-hued stripes with passages in which the rainbows dissolve, with appropriate unsteadiness, into an alcoholic blur.

**1975.** For me, Fish's mid-seventies water-glass paintings are her most ingenious achievement. Ingenious because the basic motif is so simple— nothing exotic like Georgia O'Keeffe's desert skulls or Gauguin's tropical nudes, just a routine household object waiting to be discovered, yet overlooked by the rest of us. The first versions, showing clear glasses against a neutral ground, are almost monochrome. Then, in *Skowhegan Water Glasses*, Fish lets the summer greenery outside her window flow into the picture, and the strategy of a fused interior/exterior space is born.

**1978.** Three years later we see the full development of this indoor/outdoor concept in a painting called *Grey Day*. Here, the earlier format of liquid-filled bottles in an enclosed space is replaced by one of empty glass containers in front of a distant cityscape. Although surface patterning is still important, Fish now gives full attention to deep space: Giant still-life objects fill the foreground, while buildings outside her window are softened, on the upper right, by the atmosphere of a gray day. The artist's main purpose, however, is to fuse nearby and distant views into a cohesive image.

Two new strategies contribute to this goal. First, the use of oddly shaped glassware instead of plain tumblers creates a unifying overall texture of striated, curved, and zigzag lines. Second, the shift from clear to tinted glass floods the composition with waves of color that also help to bind indoor and outdoor motifs together. Thus, in contrast to the identically

JANET FISH, *Oranges*, 1969. Oil on canvas, 48¼ × 72″ (122.6 × 182.9 cm), collection of Fred and Kathryn Giampietro; courtesy Robert Miller Gallery, New York.

JANET FISH, *Skowhegan Water Glasses*, 1975. Oil on canvas, 40¼ × 42″ (102.2 × 106.7 cm), Frito-Lay Collection; courtesy Robert Miller Gallery, New York.

JANET FISH, *Tequila*, 1974. Oil on canvas, 66 × 54″ (167.6 × 137.2 cm), courtesy Robert Miller Gallery, New York.

Janet Fish, *Grey Day*, 1978. Oil on canvas, 42 × 70″ (106.7 × 177.8 cm), courtesy Robert Miller Gallery, New York.

repeated bands of color in *Tequila*, the color in *Grey Day* is remarkable for its ebb and flow. If, for example, you trace the movement of any single hue through the picture—say the blue of the tall glass on the right—you will see how it reappears in the facets of other glass objects, glitters against its complement (orange), and blends with analogous, or neighboring, hues (green and violet).

**1981.** This kind of color "glissando"—a slide through the spectrum like a pianist's thumb across the keyboard—is encouraged by the more relaxed perspectives of Fish's later still lifes. Where objects in the early canvases are neatly organized in frontal or overhead views, her 1980s setups are casual arrangements seen from an informal vantage point. Thus the long diagonal of a tabletop and the flutter of gauzy window curtains in *Raspberries and Goldfish* presuppose an indefinite space extending beyond the picture frame. On this expansive terrain, the eye is led quite literally around the color wheel: *up* from yellow plates to lime-green vase to blue fishbowl, then *down* again from blue fishbowl to purple flowers to red raspberries. Furthermore, this implied movement is encouraged by the action of a darting goldfish and butterfly in a still life the artist obviously no longer thinks of as "still."

Another significant change is a deepening of the artist's palette. In contrast to the cheerful color and brightly lighted backgrounds in paintings like *Oranges* and *Tequila*, Fish's later work has been characterized by a velvety richness. Brilliant hues are now set against black, midnight-blue, or purple shadows, and every area of the canvas is saturated with color. In *Raspberries and Goldfish*, for example, the yellow in a stack of glass plates seeps upward as if the whole left side of the picture were illuminated by a golden spotlight, and there is a similar flood of bluish light on the right.

JANET FISH, *Raspberries and Goldfish*, 1981. Oil on canvas, 72 × 64″ (182.9 × 162.6 cm), The Metropolitan Museum of Art, Purchase, The Cape Branch Foundation and Lila Acheson Wallace Gifts, 1983 (1983.171); courtesy Robert Miller Gallery, New York.

JANET FISH, *Feeding Caitlin*, 1988. Oil on canvas, 54¼ × 70¼″ (137.8 × 178.4 cm), courtesy Robert Miller Gallery, New York.

**1988.** The portrait that emerges here is of an artist who sets herself increasingly complicated challenges. Thus it isn't surprising to find that her latest work breaks entirely with the restrictions of the still-life format. Not that there weren't traditional still lifes in her last show. But nowadays Fish is also involved with still life in vast outdoor settings, and sometimes, as in *Feeding Caitlin*, she undertakes an unorthodox combination of all the conventional genres—here, a still life of flowers and fruit in the foreground, portraiture and narrative incident in the middle ground, and a mountain landscape in the distance. This strategy of abundance is as lively as the earlier strategy of limitation, but it is of a different order. As Fish has reinvented her personal brand of realism, her work has taken on quite opposite esthetic qualities. The compressed space, cool color, and detachment of the early paintings have been replaced by expansiveness, lush chromaticism, and romantic themes.

Above all, there has been a shift in emphasis from formal issues to anecdote, portraiture, and other representational concerns. Hence, it is the verisimilitude of the artist's color rather than its abstract design that attracts us now. We note certain patterns in *Feeding Caitlin*, like the repetition of near and distant yellows and the circular movement of red spots through the composition. Yet it is the masterful re-creation of light on suntanned figures in an idyllic summer landscape that is most impressive.

Thus there are different pleasures to be found in Janet Fish's various "periods," and what appeals to one viewer may be less attractive to another. By the same token, I expect you will already have made personal judgments about the work of other artists we have discussed so far. Depending on the eye of the beholder, Pearlstein's color can be seen as "strong" or "too dry"; Bailey's as "rich" or "too bland"; Diebenkorn's as "fresh" or "stark"; Peter Saul's as either "witty" or "overly aggressive."

It is important to trust such immediate reactions, because in the last analysis the esthetic experience is a personal response that can never be fully rationalized. At the same time, anyone who is seriously interested in art must avoid the philistine's "I know what I like" stance and be open to new ideas. That's why I have put this chapter on pictorial strategies up front as a foundation for our study of color. Ahead you will find all kinds of approaches, ranging from traditional schemes to the most avant-garde experiments. Color is, of course, only one aspect of picture-making, but it is often the motor that drives the composition. And if we are to understand color in contemporary art, we must learn to see it as a vehicle for intellectual concepts and visual ideas.

1. *Peter Saul* (Aspen, Col.: Aspen Art Museum, 1989, exhibition catalogue), 4.
2. John Arthur, *Realists at Work* (New York: Watson-Guptill Publications, 1983), 74.

# 3 COLOR THEORY: WHAT THE PRACTICING ARTIST NEEDS TO KNOW

*Color is the most relative medium in art.*

—*Josef Albers*

On a summer day at the beach, we are bombarded by electromagnetic radiation. We hasten to ward off invisible ultraviolet rays with a protective sunscreen cream or umbrella. But we welcome the friendly visible rays of the solar spectrum, because the sunnier the day, the more fun we shall have in watching the passing parade of colorful robes, T-shirts, and bikinis.

In short, the solar spectrum makes the artist's world of color possible. This is a band of radiation shining upon us as white light reflected back to our eyes by certain objects—a towel, seashell, or bathing cap—which we then perceive as "white." Most things appear to us as "colored," however, because they contain pigments that absorb certain rays while reflecting others. Such substances, whether natural or applied with dyes or paints, may be thought of as another kind of sunblocker. But instead of screening invisible ultraviolet rays, they screen out part of the visible spectrum. Thus one dye or artist's pigment will block out everything but blue wavelengths, another will absorb everything except yellow rays, and so on.

## HISTORICAL BACKGROUND

Sir Isaac Newton laid the foundation for our modern understanding of these principles in a series of experiments begun in 1666, when he was only twenty-three. Working in a darkened room with one small hole in his

EDNA ANDRADE, detail, *Painted Desert—Blue* (page 54)

window shutter, he was able to direct a thread of white sunlight through a glass prism in such a way that it broke into the multicolored solar spectrum, a rainbow of progressive frequencies ranging from red (a band of the longest wavelengths) through orange, yellow, green, blue, and violet (at the short end of the scale).

This much had been known before. But Newton was the first to recombine the separated rays into white light again by means of lenses and a second prism. He discovered that objects appear colored in white light because they reflect only a segment of the spectrum. And he designed a prototype of the modern color wheel.

Since Newton's time, various color "systems" have been put forward with two- and three-dimensional charts. The German chemist Wilhelm Ostwald (1853–1932) developed a system based on twenty-eight key colors arranged, together with layers of subordinate mixtures, in the form of a dimensional double cone. This is widely used in Europe, while the best-known American system was designed by Albert Munsell (1858–1915). His plan features a color wheel of ten hues modified by a vertical scale of variations according to lightness or darkness and a horizontal scale of brilliance or dullness, the whole collection of color chips assembled as a dimensional tree.

Munsell also invented a detailed notation system that is used in industry. The label PB 3/12, for example, translates as a purple-blue in the third degree of lightness and the twelfth level of intensity. In recent years, scientific color analysis has been still further advanced by the invention of a spectrophotometer that can measure any color's component wavelengths in millimicrons. We live in an age of color analysis so precise that industrial designers in New York and Tokyo can match colors without looking at each other's swatches, and home owners can coordinate wallpapers with paints mixed by machine at any local hardware store.

## ANATOMY OF THE COLOR WHEEL

As we shall see in the next chapter, the concept of a rigorous, mathematical logic of color relationships is an exciting prospect for certain artists. Such a theoretical approach, however, is of little interest to most studio people, who tend to work with an idiosyncratic selection of pigments and to mix them spontaneously rather than by formula. Furthermore, we speak a different language than the theoreticians do. Instead of using terms like "red–red violet" or "mid-value grayed yellow," we talk of "earth colors," "alizarin," "ultramarine," or "Payne's gray." Nevertheless, the practicing painter has a great deal to learn from color theory. The trick is to translate technical terms into a studio vocabulary, seek out key concepts, and discover how they may be utilized in the creative process.

The basic color wheel is our inevitable starting point. Although routinely familiar—my own memory goes back to diagrams folded into boxes of Binney & Smith Crayola crayons in the eighth grade—it still offers a few surprises upon reexamination. You will recall that the color wheel diagrams the following elements:

**1. Hues.** Hue is the attribute of color associated with a dominant spectrum wavelength. Thus *hue* is a family name for all the different reds—or different greens or blues—on your palette. A vivid lipstick red, a deep maroon, and a light shocking pink, for example, are all variations of the same red hue.

When used in this sense, to describe one of the properties of a color in contrast to another, the word *hue* has a specialized scientific meaning. We must remember, however, that hue also has a more general everyday meaning in which it is virtually synonymous with *color*. In most art discussions, unless there is a technical point to be made, the words are used interchangeably.

**2. Analogous Colors.** The basic color wheel arranges six segments of solar radiation in order of their wavelengths—red, orange, yellow, green, blue, violet—with the long- and short-wave ends of the spectrum (red and violet) connected up to form a circular continuum. Obviously, the spectrum can be divided more elaborately, as in the ten-hue Munsell Wheel used in industry. The six-color wheel is generally preferred by artists, however, as a simpler, more easily remembered diagram of basic relationships.

In any case, *analogous colors* are those close to each other on the wheel. They are generally harmonious—as in the yellows, oranges, and reds of autumn foliage—and they are often used to describe shifts from warm to cool tones created by sunlight and shadow. For example, you might use warm orange on the light side of a red apple and cool violet on the dark side.

**3. Primary and Secondary Colors.** The *primary colors*—red, yellow, and blue—are those that can be combined in various mixtures to create all other colors. Or to reverse the definition, these are the unique hues that cannot be produced from anything else.

*Secondary colors* are derived from a mixture of primaries: orange (from red and yellow), green (from yellow and blue), and violet (from blue and red).

*Tertiary colors* aren't shown on the basic color wheel, but they are implied by the fact that the spectrum can be divided and subdivided ad infinitum into narrower and narrower bands of radiation. Thus the circle of six colors may be extended to twelve by in-between mixtures: yellow-green, blue-green, blue-violet, red-violet, red-orange, and yellow-orange.

BASIC COLOR WHEEL                    MUNSELL COLOR WHEEL

**4. Complementary Colors.** The dictionary defines *complement* as either of two things needed to complete each other. Accordingly, the perfect marriage is one in which the qualities of husband and wife complement each other. By the same token, *complementary colors* are those that, when combined, incorporate all the rays of the spectrum.

On the color wheel complementary hues are shown as opposites: red versus green, blue versus orange, and yellow versus violet. They are also opposites psychologically and in their references to nature: fire and ice (orange/blue), sun and shadow (yellow/violet), flower and foliage (red/green), and so on. Unlike analogous hues, these are colors of extreme contrast. When used together, they create brilliant, vibrating, or even clashing effects.

After looking at a brightly illuminated object, doubtless you have sometimes observed an afterimage, in an opposite color, upon closing your eyes or looking suddenly at a white wall. This visual phenomenon is an interesting proof of the complementary principle. Try this experiment. Put a red apple on a black cloth in bright light. Stare at it for a minute or two, then turn to a blank sheet of white paper, where a green afterimage should appear. Oranges, lemons, and limes will produce similar effects in their respective complementary hues.

## ADDITIVE AND SUBTRACTIVE MIXTURES

The Munsell, Ostwald, and other systems I have mentioned have one thing in common: They offer a rationale for the interaction, not of pure color in the form of *light*, but of colored *pigments*. In short, this is color theory for

painters and designers. And a crucial consideration for any studio person is a fact that is seldom emphasized or fully understood: namely, that mixing colored pigments is a *subtractive* process.

By subtractive we mean that any given pigment absorbs, or "subtracts," a segment of white light in order to reflect back its distinctive hue. Hence, a combination of two such pigments is, by definition, the sum of their subtractions—or to put it in practical terms, a derivative color of diminished brilliance. Thus a green mixed from blue and yellow is less vivid than the colors you start with—or for that matter, than a tube of unmixed green paint made from a substance that was bright to start with. (I learned this lesson early, when attempts to draw grass with blue and yellow Crayolas, according to the color chart we were given in grade school, proved frustrating. Reaching for a grass-green crayon produced a far happier result!)

The German poet, dramatist, and philosopher Goethe (1749–1832) is also known for pioneering treatises on color, a subject he referred to affectionately as his "most beloved child." Instead of a color wheel, he proposed a triangle with the three primaries as cornerstones for three secondary mixtures along the sides and three tertiaries in the middle. The tertiaries are cleverly conceived, since each has a dual identity. Take the color immediately below the red at the top of Goethe's pyramid, for instance. It can be read horizontally as a mixture of orange and violet secondaries, or if you see it vertically, as a combination of red and green complements. In any case, Goethe's diagram makes a helpful point in showing us that subtractive mixtures are noticeably less brilliant than their parent hues.

Follow this principle to the bitter end and you will see that, at least theoretically, a mixture of all pigmented colors should result in total blackness, or absence of color. In practice, however, stirring up all the paints on your palette will produce not a dead black but the dark gray shown at the center of the color wheel. You will find that the only way to make a true black out of other colors is to start with very dark pigments like umber, alizarin, and Prussian blue.

Meanwhile, on Broadway, Hollywood, and TV stages there is another kind of artist: the lighting designer with batteries of spotlights and a computerized keyboard, who speaks an entirely different color language. This is the language of *additive light mixtures*, best visualized not as a wheel or triangle but as three interlocking spotlights. These circles of green, red, and blue-violet light overlap in pairs to produce three other hues—yellow, greenish blue (or cyan), and red violet (or magenta). Most significant, of course, is the fact that all colors overlap in the center to produce not blackness, as in the pigment system, but white light.

GOETHE'S COLOR TRIANGLE

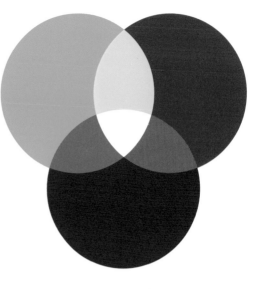

LIGHT MIXTURE CHART

At first glance, relationships in the light mixture chart strike anyone who works with paints as utterly bizarre. It is hard to imagine creating blue from green plus violet or mixing yellow from red plus green! Nor do we find familiar primary and secondary relationships here. Since any of the colors can be produced by a blend of its neighbors, none is "unique" and "unmixable" like the pigment primaries. Instead, in this purely additive system, combining colors strengthens rather than weakens them—the opposite of what happens in pigment mixing. The effect is like that of turning on a series of lights in a dark house. Each newly switched-on lamp—the green-shaded desk lamp, the red Tiffany chandelier, and then the yellow floor lamp—increases the overall level of brightness in the room.

I was reminded of these diametrically opposed color systems when friends from an African photo-safari met to show their prints and slides. The radiant screen projections of tawny lions, iridescent peacocks, and tropical flowers were so dazzling in comparison with my quiet color prints that for a moment I was a bit envious. Yet I shall remain a "print man" because, for me at least, images on paper or canvas, though less showy, have greater depth and solidity.

In any case, brightness is by no means the ultimate artistic achievement. For centuries painters veiled their colors in Rembrandtesque shadows. And in today's galleries you will find a great deal of art, ranging from Wyeth's weather-beaten realism to Anselm Kiefer's metallic expressionism, that capitalizes on muted harmonies. Nevertheless, the main thrust of modernism has been toward increasingly dynamic color relationships. And for most artists, the problem of keeping color fresh and alive—of making the painted rose as red as the real one, even as it wilts on the studio table—is an ongoing, never-ending challenge.

# PRACTICAL GUIDELINES

In this connection, our review of additive and subtractive color systems suggests at least two practical guidelines if you are a painter interested in achieving the most vibrant color relationships.

First, for maximum brilliance, work with a generously stocked palette of at least ten or twelve spectrum hues (not counting earth colors and neutrals). Because pigment intensity can only be diminished by mixing, you must start at the top of the scale. Some artists prefer the subtleties of a limited palette, but for sheer brilliance the broadest possible spectrum is required. In short, your palette should look something like the ten-hue Munsell Wheel. (A check of my own paintbox shows fourteen brilliant tubes in oils and eighteen in watercolor.)

Unfortunately, the popular interpretation of the color wheel as a guide to mixing up a storm from three little tubes of red, yellow, and blue paint is simplistic and, from the professional artist's standpoint, downright misleading. Red, yellow, and blue can indeed beget the secondary hues, but their offspring, though not unlovely, will be muted rather than brilliant. The same principle applies to secondary and tertiary mixtures down the line. That is why the basic wheel's six hues alone won't do. You need three reds (warm orange-red, true red, cool violet-red), three greens of similar warm/cool variation, at least two yellows, and so on.

A second helpful hint is to make the most of transparent passages wherever you can. Watercolorists quickly learn that a pink created by a thin red wash on white paper is more vivid than the same pink made by mixing red with opaque white. The reason is that, instead of being blocked by heavy pigment, light penetrates to the paper in watercolor. It is then reflected back *through* the transparent wash, which becomes, in effect, a film of color lighted from behind like a bit of stained glass.

The "stain painting" of abstract artists like Helen Frankenthaler and Morris Louis may be seen as an extension of this watercolor wash principle, as liquid acrylics are poured out like multicolored dyes onto unsized canvases. Transparent colors are even more luminous when used as glazes over built-up opaque pigments in oil painting. This was the technique of Flemish masters like the van Eycks, who worked out details on a white-highlighted underpainting and then finished off their pictures with enamel-like varnish-and-oil glazes. Many of today's realists still use this approach.

A third way of intensifying color should also be mentioned here, even though it is more intriguing as a concept than as a practical suggestion. This is the notion put forward by the nineteenth-century French scientist Chevreul that tiny dots of color will merge in the beholder's eye to produce intermediate tints more luminous than those mixed on the palette. His argument, of course, was that such optical measures are a blend of additive light rays rather than subtractive pigments.

Monet and the impressionists were thus encouraged to work with spontaneous touches of unmixed color, and Seurat subsequently refined their approach with a more formalized system of measured dots, or "points," of color. In a few short years, Seurat produced a remarkable body of highly personal images, and a masterwork, *Sunday on the Grande Jatte*, which has been widely publicized both as a painting and as the subject of a Stephen Sondheim musical.

Although Seurat's pointillism has had few imitators, his idea—that in a picture you can see "ghost" colors that aren't actually there—has enormous popular appeal. Most critics agree, however, that his paintings, though beautiful as art, do not conform to his theory. The difficulty is that at a comfortable viewing distance of ten or fifteen feet, Seurat's color dots don't really dissolve and melt into one another. They remain stubbornly visible because they simply aren't small enough.

Oddly enough, this difficulty has finally been overcome by twentieth-century commercial printing technology. Nowadays any image can be reduced to almost invisible dots by a photomechanical process. When inked, these tiny "points" produce tones of varying darkness according to how closely they are clustered. In color reproduction, four hues are printed separately, one over the other, each with its individual dot pattern. The usual inks are yellow, magenta, and cyan blue—the inner triad of the light mixture chart—plus black. Thus modern printers employ a technique akin to a painter's "glazes," with transparent inks designed to show through one another on a glossy white ground. If you take a magnifying glass to the cover of *Vogue* or *ARTnews*, you will also see Seurat's principle of pointillism at work—separate yellow, blue, and magenta dots that blend, once the glass is removed, into a luminous shimmer.

## VALUE AND INTENSITY SCALES

When describing a color, our first thought is of its hue. We identify someone as wearing a "red" dress or "blue" suit. Then, if further information is needed, we add phrases like "dark dull red" or "vivid light blue" to suggest how the basic hue has been modified by other elements. These modifiers, though variously named by different theorists, are most commonly known as *value* and *intensity*.

*Value* refers to a color's lightness or darkness. Pale colors with everyday names like pink or aqua are identified, technically, as reds and blues of high value, while dark colors like maroon and navy are defined as reds and blues of low value. In value/intensity chart #1, the vertical columns show four different hues (red, green, yellow, violet) in value scales shading from light to dark. They have been made by lightening each basic hue with white to form "tints" and adding black to create darker "shades."

*Intensity*, on the other hand, measures a color's brightness or "saturation." To put it another way, intensity refers to a color's purity and freedom from dilution by other colors. Thus the crosswise bands in this chart show how colors become dulled by complementary mixtures. Here, red moves toward brownish gray when mixed with green, and yellow is similarly neutralized by violet. The contrast of **H** and **N** shapes also helps to explain the difference between value and intensity. As you see, each hue has a particular value when it is at full intensity. Thus the green-to-red crossband is horizontal because both hues are in the same mid-value range, whereas the yellow-to-violet band is diagonal because these colors are value opposites, yellow being an intrinsically light hue and violet a fairly dark one.

There is probably no more difficult color principle to grasp than this distinction between value and intensity, because words like *dark* and *light* (describing value) and *dull* and *bright* (describing intensity) sound so much alike. Nor is the difference always evident in looking at the actual colors. In value/intensity chart #2, however, I have come up with a diagram of an imaginary cube that should make things a bit clearer. Here, the left, sunny side shows dark, medium, and light values of a bright (or high-intensity) color, while the shadow side shows dark, medium, and light values of a dull (or low-intensity) version of the same basic hue.

This diagram shows you how value and intensity function as independent variables. It also demonstrates that, of the two, value is the more measurable quality, and hence of greater importance for the artist. Whereas the eye makes an immediate assessment of these dark, medium, and light stripes, the precise hue and intensity of the colors is harder to assess. Accordingly, painters generally pay fairly systematic attention to dark and light patterns, while other aspects of color are approached more intuitively.

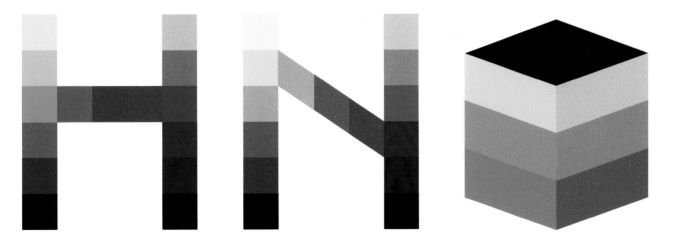

VALUE/INTENSITY CHART #1          VALUE/INTENSITY CHART #2

**Working with Value Scales.** Housepaint and textile manufacturers employ a minutely calibrated system of color measurement based on hue/value/intensity formulas that you have doubtless seen in decorator shops. For industrial use, just imagine my chart #1 extended to ten vertical values and ten horizontal intensities. Then, with all the cross rows filled in like a checkerboard, each hue would require a hundred mixtures—or a grand total of a thousand for the ten-color Munsell system!

Art teachers also like to emphasize fine-tuned gradations, and painting an evenly modulated value scale is a classic freshman assignment. Such exercises help you develop control, but having to mix paints with an eyedropper can also be hateful. And unless carefully taught, a precisionist approach to color can give the wrong message to a creative person. My own best advice for the painter is to look for ways in which theoretical concepts can generate visual excitement and be absorbed into the basic rhythms of picture-making. Needless to say, this calls for simplification rather than elaboration. It means reducing complicated possibilities to a workable few.

Carmen Cicero's watercolor *The Derelict Boat* is a wonderful example of the power of reductive thinking. The subject is presented in elemental terms—sun, sea, sinister underwater creature, drifting boat. The color chord is equally stark: only yellow and blue-violet—complementary colors signifying sunlight and shadow—mixed with blacks and grays. With this bare-bones palette, and the image of a hypnotic sun glittering on the floor of a leaky boat, Cicero creates a brooding atmosphere reminiscent of Eugene O'Neill's early one-act plays.

The main thing to note, though, is his masterful handling of values. The sky is shaped with long, horizontal, raggedy strips and the sea with loosely sketched, rippling marks. In each area we see that Cicero develops his forms with just four values: light, medium-light, medium-dark, and dark.

**Advantages of a Four-Value System.** Values are the building blocks of a color composition. They determine whether your painting carries across the room or fades into the woodwork; whether it makes a snappy black-and-white publicity photo or one that lacks contrast. As an artist who is an equally acclaimed jazz musician, Carmen Cicero understands that a painter's values must be shaped like the notes of a musician's scale—as evenly spaced intervals that can give the viewer a sense of sequence, rhythmic repetition, and structure.

In painting, however, the number of "notes" on a value scale a viewer can keep in mind, or that an artist can comfortably work with, is limited. A composition can sometimes be reduced to just two main light and dark

CARMEN CICERO, *The Derelict Boat*, 1988. Watercolor, 17½ × 22½" (44.5 × 57.2 cm), courtesy June Kelly Gallery, New York.

values representing areas of sunlight and shadow. A traditional landscape format with foreground, middle ground, and distance calls for a three-value scheme (perhaps with subordinate dark and light scales in each of the three main zones). And watercolorists who paint with spontaneous brushmarks—Homer, Cézanne, Welliver, and Fairfield Porter come to mind, as well as Cicero—generally rely on a *four-value* technique. The reason: Three tones are insufficient, five too complicated, but working with four main values has the naturalness of a runner's jogging rhythm.

Cicero's rendering of the sea in *The Derelict Boat* is a prime example of the rhythmic interaction of values. I count about two hundred wave marks in the lower half of this watercolor; one can visualize the artist's hand moving across the page, starting with light touches, strengthening the emerging image with medium-light tones, adding more decisive medium-dark marks, and finally, punching in a few strategic darks. Painting a vast space like this with hundreds of disconnected marks is an assignment that, in the hands of an inexperienced person, might very well end in confusion. Cicero solves the problem admirably by combining spontaneous marks with

systematic placement, scale, and value control. Not only are his darks and lights strategically arranged, but also the waves are progressively narrowed as they recede toward the horizon.

As we see in the lower left corner, the watercolorist's strokes eventually begin to overlap, and here again the four-value technique proves advantageous. You see, one of the medium's finest qualities is its potential for overpainting—building multilayered, see-through effects with transparent washes painted over one another. To avoid mushiness, however, such layering must be done in clearly defined steps, and usually with no more than four tones.

## GRADATION AND COLOR MOVEMENT

Throughout her career, Edna Andrade has been fascinated by a quite different approach to values: their use in sequential passages or gradations. In contrast to Cicero's spontaneous handling of darks and lights, Andrade works with immaculately rendered color planes arranged in geometric progressions. In her acrylic canvas of Arizona's Painted Desert, for example, the sky is divided into four light-to-dark bands of color, the mountains into three somewhat deeper planes, and airplane and highway routes are shown by variously toned horizontal lines.

For the viewer, such gradations can provide an intensely focused color experience. Color is, in a sense, separated out from other pictorial elements by the arbitrary scheme. Instead of a plain blue sky shading gradually toward the horizon, we are made aware here of isolated, and hence more potent, color notes. At the same time, however, we perceive these colors as

EDNA ANDRADE, *Painted Desert— Blue*, 1983. Acrylic on canvas, 37 × 60″ (94.0 × 152.4 cm), collection of Prudential Life Insurance Co., Philadephia; courtesy Marian Locks Gallery, Philadelphia.

a sequence or "chord," moving from mid-value lavender-blue at the top to pale aquamarine below. Indeed, the effect is not unlike that of a broken chord in music—an arpeggio of notes struck separately but sustained so they will echo together in a mingled resonance.

Andrade's way of reducing images to color planes was inspired by an early interest in cubism and the theories of such Bauhaus artist-teachers as Paul Klee and Josef Albers, who worked with chordlike compositions of flat colors. These ideas continue to have relevance for serious abstract painters. And the introduction of masking tape and fast-drying acrylics after World War II simplified "hard-edge" painting technique to the point where the geometric abstract has become one of today's popular art forms. This is an idiom of limited interest when pursued as a mere technique for making neatly striped canvases. But it offers high excitement for anyone interested in exploring truly dynamic color relationships.

So the big question for the end of this chapter is, What *is* "good"—or "interesting" or "exciting" or "dynamic"—color? And how can understanding color theory help the artist to achieve it?

The answer is quite simple. Color interest derives from movement between and among its three polarities: hue, value, and intensity. To have any kind of drama or excitement, you usually have to involve all three. Furthermore, the sequence has to have the logic of the charts we have been studying. Hence, a move from yellow to red needs an orange halfway step; a light-to-dark move requires a medium-value transition; and a shift from vividness to dullness calls for a neutral mixture in between.

Andrade's *Painted Desert—Blue* is a wonderful illustration of such color dynamics. Where a novice's sky might have bored us with tones made from a single tube of blue mixed with white, Andrade shifts from a greenish blue to a lavender-blue as well as from light to dark. Colors in the mountain range are especially rich. Here the sequence of light/medium/dark hills is joined by a parallel progression of hues: yellow to red-orange to a subtle brown, which ties the picture together by echoing other colors. "Brown" is always an inadequate term for the low-intensity mixtures that can make or break a painting, but if you look into these distant hills, I think you will see both a greenishness influenced by the sky and a golden tonality that relates to the desert's reds and oranges.

Finally, one admires the way Andrade refines her color chord. In front of the most distant mountains, pencil-thin strips of cerulean, violet, and teal blue echo the hues of the sky, but with greater intensity. Similar strips create red/violet vibrations on the middle, orangish mountain range. And at the bottom of the picture, a framing band of triangles adds two important accents: a green that connects with the warm colors of the mountains, and a pale blue that brings a bit of the sky into the foreground.

# 4 ALBERS AND HIS LEGACY

*Knowledge does not destroy spontaneous work; rather, it creates a solid base for it.*

—*Josef Albers*

The name Josef Albers is as closely linked with the study of color as Freud's is with psychology. Albers (1888–1976) was one of those rare individuals with a sense of mission and the ability to persuade others by teaching, writing, and creative example.

His compatriot, the painter-teacher Hans Hofmann, also found fame in America after emigrating from Germany in the thirties. But whereas Hofmann emphasized painterly dynamics, Albers focused on color as a self-sufficient, independent element. His Homage to the Square series, featuring designs in three or four flat colors, has been a continuing inspiration for color purists and artists of minimalist persuasion. By the 1960s, the Albers "Square" was so well known that it became the subject of TV shows, *Time* and *Life* articles, and *New Yorker* cartoons. One was even reproduced on a U.S. postage stamp with the motto Learning Never Ends.[1]

As a teacher, Albers had a world forum provided by three of our century's most influential art schools. In the twenties, he taught at the Bauhaus in Weimar, Germany. This was the famous institute devoted to the unification of art, architecture, and crafts and to a rethinking of esthetic principles in the light of twentieth-century technology. In 1933, when Hitler denounced the Bauhaus as a "germ cell of Bolshevism," Albers and his wife, Anni, the distinguished weaver, came to America, where they reestablished the Bauhaus curriculum at Black Mountain College in North Carolina. This quickly became a prestigious avant-garde center that attracted people like Willem de Kooning, Robert Motherwell, John Cage, and Buckminster Fuller as lecturers, and numbered many future leaders of American art among its alumni.

Finally, in 1950, Albers took on his third teaching assignment as chairman of Yale University's department of design. By then the modernist battle had been won, and the intellectual action had moved to college

CARLOS CRUZ-DIEZ, detail, *Additive Color* (page 65)

campuses. During the next decade Albers was one of the most persuasive voices in the education of our present generation of artists. Few of his now-famous students would deny his influence, but many found his authoritarian manner difficult. Richard Anuskiewicz describes him as dogmatic and unwilling "to compromise his ideas in any way";[2] Robert Rauschenberg remembers him as a "beautiful teacher and an impossible person" whose criticism was "so devastating that I never asked for it." Nevertheless, Rauschenberg also admits that "years later I am still learning what he taught me . . . I consider Albers the most important teacher I ever had."[3]

At Yale, Albers focused more narrowly than before on the issue of color. In his view, color had been subservient throughout history to the representation either of images or abstract designs. He argued that color should be understood instead as the basic structure of a painting, and as an "autonomic" or self-governing esthetic element. To this end, students were guided through a remarkable series of experiments that he summed up in *Interaction of Color*, a treatise published with a boxed set of more than two hundred color exercises.

 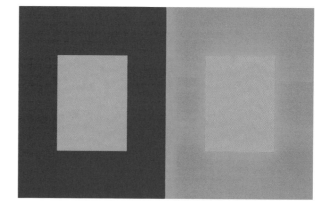

COLOR RELATIVITY STUDY

The overall theme of these exercises is our changing perception of colors when they are seen in different combinations. In the color relativity study shown here, for example, identical swatches of the same neutral beige are shown against four distinctive backgrounds. Yet visually, the beige squares on the left don't seem to match the brown squares on the right at all! This is because a color's value is relative to its surroundings. It will appear dark against a light yellow or orange, and comparatively light against dark colors like blue and purple. Hold a manila envelope up to the window, then down against a dark rug, and you will see that this principle works in real life as well as in art. Thus, it is an important consideration for the figurative painter as well as for the abstractionist.

A color's hue is also modified by its environment, though so subtly that the change is less easily detected. Be assured, however, that spectrum hues, like yin and yang or male and female, attract their opposites (or

complements) in any relationship. Accordingly, by staring at the four center squares, you should be able to make out a faint yellowish glow to the tan that is shown against purple, and a corresponding purplish cast to the brown shown on yellow. Orange and blue have a similar complementary interaction, and to my eyes, the clearest example of this principle is the distinct orange tonality of the tan square on the blue panel.

Albers was a teacher who also practiced what he taught. Although he was an artist of considerable range—in painting, printmaking, photography, sculpture, and glass design—he is most famous for a project of unique single-mindedness, the Homage to the Square series. Begun in 1950, when Albers was sixty-two, these paintings were developed in tandem with his Yale teaching experiments. They addressed the same concerns of infinitely refined color relationships, and they were, in a sense, his proof of propositions put forward in lectures and theoretical articles. After his retirement from Yale, the Homages occupied Albers for the rest of his life. In all, there are more than two thousand paintings and prints on this theme.

Like Schönberg's twelve-tone scale, Mondrian's abstractions, and the Greeks' golden mean rule of perfect proportion, Albers's Homages were motivated by the belief that transcendental esthetic experience is rooted in mathematical order. Accordingly, his paintings—which he called "platters to serve color"—are in the form of a perfect outer square, with two or three smaller interior squares arranged in a symmetrical, descending order. Because their corners create invisible diagonal lines that converge to a vanishing point in the lower third of the composition, there is an inherent illusion of depth perspective. The image suggests a great hall with portals receding into distance, and one of the complexities of Albers's compositions is the tension between this depthward thrust and the contradictory forward push of his colors. As in the four Homages shown on pages 60 and 61, the most "distant" central square is usually assigned the composition's most aggressive color.

Even the intervals between squares are determined by mathematical ratio. In the early Homage dated 1950, for example, you can see that the orange and blue-toned bands below the yellow center are doubled in width as they move up the sides and then tripled when they reach the top. Throughout the series this 1–2–3 proportion, with the broadest spaces at the top of the picture, is unvarying. For Albers it symbolizes color's role as both earthbound and spiritually ascendant. Equating the upper reaches of a composition with the heavens is, of course, an idea reminiscent of Renaissance entombments and risen souls. It is fascinating to find this traditional, humanistic impulse in such nonobjective work.

Some of the Homages are untitled, but Albers often gives verbal clues to his thinking. The title *Saturated*, for instance, refers to purity of hue,

JOSEF ALBERS, *Homage to the Square*, 1950. Oil on Masonite, 20⅝ × 20½" (52.4 × 52.1 cm), Collection Yale University Art Gallery, New Haven, Gift of Anni Albers and The Josef Albers Foundation.

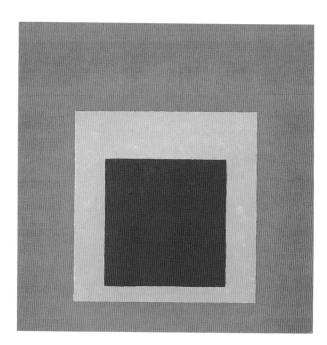

JOSEF ALBERS, *Homage to the Square: Festive*, 1951. Oil on Masonite, 24 × 24" (61.0 × 61.0 cm), Collection Yale University Art Gallery, New Haven, Gift of Anni Albers and The Josef Albers Foundation.

JOSEF ALBERS, *Homage to the Square: Saturated*, 1951. Oil on Masonite, 23¼ × 23⅜" (59.1 × 59.4 cm), Collection Yale University Art Gallery, New Haven, The Katherine Ordway Collection.

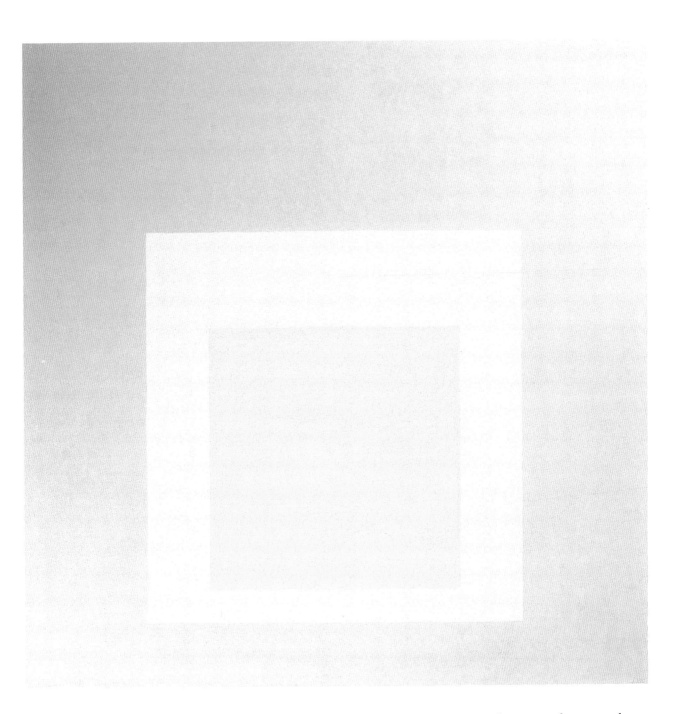

which in technical language is called *saturation*. Thus we infer a merely formal intent to give one color, red, its maximum potency. With the title *Festive*, on the other hand, Albers reminds us of the power of colors to evoke distinctive moods. We speak of "feeling blue" or being "in the pink," and here a blue-and-orange scheme has the cheerfulness of college colors at a football game.

For my money, Albers's finest efforts explore still another color possibility: the illusion of light. As its title suggests, *Light-Soft* is one of numerous Homages devoted to luminosity and radiance. Some are very dark, some very dim, and others, like *Light-Soft*, so pale they draw you into a hypnotic twilight world. What is most remarkable, though, is the

economy of means—three flat colors: yellow, gray, and a mixture halfway between—with which Albers creates the effect of a nimbus, or halation, around a squared-off sun.

## THE ALBERS COLOR EQUATION: A LESSON FOR PAINTERS

Earlier, we considered the strategies of Philip Pearlstein and Janet Fish, realists who use color for both formal and representational purposes. By now, however, I suspect you will already have recognized Albers as the ultimate color strategist, because, like a research scientist, he isolates color as the only variable in his compositional experiments.

To understand what Albers is up to, we must be aware of the difference between a "meaningful" color relationship—to use a popular idiom—and one that lacks "commitment." Casual painters may achieve charming effects, but serious artists aim for color relationships that are more dynamic, complex, and, as Albers says, "interactive." In short, this is a view of color as an equation in which the painter pits various forces against one another in order to create interesting movement, on the one hand, and equilibrium on the other.

Just what are these forces, and how does one balance them? Quite simply, color movement—or "push and pull," as Hans Hofmann called it— is created in two ways: either by opposites tugging against each other, or by neighbors in a chain-reaction impulse.

The polarities, as we saw in the last chapter, are light versus dark *values*, bright versus dull *intensities*, and opposing (or complementary) *hues*, plus one additional factor—the backward or forward *spatial thrusts* of various colors. Sun-bright yellow, for instance, has an aggressiveness that makes it a perfect choice for traffic signs, whereas blues and violets—colors we associate with the sky—tend to be recessive.

These elements establish a painting's basic dynamics, but movement is also created by transitional sequences that lead the eye from one color to another. In *Light-Soft*, for instance, the yellow square and gray background are bright/dull opposites. But a third, intermediate, color provides a stair-step interval for the eye, so that as we gaze into the picture space, we feel a pulsation, like the sun's rays, outward and then back again to the vibrant center.

Admittedly, this is a very subtle movement, and Albers's neat designs are hardly the most dramatic examples of color interaction one could cite. But by the same token, their schematic, clear-cut structure provides the best possible lesson for anyone interested in color. So let's take a moment to analyze the color equations in three typical Homages:

1. Albers's plan for the (unsubtitled) 1950 version is notable for opposing a warm center with a cool frame, and then subdividing these zones in the interest of complexity. An orange band spreads the light of a yellow square outward, while at the same time creating a deep, darker space behind it. Spatial relationships, however, are ambivalent, since the picture can be read in two ways: either as light-blue and yellow foreground shapes against a darker ground, or as yellow foreground, orange and turquoise middle ground, and "sky"-blue distance. Meanwhile, hue relationships involve slightly skewed complements. We connect the blue band with its obvious complement, orange. But instead of using a straight blue, Albers adds a bit of violet that relates indirectly to another complement—the yellow of the central square.

2. *Homage to the Square: Festive*, composed with just two complementary colors, is the boldest of these pictures. The basic hues of orange and blue are skillfully varied in value and intensity, however, with a muted orange as the mid-value, vivid ultramarine as the dark color, and a pale ultramarine tint as the light tone. As before, spatial relationships are ambiguous. Is this an arrangement of flat squares laid one over another with the smallest on top? Or is the central one a dark panel suspended in an open window with the sky behind? Better still, is the center square perhaps an opening rather than an object—a window into blue infinity?

Actually, the picture is meant to be read in all these ways, since—as in much modernist painting—Albers's color gives intentionally contradictory spatial signals. Such opposing thrusts, so the theory goes, preserve the picture plane by canceling each other out rather than poking an illusionistic hole in the canvas the way traditional perspective does. The process is commonly referred to as "opening and closing" the picture.

3. Finally, *Homage to the Square: Saturated* is the most painterly of these compositions, and hence, for me at least, the most satisfying. The color is not only vibrant but also the paint is applied with richly textured strokes and, in the center square, with a violet glaze over a pink underlayer. Above all, this is an object lesson in how to compose a "one-color" picture. A Picasso "blue" or an Ad Reinhardt "black" canvas is almost never truly monochrome, as imitators working with a single tube of paint plus white sometimes think. Instead, all of the color variables are normally present, even when compressed into a narrow range as here. Note that Albers gives us evenly graded light, medium, and dark values; hues ranging from an outer ruby red to an inner red-violet; and a sequence of bright-to-dull intensities that evoke light and atmosphere.

# OPTICAL ART AND KINETICISM

Albers's small-scale, impersonal art was diametrically opposed to the action painting that dominated the art scene during his Yale years. Thus his ideas really took root during the next decade, the sixties, when newly emerging painters turned to "cool" strategies as an antidote to the heated abstract expressionism they had grown up with. Tongue-in-cheek pop art was the big news. But op art and minimalism, formalist styles in line with Albers's thinking, also emerged at this time, the former for a brief fling, the latter as a movement with ongoing vitality.

Although op art was short-lived as a movement, its rationale for an art of color-energized optical illusions has continued to attract a small but significant list of dedicated followers. The works of Agam, the popular Israeli artist, and Victor Vasarely, the Hungarian-born French painter, are widely circulated in the United States. And the Venezuelan Carlos Cruz-Diez is one of South America's most influential artists.

I got a particular kick out of a recent visit to Cruz-Diez's Caracas studio, because his exhibit was one of the few I have ever encountered in which the much-touted theory of "colors mixing in the eye" actually worked. This takes place when color spots are small enough and the viewing distance great enough that the eye can no longer separate them. During the TV broadcast of a golf tournament, for instance, you can observe this phenomenon yourself as the camera pans away from a crowd of spectators. Their shirts—for some reason, always predominantly red, blue, and white—are gradually reduced in size until, at a certain point, the red and blue dots suddenly dissolve into a violet tone.

Monet and Seurat were fascinated by this concept, but as we saw in the previous chapter, their touches of color weren't quite small enough or sufficiently intense to produce true optical mixtures. Albers took up the challenge in his *Interaction of Color* exercises, however, and today's artists have access to technology that can produce smaller and more sharply defined calibrations than were possible before. In contrast to the heavy, slow-drying oil paint of an earlier day, quick-drying acrylics, masking devices, airbrush, and photomechanical processes are typical resources for the contemporary optical artist.

Although pictures always lose something in reproduction, optical art is an extreme case, since its effect depends on a predetermined scale and distance from the eye. Nevertheless, our illustration of the Cruz-Diez serigraph *Additive Color* will give you an idea of the artist's general approach. As you see, his color unit is a linear "interval" rather than the familiar impressionist dot. And instead of using touching colors, he separates them with black bars that give a stained-glass brilliance. Furthermore, the vertical color intervals are made to pulsate by varying the hues from top to bottom: warm chords of orange, pink, and magenta

flowing into cool violet and green between black strips that are tapered like
the teeth of a comb. In his three-dimensional bas-relief paintings, Cruz-
Diez heightens the effect still further by replacing painted separation strips
with projecting metal fins, which create changeable shadows and reflections
as you walk by.

Believe me, a roomful of such optical effects is eye-boggling, for the
colors flicker and change like the whirling crystals of a kaleidoscope.
Actually, Cruz-Diez calls himself a kinetic artist, and his ideas hark back to
Vasarely's 1955 manifesto of kineticism, a proposal for color effects that
would change with the viewer's movements in space. To this end, Cruz-Diez
has covered the Caracas airport and nearby industrial silos with colorful
stripes. Among his visions for the future, one is especially intriguing: the
proposal for a cruise ship patterned with striated bands of color and
alternate panels of sky-and-water-reflecting mirrors.

In this country Richard Anuskiewicz is perhaps the best-known
champion of optical color. A student of Albers at Yale, he achieved instant
recognition by the Museum of Modern Art and *Time* magazine in 1963 as a
founder of the op-art movement. But whereas others in the group moved
on, Anuskiewicz has devoted his career to optical phenomena.

*Deep Magenta Square* illustrates both Anuskiewicz's debt to Albers and his innovative outlook. The symbolism of the perfect square is again evident, and so is an Albers-like "scientific" color chord: radiating strips of the complements violet and yellow that create an optical vibration behind a square of magenta, violet's neighbor on the color wheel. However, Anuskiewicz has a quite different approach to technique and space. Where Albers's paintings are "handmade," with obvious brushmarks on rough Masonite, the younger artist's surfaces have an industrial precision. And where Albers sought to preserve the picture's flatness, Anuskiewicz uses color to create the illusion of a radiantly lighted three-dimensional space. His *Deep Magenta Square* has an almost Dali-like sense of spiritual levitation as it floats, like a heavenly body, against a phosphorescent sky.

Like Albers's Homages, this is also one of a series of Squares based on a single underlying design or grid. Over the years, Anuskiewicz has used this serial approach with more and more complicated formats. The columnar grid of *Rose Sunset*, for instance, utilizes the linear intervals we saw in Cruz-Diez's work to create three-dimensional, tubular volumes as well as color pulsation. Here, twin sets of complements interact, as airbrushed clouds of yellow and violet float in a framework of blue lines and orange

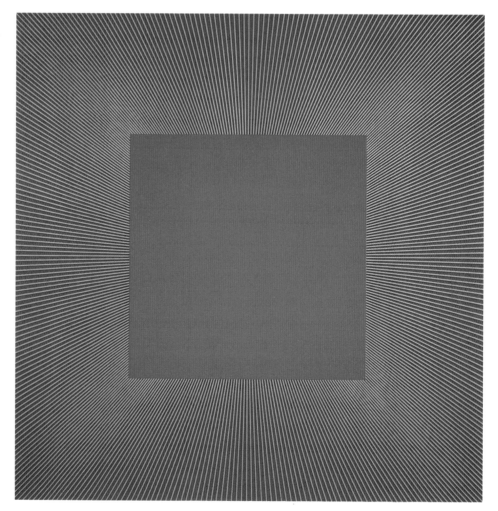

RICHARD ANUSKIEWICZ, *Deep Magenta Square*, 1978. Acrylic on plywood panel, 48 × 48″ (121.9 × 121.9 cm), courtesy Graham Modern, New York.

bars. More important, though, is the sculptural roundness Anuskiewicz achieves by varying the spaces between vertical lines—wide intervals in the center and narrower ones at the sides of each shaft, like the flutes of a column in a perspective drawing.

For sheer color excitement, another series, the Temple paintings, is most impressive. And who says titles aren't important? Listen to the key words in Anuskiewicz's descriptive titles—"Royal" *Temple of Blue*, *Temple of* "Fire" *Red*, *Temple of the* "Evening" *Yellow*, *Temple of* "Neon" *Reds*—and you will see where this artist is coming from. Color intensity is obviously crucial, but he also sees color associatively, as expressing particular moods or experiences.

In terms of design, Anuskiewicz's Temple grid features the linear intervals of his Column series in a more elaborate spatial fantasy. This time lines are of variable thickness as well as placement; they are both horizontal and vertical; and they direct the eye in a more complex spatial movement—first outward from the picture frame, and then sharply inward toward slitlike windows. In some versions, Anuskiewicz emphasizes depth perspective by painting these slits a recessive blue or purple. In others, however, he counters it with an aggressive color, like the bright vermilion in *Temple of Neon Reds*, which pushes the slits forward, turning them into solid columns rather than open windows.

In any case, these Temple paintings are among the most brilliant examples of color vibration you will ever see. Vibration is set off by a confusion in the eye that blurs the edges of forms. And since the effect is like that produced by looking suddenly at the sun or a spotlight, vibrating

colors seem to be illuminated, as in a slide projection, rather than opaque. In *Temple of Neon Reds* there is an almost palpable radiance as three vermilion strips, in the shape of neon tubes, light up a fluorescent space.

As a practical matter, if you want to try this yourself, look for three main situations in which colors vibrate. Anuskiewicz's painting has them all:

1. Adjacent complements of equal value tend to vibrate. You can see this in the framing hues of green and magenta-red.

2. Warm and cool variations of a dominant hue will also vibrate if the colors are sufficiently vivid. Color temperatures are relative, however, and here the magenta (or violet-red), which seems warm against the cool green border, turns cold when seen with the three hot vermilion (or orange-red) interior strips.

3. High-contrast darks and lights vibrate when broken into finely stippled dots or striated lines. The grid's graduated black lines take clever advantage of this by setting up areas of intense dark/light vibration that fade off into paler zones of pure color.

## MINIMALISM AND POSTMODERN ATTITUDES

At some point in the 1960s, the era of modern art ended and post-modernism took over.

Yet there was no sudden shock, no explosive impact like that of the Armory Show, which introduced cubism and futurism to this country back in 1913. And since "modern" is interchangeable with "contemporary" in everyday speech, most people still think of any work that is new and lively as "modern." To fully understand what is happening, however, we should see current art trends in the perspective of a historic shift in attitudes.

Modernism, for all its variety, drew strength from a remarkably unified underlying philosophy. The esthetic experience was held to be unique, and since art was sufficient unto itself, abstract form took precedence over representational or "literary" content. "Truth to materials" was the credo of painters, sculptors, architects, and modern dancers alike. Accordingly, the picture plane was not to be destroyed by false perspectives, sculptures could not be painted, and each of the creative mediums was defined as similarly inviolate. Above all, past styles were to be avoided, as artists reached out for the new.

Today's art world hasn't lost enthusiasm for innovation. But after nearly a century of discoveries—from Monet's broken color to de Kooning's action painting—it's no wonder that modernism finally lost its novelty. For some time now, artists have been reversing modernist principles. Beginning with pop art, subject matter of all kinds—illustrations, photos, words, cartoons, political comment—has been reintroduced. Mixed-media effects ranging from installations to performance art are now the order of the day. And ironically, resurrecting past styles has become an avant-garde strategy.

It is in this context that the minimalist movement should be understood. For as the contemporary scene has become more and more eclectic, grandiose, and commercial, minimalism has emerged as a vital—and some would say the only significant—link with the esthetic goals of early modernism.

The movement was established during the sixties by artists like Donald Judd and Ellsworth Kelly as an intellectual challenge to the media hype of pop art. Today the situation is much the same. Extravagant figures like Anselm Kiefer, Francesco Clemente, and Julian Schnabel (the artist who paints on velvet and broken crockery) have captured headlines. But minimalists like Joel Shapiro, Sol Le Witt, and Andrew Spence are seen by

many critics as truer keepers of the flame. And in such recent trend-setting exhibitions as the Carnegie International and Whitney Biennial, they have taken center stage.

Sol Le Witt's serigraph *Two Cubes* is a fascinating example of the complexities one can find in so-called minimalist art. The movement is based on the familiar idea that "less is more." Yet when confronted by a blank white canvas or a pile of bricks, people often ask, "What on earth do you see in this sort of thing?" Sometimes there is no easy answer. But having acquired *Two Cubes* recently, I must say that living with this print—which I might merely have glanced at in a gallery—has been an enriching experience.

Look at *Two Cubes* carefully, and you will see that the artist has done interesting things with both design and color. A latter-day version of an Albers "Square," Le Witt's print doubles the image, makes it three-dimensional, and then projects it against a backdrop outlined by a bold black frame. In so doing, Le Witt introduces a depth perspective that earlier artists had taken pains to avoid. At the same time, however, he affirms his abstract intent with contradictory visual signals. Although his cubes are dimensional, any sense of actuality is undercut by two factors: first, a drawing based on parallel lines rather than a realistic perspective with vanishing points; and second, the choice of a spatially ambiguous background plane on which his strongly lighted cubes mysteriously cast no shadows.

Le Witt's approach to color reveals a similar concern for the ambiguities inherent in a simple format. His starting point is Mondrian's famous "primary chord" of red, yellow, and blue plus black, white, and gray. But in *Two Cubes* the boldness of this scheme is countered by an elaborate illusionism. Instead of poster-bright hues on a white ground, Le Witt gives us a foggy space, with one cube rendered in shadowy tones and the other's native hues dimmed by grayish mist. Thus his "theoretical" scheme of red, yellow, and blue is transposed visually into another set of colors entirely: rust, chartreuse, and blue-black. And we see that his gambit has been to transform obvious colors into something more interesting, much as Jasper Johns did with his well-known variations on the American flag.

A member of the original sixties minimalist group, Le Witt has been a long-time spokesman for conceptual art. He believes the idea behind a work is all-important, and, in opposition to the early modernist faith in the creator's "touch," he writes directives for projects like *Two Cubes* that are then executed by others. The craftsmanship of his technicians is superb, and although Le Witt works with simple modular forms as here, he is perhaps best known for repetitive (or serial) arrangements of these units in large-scale architectural installations.

Andrew Spence is a younger artist with a quite different background. For those who began to paint seriously during the seventies, the ideas we have been discussing were already history—concepts learned in art school, and fully absorbed. Furthermore, painters of Spence's generation faced an art world of exploding ambitiousness. More and more galleries. More and more money. Bigger paintings. Jazzier styles. And a shorter life expectancy for new ideas.

Spence has resisted this trendiness, choosing instead to pursue an idiom of pared-down imagery. His work is quietly personal rather than the product of any dogmatic rationale. Executed with firm but subtly varied brushwork on canvas-covered wooden panels, his paintings are modest in scale, and they are usually composed of only two or three flat colors.

In an age of hype and bombast, Spence has won increasing respect for his devotion to esthetic first principles rather than showy effects. His quirkily simplified interpretations of industrial objects, such as *TV Stereo*, *Bulletin Board*, *Car Racks*, and *Swivel Chairs*, are also in tune with the work of other emerging thirty- or forty-something artists. And although we are talking about individuals rather than a movement, Spence's work illustrates the reductive thinking that is in the air as well as the way it differs from earlier minimalist attitudes.

Perhaps the most significant distinction is the prominence of subject matter in recent abstraction. Whereas Mondrian's legacy was the reduction of figurative images to nonreferential geometry, and Le Witt's generation

followed his lead, many of today's younger artists find nonobjective art either boring or too limiting. Thus instead of calling their paintings "Untitled," or using formal titles like *Two Cubes* or *Homage to the Square*, the newer mode is to give even the most abstract work an associative title.

Spence's simplified shapes, for example, have only marginal traces of realism; his canvas *TV Stereo* might well be taken for a nonobjective design, were it not for the title. Yet once we are aware of the subject, our perception is forever changed. The spatial ambivalence of an abstraction that can be looked at in different ways—what Hans Hofmann called "opening and closing the picture"—is replaced by representational logic. Here, for instance, the white area, which might be behind or in front of the black rectangle, jumps forward the minute we see it as the frame around a TV screen. The orange rectangle becomes a positive volume,

ANDREW SPENCE, *TV Stereo*, 1988. Oil on linen mounted on wood, 75 × 60″ (190.5 × 152.4 cm), courtesy Barbara Toll Gallery, New York.

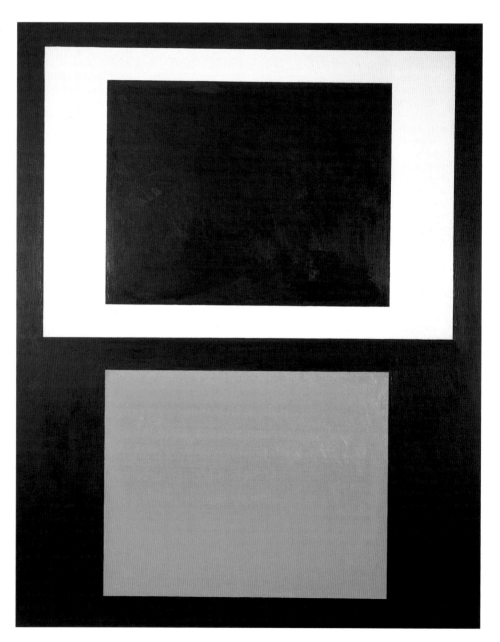

rather than a window, when we know it is a stereo player. And for me, at least, the black areas are shaped by the mental image of a central TV shelf with shadows underneath.

Not all recent minimalism is figurative, of course, but there is a general search for excitement beyond that of pure color and form. Painted words—naughty or nice, banal or polemical—are one source of inspiration. Unusual materials are another. The German artist Günther Förg contrasts panels of orange or yellow with sheets of darkly patinated lead. And the American Peter Halley has won instant fame with canvases of a single solid color, varied only by contrasting strips of smooth Day-Glow and roughened Roll-a-Tex paint.

Thus today's excitements are very different from those of the Bauhaus years, when Albers's ideas about pure color and minimal design were shared by colleagues around the world. Modernist principles were seen not as the rationale for a passing style but as the key to an enlightened future in which international-style architecture would prevail, people would sit on functional chairs, and painters would share a universal language of nonobjective shapes.

As things turned out, however, twentieth-century art has been characterized by explosive variety rather than unity. Minimalist ideas have attracted some artists, but if they have stood out, it has been as rare birds in a gaudy crowd. The furor over I. M. Pei's Plexiglas pyramid in the courtyard of Paris's Louvre Museum illustrates the point. Its diamond-hard minimalism is effective less as a self-contained vision than for the way it contrasts with the other architectural styles around it.

You will find similar contrasts in any contemporary painting exhibition—artists hell-bent on expressing themselves, others painting what they see, and usually a few individuals of minimalist persuasion whose work stands out because of its simplicity. I suspect that most of my readers will be involved with still life, figures, landscape, or experimental modes rather than with scientific color or minimalism. Be assured, however, that whatever your enthusiasms as a painter, teacher, or aficionado, your understanding of art must be rooted in first principles. Nowhere are the basic relationships of color and form more clearly illuminated than in the work of the artist-theorists we have been discussing.

1. Nicholas Fox Weber, "The Artist as Alchemist," in *Josef Albers—A Retrospective* (New York: Solomon R. Guggenheim Museum, 1988, exhibition catalogue), 14.

2. Gene Baro, "Richard Anuskiewicz," in *Richard Anuskiewicz* (New York: Andrew Crispo Gallery, 1975, exhibition catalogue).

3. Mary Emma Harris, "Josef Albers: Art Education at Black Mountain College," in *Josef Albers—A Retrospective*, 55.

# 5 STRUCTURAL COLOR: BUILDING AN IMAGE WITH COLOR BLOCKS

*I want to make the whole picture some kind of machine,
or gestalt, an organism which has a life of its own. In
order to do that, you have to build a structured
composition, like a piece of music.*

—Jack Beal

I am sure you have heard people say things like "Blue is my favorite color" or "I can't stand pink." Painting, however, is an art of relationships rather than separate colors. And the best way to develop a color sense, if you are a practicing artist, is to work as a collagist does—piecing together solid blocks of color, moving them about, and reshaping them until a satisfying composition emerges.

## THINKING LIKE A COLLAGIST

This is the method of an abstractionist like Leo Manso, who works with paper, cloth, and found objects, but it also applies to representational art in all the familiar genres. Still-life and figure painters spend long hours arranging their subjects in the search for satisfying shapes and colors, and a landscapist like Fairfield Porter scans his environment with a kind of mental viewfinder programmed to detect exciting color patterns in nature.

From the standpoint of pure color and design, you will see that Porter's "realistic" *South Meadow, Afternoon* and Manso's nonobjective *Argosy*, despite differences of medium and mood, are composed in an almost identical idiom of flat color strips with "torn" edges. Although both pictures have an air of improvisation, they are based on systematic color

HARRIET SHORR, detail, *Scarf Musicale* (page 82)

chords. Manso employs a complementary scheme of orange and blue (plus neutral brown and black), while Porter uses an analogous harmony of blue, green, and yellow-green with just a touch—like a dash of bitters—of blue's complement, orange, on the lower right.

In working with color, it is essential to master such basic formats. It should be understood, however, that they are guiding principles rather than "recipes," and that basic colors will be enriched by other elements in the finished painting. You see, composing with color blocks is like making chord progressions on the piano. The musician relies on a few basic harmonies, which, though not unusual in themselves, take on personality with the addition of rhythm, melody, and instrumentation. So it is with

LEO MANSO, *Argosy*, 1987. Mixed media and collage, 48 × 36″ (121.9 × 91.4 cm), courtesy Long Point Gallery, Provincetown, Mass.

FAIRFIELD PORTER, *South Meadow, Afternoon*, 1970. Oil on canvas, 23½ × 27½″ (59.7 × 69.9 cm), collection of Adam and Rosalind Lewis, Northeast Harbor, Maine; courtesy Hirschl & Adler Modern, New York.

painting. A well-conceived color chord has a logical structure that is easily diagrammed. Yet it isn't the diagram we respond to, but the wedding of color, line, texture, and imagery in the final work of art.

In Leo Manso's *Argosy*, for instance, color is inseparable from the artist's choice of materials. We perceive orange as stained fabric, black as Fabriano paper, brown and gray as leather and zinc. In short, the "medium" is Manso's "message," and the interaction of colors is bound up with our perception of the work as a collage. Thus we don't assume Albers's self-contained color principles here. Theoretically, orange is aggressive and black recessive, but in *Argosy* their roles are reversed. Black comes forward because it is pasted *on top* of the orange cloth, and the contradiction between this "material" reality and purely optical color principles makes for an interesting visual counterpoint.

Fairfield Porter (1907–1975), on the other hand, is an artist who saw color in terms of subject matter. An admirer of Vuillard and the impressionists, he painted coolly observed scenes from a pleasant, leisurely life. In *South Meadow, Afternoon*—a view from the Maine island where his family spent their summers—Porter uses a typical, quietly attractive color chord. Yet we respond to it less as an abstract scheme than as an evocation of light and atmosphere. Nor do we theorize about the spatial implications of his colors; quite plainly, blue represents sky and distant islands; yellow-green, the foreground grass and trees.

# REDUCING THE IMAGE TO FLAT SHAPES

In looking through this book, you will find that most pictures, like Manso's and Porter's, are composed with clearly defined blocks of color. This underlying structure is often enriched by rendering techniques, of course, and some books on color start with directions for painting sunsets, stormy skies, and "creative" effects with drips and spatters. But for my money, this is like putting frosting on one of those cardboard cake forms used for display rather than starting with the cake itself.

Serious students of color should begin with structural principles. Like a house, sun deck, coffee table, or anything else you might want to construct, a color composition is made of units that must fit together. There are no rules about their size or number, which can range from Ellsworth Kelly's two-color panels to Seurat's hundreds of dots. These are extremes, however. Most pictures are composed, like Manso's and Porter's, with about eight or ten major color blocks. Usually just two or three large areas are needed to define the space, while smaller shapes create movement and specific imagery.

Another reason for starting with structural color rather than the refinements of shading and brushwork (which we shall take up later) is that it is the more contemporary approach. Fairfield Porter, for example, is admired by avant-garde critics precisely because, unlike many realists, he is willing to leave the first bold, "abstract" color shapes alone—undetailed, unmodeled, un-gussied up.

Such simplification puts the kind of emphasis on paint *as paint* and color *as color* that, in a broad historical sense, differentiates the modern wing of any art museum from its old master collection. In Rembrandt's day brilliant colors were veiled in shadows built up by a laborious, indirect technique of varnish-and-oil glazes. A few artists, like the Wyeths, still work this way, but the vast majority of contemporary painters use a direct technique, mixing each color on the palette and then putting it on canvas for an immediate effect.

It would be fair to say, I think, that the mid-nineteenth-century shift to direct painting was as significant in shaping modern art as the discovery of perspective in creating Renaissance illusionism. In the work of painters like Monet and van Gogh, the brushstroke (or mark) took on new importance, and working "directly" also encouraged artists to use larger areas of unbroken color. Manet introduced the technique of painting with "flats"— or in what is sometimes called a broad style—after discovering Velázquez during an 1865 trip to Spain. Although his front-lighted nudes in *Luncheon on the Grass* and the notorious *Olympia* seemed naked to a public used to subtler shading, Whistler, Sargent, and Toulouse-Lautrec soon followed his lead as artists of both avant-garde and academic persuasion began to recognize the modernity of this bold approach.

For the representational painter, a broad style emphasizing simplified planes is the most economical way to achieve a figurative image. Douglas Ferrin's *Nude on Table* shows you how this shorthand notation works. Many color areas are left literally flat and undetailed, and although the figure's anatomy is carefully rendered, the portrait has the character of a cutout silhouette. Squared shoulders conform to a composition of boxlike shapes (in windowpanes, floor, and table) that is brought to life by offbeat, quirky motifs. The pose of the upper body, for instance, is wittily imitated in the curves of a Victorian picture frame and, again, in the erect stance of a tiny ceramic vase. Still another visual pun is the way butterfly handles on the window echo the wiggly gesture of the model's feet.

If flat shapes simplify images, they also intensify colors. In *Nude on Table* Ferrin uses a traditional palette—black, white, gray, and terra-cotta— keyed to the model's flesh tones on the one hand, and to the neutrality of a "real-life" environment on the other. Yet by painting these subdued colors in flat planes and strips, like bits of cut paper in a collage, he gives his conservative scheme an admirable crispness and snap.

DOUGLAS FERRIN, *Nude on Table*, 1987–88. Oil on linen, 45¼ × 42″ (114.9 × 106.7 cm), collection of Mr. Burt Reynolds, Jupiter, Fla.; courtesy Marian Locks Gallery, Philadelphia.

ELIZABETH OSBORNE, *Nava with
Green Cup*, 1981. Watercolor,
41 × 29½″ (104.1 × 74.9 cm),
courtesy Tatistcheff Gallery,
New York.

In abstract art solid colors have even greater potency. Think of Matisse's cutouts, Rothko's radiant stain paintings, and Hofmann's thick chunks of color. Or compare Ferrin's realistic *Nude* with Elizabeth Osborne's abstract treatment of a similar theme, *Nava with Green Cup*. These two pictures have much in common: a single-figure pose, an interior setting defined by rectangular planes, and even the contrast of solid and ornamented shapes (an Oriental rug in Ferrin's composition, a patterned dress and pillow in Osborne's). Yet Ferrin's color, like Fairfield Porter's, is tied to representational logic. Osborne, on the other hand, sees color as an abstract element that, though suggested by the subject, has a life and logic of its own.

For this reason, Osborne is one of the best models I can think of for anyone interested in a painterly approach to color. Albers saw color as an independent element, too, but where his approach was cerebral, Osborne's has a more spontaneous rhythm. She explores what color can do in various mediums—oils, watercolors, pastels. She interprets a range of subjects— still lifes, landscapes, interiors, figures. And as you can see in both *Nava* and one of the beautiful Color Test Sheets she makes as a way of outlining her ideas, Osborne's feeling for color is at once structural and highly poetic; that is to say, she builds pictures with sturdy color blocks, yet they are rendered with hints of light and shade, touches of iridescence, and sensitively varied edges. Thus the final effect, far from being schematic, is subtle and atmospheric.

# LOCAL COLOR VERSUS SHADOWS IN A STILL LIFE

One of the best places to study color, whether as observer or artist, is in still-life painting. Long considered a minor art, still life has a contemporary importance based in large measure on the fact that it is more compatible with high-key, abstract color than other representational idioms. Although the everyday colors of a landscape may be transformed by sunset or storm and the model's flesh tones may appear green in certain lights (as Degas shows us in scenes of the gaslit Parisian ballet), colors in a still life are arrived at more directly. You simply collect objects and drapes in interesting colors and arrange them to your satisfaction.

Thus, despite the realism of the subject matter, arranging a still life is as arbitrary as putting together a collage or abstract design. There is also no limit to the colors you may use, and this is particularly helpful in handling large background areas, which are often limited to neutrals in other representational genres. Where figures are normally posed in an interior with white or beige walls, flowers and fruit call for a tabletop setting that can be pink, purple, chartreuse, or whatever your fancy dictates.

Some artists like to "find" their still-life subjects in the same way that Porter "discovered" his landscapes—an unfinished breakfast, perhaps, with egg cup, napkin, and morning paper, or a display of fish in a grocer's window. Most contemporary painters, however, see the genre not as a mirror of life but as an essentially formal idiom—a studio arrangement of forms, shapes, and colors.

HARRIET SHORR, *Scarf Musicale*, 1986. Oil on canvas, 54 × 104″ (137.2 × 264.2 cm), courtesy Tatistcheff Gallery, New York.

The work of Harriet Shorr is a case in point. As you see in *Scarf Musicale* and *Sewing and Roses*, she paints with richly brushed oils on

HARRIET SHORR, *Sewing and Roses*, 1984. Oil on canvas, 70 × 135″ (177.8 × 342.9 cm), courtesy Tatistcheff Gallery, New York.

canvases eight to ten feet wide, and her images of brilliantly dyed fabrics—shown in a flat, two-dimensional view from above—pack a terrific wallop as abstract shapes. Instead of objects against a neutral wall or floor, Shorr gives us ragged, diagonal fields of undiluted spectrum color. And her subjects—music, sewing, and flower arrangement—represent esthetic activities that are a metaphor for her own involvement as an artist. *Scarf Musicale* has an especially clever design in which the tubular shapes of a clarinet and xylophone play a visual obbligato to the multicolored stripes of a billowing scarf.

The main thing to note, though, is this important principle: In a still life the colors of the setup are the colors you get in the final painting. Obviously there is a great advantage in testing ideas in the setup rather than on canvas, and in being able to make changes easily at an early stage. Furthermore, painting from a still life is one of the best ways I know of learning about color. In a setup seen at close range, forms are clearer than forms observed at a distance, lighting is more controlled, and the accuracy of the colors you mix can often be checked simply by holding them up to the objects in question. Thus you start to paint with an extra measure of assurance, and after making a rough outline drawing, you are ready to lay in the blocks of color we have been discussing. However, the question of what to look for—what aspects of color in the setup to emphasize in the painting—still has to be resolved. At this point there are two ways to go: You can focus on what painters speak of as *local color*—the red of an apple, the blue of a vase, the specific greens in a bouquet—or you can deal with the way these native hues are transformed by lights and shadows.

WAYNE THIEBAUD, *Seven Suckers*,
1970. Oil on canvas, 19 × 23″
(48.3 × 58.4 cm), courtesy Allan
Stone Gallery, New York.

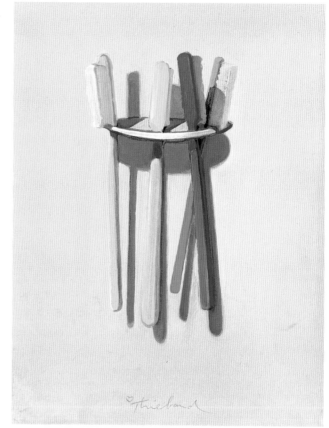

WAYNE THIEBAUD, *Toothbrush
Holder*, 1962. Oil on canvas,
19 × 23″ (48.3 × 58.4 cm),
courtesy Allan Stone Gallery,
New York.

The first approach, as we have seen, is the choice of Elizabeth Osborne and Harriet Shorr. Both artists rely on flat areas of local color set down with minimal shading; and where modeling is used, it is typically monochromatic. Accordingly, the bright red drape in Shorr's *Scarf Musicale* is shaded with dark red, and the folds of her blue cloth are painted with a deeper value of the same hue. By simplifying such large areas, the artist energizes abstract shapes while maintaining a convincing realism with a few small touches of detailed illusionism. In the lower left corner, for instance, one small vase casts a significant shadow in an otherwise flatly lighted canvas. Here, colors are atmospheric rather than local, as this black vase reflects the light of a yellow drape, and, in a reversal on the opposite side, a yellow vase is darkened by black reflections.

The second option I have suggested—dealing with light and shade—is a bit more problematic. Indeed, one can become so involved with reflections and atmospheric effects—the sort of illusionism that Shorr limits to a few carefully edited touches—that local colors all but disappear. On the other hand, shadow patterns can be rendered quite simply if you stick to flat blocks of color. Wayne Thiebaud's studies of small objects like neckties, sunglasses, lollipops, and gum-ball machines are the things to look at. In chapter 9 we shall see that he works with pastels in an entirely different, delicately atmospheric style. But each medium has its own character, and in oil painting Thiebaud is a past master of Manet's broad style, updating it with neon-bright color and slabs of thick, buttery paint.

Certainly Thiebaud's *Toothbrush Holder* and *Seven Suckers* exemplify the kind of simplicity a student of color should strive for at the outset. Later one might try for more subtle effects, but Thiebaud's strategy is basic. He uses just one light source, his shadows are flat rather than shaded, and they are solidly opaque rather than suggesting a transparency that permits colors underneath to show through.

To do something along these lines, all you need is a spotlight positioned to cast a clear pattern of light and shade. Shadowed areas are then painted in a color that will harmonize with, or complement, positive objects in the picture. Like many California School artists, Thiebaud strives above all for color dynamics, and his trademark shadows are an intense blue designed to bounce off the commercially bright hues of his still-life subjects. This is the blue of shadows on snow rather than the neutral tones one observes in most interior situations. In choosing a shadow color, however, you will find there are many options. Shadows are often bluish gray, but they also may be tinged with violet, beige, rust, or even green; ultimately, you will be guided by what you see.

Finally, don't forget that backgrounds are as important as foregrounds in creating color excitement. Since beginners tend to be more interested in

positive volumes than negative space, I generally advise students to establish walls and tabletops early on. There is no law about this, however, and Thiebaud likes to save the crucial background color until everything else is finished. Then, at the last moment—as you can see in *Seven Suckers*—he dashes in frostinglike swirls of pigment that are left undisturbed until they dry.

## SPATIAL COLOR IN A LANDSCAPE

Flat, unshaded colors heighten a painting's chromatic impact by pushing hues, observed at a distance in life, forward to the picture plane— thrusting them at the spectator, as it were. Since the days of Manet and Gauguin, this has been a modernist strategy for affirming a painting's two-dimensional reality as opposed to the traditional view of it as a "window on the world." This is not to suggest that contemporary artists ignore space, but rather, that they see it as a duality. The viewer is invited to enjoy the illusion of distances while responding at the same time to the interaction of flat shapes and colors on the surface.

This dichotomy is most comfortably resolved with a still-life subject in which, as in Thiebaud's *Toothbrush Holder*, objects are seen at close range against a wall or table parallel to the canvas surface. This arrangement of objects, as if in a shadow box, translates quite readily into flatly designed color areas without a significant loss of realism. As the paintings of Elizabeth Osborne and Douglas Ferrin demonstrate, this approach also works well with studies of figures and furniture in an interior space where the walls and floor form a similar shadow box.

Landscape subjects present a more difficult problem, since what comes naturally in a still life takes an effort of will when you confront the vastness of all outdoors. When Thiebaud paints the front and side planes of a toothbrush handle, he describes just about all that meets the eye. In the landscapes shown on the following pages, however, you can well imagine how much detail the artists have had to leave out, and how crucial the decisions about each color area have been. This makes for a tremendously creative experience, of course, because in a landscape you are free of the constraints that painting solid objects in logical perspective impose. Clouds, trees, and oceans invite fanciful interpretations, and their proportions are more flexible. Still, the first thing to look for, as you set your easel on a windy hill or balmy beach, is a pattern of simple color shapes that will fit together in a coherent image.

To show how this might be done, I have put together a group of landscapes representing various styles and attitudes for your consideration. Each of the artists is a masterful image maker, and the paintings of Fairfield

Porter and Arthur Cohen suggest ways of working outdoors from on-the-spot observation, while Elizabeth Osborne, Raimonds Staprans, and Paul Resika show how landscapes can be heightened and clarified in the studio.

Porter's *Jimmy with Leaf Cart* is especially instructive because his visual material is so typical of what the average person might encounter in an everyday sketching situation: blue sky, green trees, a house or two, and someone at work in the sun. In short, a pleasant scene, but utterly normal rather than in any way exciting or dramatic. Yet see how deftly Porter organizes this material. His analogous scheme of blue, blue-green, green, and yellow-green is similar to that of *South Meadow, Afternoon*, which we looked at earlier, but the dark/light pattern is much stronger. Here, the value range extends from pure white houses to almost black shadows and the various greens are carefully stepped, so that each of the eight or ten gradations in the light-to-dark value scale is sounded as a distinct, unblended note.

To translate nature's infinite variety into this controlled color system, Porter paints each object as a flat plane that erases detail. Trees become foliage masses rather than separate leaves, and instead of shading the lawn, or showing blades of grass as Wyeth might do, he divides it into four flat, curving shapes, each with a distinct hue and value. Even the figure of Jimmy is reduced to flat colors designed not to make him stand out, as in a conventional treatment, but to blend into the scene. To this end, Porter paints the boy's shirt a sun-bleached blue that gets lost in the grass, and his hair a dark patch that melts into the trees.

# STRUCTURAL VERSUS ORGANIC SHAPES

It is easy to visualize a landscape in these terms. Just narrow your eyes and squint until details become blurred, as in one of those soft-focus camera shots called a dissolve. Shaping this vision into solid color areas is more difficult, but you can get off to a good start by focusing on either *structural* or *organic* shapes. Most outdoor vistas are a mixture of structural elements such as buildings, boats, rocks, or tree trunks, and fluid shapes like clouds, foliage, waves, and sand dunes. But because these motifs are as diametrically opposed as major and minor chords in music, they tend to cancel each other out, unless you make sure one or the other is dominant.

I recently watched a TV miniseries with an endlessly repeated logo of rippling waters that drummed the idea of organic shapes into viewer consciousness: wobbly, irregular forms suggesting movement and flux. Such shapes can be drawn in various ways—as flamelike, rounded, sinuous, or lumpy motifs. And they can even evoke an amazing range of feelings— Gauguin's aura of primeval mystery, Munch's screaming expressionism, Beardsley's jaded elegance, and, in a less dramatic vein, Fairfield Porter's gentle lyricism.

*Jimmy with Leaf Cart* is designed with color areas that move lazily as if in a summer breeze. Organic shapes predominate here, but they are roughened up by squarish zigs and zags; and the curving rhythms of the foreground become increasingly angular as they mingle with the structural shapes of distant houses. Thus we see how free-floating organic shapes can be integrated with more rigid architectural motifs by means of skillful transitions.

Porter's great virtue is the ability to balance representational verisimilitude and abstract structure; Elizabeth Osborne's strength, on the other hand, lies in her feeling for more stylized color and formal design. In contrast to Porter's lifelike blues and greens, Osborne's colors stir the imagination. Her starting point for a landscape is a real-life subject, but she sees the on-site sketch as a mere germinal idea to be abstracted and intensified during the painting process. The result, in a canvas like *Passage*, is a color scheme as dramatic as Porter's is understated. The purplish rust in the foreground does describe a sandy shore—but in a visionary, unearthly light. The climactic slashes of yellow and purple remind us less of observed reality than of a poet's "golden sands" and "wine-dark sea." And Osborne's shapes are equally distinctive—smoothly flowing, rather than sturdy like Porter's—and designed with art nouveau elegance.

Turning now to our other landscapists, we see that Staprans, Cohen, and Resika take a different tack. These are structural painters who work with architectural subjects in treeless, cloudless settings. Except for the bow of a Resika boat, you won't find a rounded line anywhere; and even this motif is a geometric arc rather than a free-flowing curve.

ELIZABETH OSBORNE, *Passage*, 1979. Acrylic on canvas, 40 × 60″ (101.6 × 152.4 cm), courtesy Tatistcheff Gallery, New York.

The first of the group, Raimonds Staprans, is a San Francisco painter who does exciting things with rough-hewn, primal forms like chairs, tables, toolboxes, and workbenches. His landscapes also feature a semiabstract approach to subjects that can be reduced to geometric shapes—boats, piers, and sheds by the sea, or treeless vistas with fences, roads, and rooftops seen from above. In dealing with this material, Staprans's overriding concern is the projection of a powerful sense of California's wide-open spaces and blazing sunlight. To this end, he favors harsh planes of primary color, as in the ink-blue expanse of *Bodega Bay*, and he likes to stretch them to the outermost edges of the canvas.

Reducing a subject to flat shapes is half the battle in picture-making. It is important to remember, however, that "flat" planes can also be used to build dimensional "volumes," and Staprans shows us how to do this with colors keyed to a simple light-and-shadow pattern. In *Bodega Bay* the artist imagines his sun at the left and slightly above the canvas. In accordance with this light source, he then paints the tops and left sides of objects in warm tones; the shadowed front of his white boathouse, a cold blue; and his cast shadows, a solid black edged with bands of neon-bright yellow, which re-create the sun's dazzle.

RAIMONDS STAPRANS, *Bodega Bay*,
1986. Oil on canvas, 48 × 45″
(121.9 × 114.3 cm), courtesy
Maxwell Galleries, San Francisco.

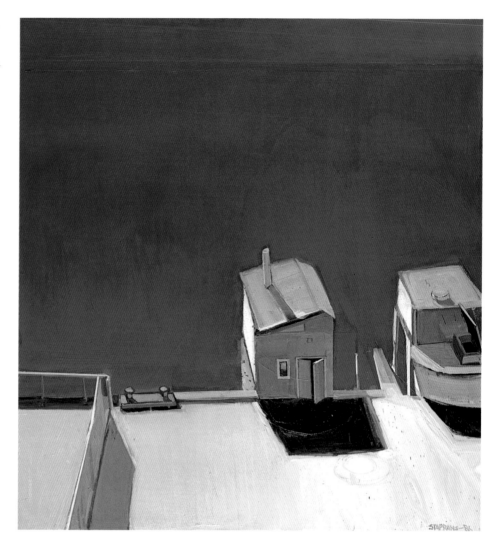

Throughout this discussion I have emphasized the "view from above" as the most direct way to visualize colors as abstract shapes with a landscape subject. The paintings of Porter, Osborne, and Staprans are all laid out on a terrain that echoes the picture plane. In this format, distance is created by a linear progression of color areas reading upward from foreground to horizon. Normally, the sequence is one of large, medium, and smaller shapes, which—as in Porter's and Osborne's landscapes—suggest a diminishing perspective. There are other possibilities, however, and Staprans creates an especially powerful image with just two color blocks— a narrow beige foreground strip and a huge expanse of blue.

Despite the advantages of this perspective, outdoor locations don't provide high-rise vistas all that often; thus, the head-on view of a person standing on the ground facing the scene is a much more common landscape perspective. Put yourself in this situation and you will find forms moving *into* the picture toward a low horizon rather than *upward* on the canvas's surface. The result is an overlapping of near and distant objects that needs to be clarified by color.

One of the best ways of doing this is to divide the picture space into clearly defined areas, each with a distinctive coloration. In a traditional nineteenth-century landscape, for instance, there are often three spatial zones—foreground, middle ground, and distance—with a passing cloud shading one of the first two, bright sun hitting the other, and a bluish haze enveloping the distance.

Contemporary painters, however, generally favor the simpler format of foreground versus distance, a scheme Arthur Cohen uses in *The Bridges*. One can imagine his composition as the set for an Arthur Miller play, with an up-front flat representing the looming understructure of the Manhattan Bridge and a backdrop of distant skyscrapers and the distant span of the Brooklyn Bridge. There are many color possibilities for such an industrial image—Monet painted Paris's railroad sheds violet against a pink sky; Whistler saw London's Battersea Bridge as a "Nocturne in Blue and Gold." The main thing, however, is to treat foreground and background differently. Cohen does this by throwing an enormous shadow over the foreground and bathing the distance in silvery light. Although his shadings are subtle, a close look will show you that tonal gradations in the city towers on the right are in a distinctly lighter key than those in the foreground bridge pylon. And although the sun is fading behind these buildings, their edges are lit with touches of gold.

Interestingly enough, both Cohen and Resika are New Yorkers who find inspiration in the water views and pearly light of Cape Cod, where they spend their summers. Cohen is particularly sensitive to the atmosphere of a late hour or gray day, and he is best known for interpreting expanses of sky

ARTHUR COHEN, *The Bridges*, 1972–79. Oil, 5 × 9″ (12.7 × 22.9 cm), collection of the artist.

and water, often with tiny details (like the threadlike cables of his Brooklyn Bridge) glimmering in the distance. Resika deals with similar themes but more abstractly. He is much admired as a painter who brings nuances of color and brushwork to images of iconlike simplicity—a dead fish floating in the bay, a pale moon rising, or the brooding shapes of waterfront shacks.

The subtlety of these artists' color is at a far remove from the brash chromaticism of Thiebaud, Straprans, and the California School. It suggests that one of the best ways to achieve depth in a painting is to establish an overall atmosphere that will modify the colors of distant objects. This pervading light can be bluish, as in Cohen's *The Bridges*; yellow, as in Resika's *The Pier (Claude)*; or even multicolored, as in his *Red, Yellow, Blue*. *The Pier* is a particularly striking example of the way local colors can be dissolved by lighting effects. As a yellow sunset strikes

PAUL RESIKA, *The Pier (Claude)*, 1984–86. Oil on canvas, 78 × 62" (198.1 × 157.5 cm), courtesy Graham Modern, New York.

PAUL RESIKA, *Red, Yellow, Blue,* 1988. Oil on canvas, 50 × 70″ (127.0 × 177.8 cm), courtesy Graham Modern, New York.

from the side, the fronts of warehouses and sheds are engulfed in such deep purple shadows that we lose all sense of their actual color. Only one small boat remains curiously aloof from the general illumination, maintaining its separate black-and-white identity.

There is much to learn from these painters' working methods. It is often advantageous, for instance, to work quickly on a small scale, as Cohen does, rather than having to spend hours "covering" a large canvas. Only nine inches wide, Cohen's *The Bridges* is a model of what can be achieved in the way of realism and monumental design on a surface no bigger than a note pad. This is a vital point for anyone who sketches outdoors, because the smaller your canvas, the easier it is to simplify color areas. In a small format you see the "big picture," and there just isn't room for distracting details. A small format also encourages you to capture a first impression quickly, before the light changes or the rains come. Later, the image can be developed or edited in the studio, as Cohen likes to do. (When asked about his twin dates for *The Bridges*, Cohen explained that it was painted on the spot in 1972, but that he reviews old canvases regularly and added some finishing touches to this one in 1979—seven years later!)

Resika is equally concerned with immediate, small-scale impressions, but such studies play a different role in his work. Each summer he does scores

PAUL RESIKA, *Moon on the Bay*,
1984–86. Oil on canvas, 76 × 60″
(193.0 × 152.4 cm), courtesy
Graham Modern, New York.

of oil-on-paper sketches that interpret the same vista of sea, boats, and harbor in different moods and lights. The small studies, while complete in themselves, are also the source material for monumental canvases developed thoughtfully over a period of months or even years. In the three views of Provincetown harbor shown here, for instance, we see an artist who is less concerned with realistic detail than with abstract shapes and the way they can be transformed by light. Accordingly, Resika gives us three arrangements of essentially the same motifs—the silhouette of a warehouse, the cube of a smaller shed, the curve of a ship's bow, the line of a mast—in various proportions and color schemes.

I close this chapter with these paintings because there is no better advice for a student of color than to follow Resika's lead in exploring *different* possibilities of a *familiar* image instead of always going on to something new. An artist's first sketch is often an obvious interpretation of the subject, while a second version may offer surprises. Then, too, we learn how color works by making comparisons; and different color treatments of the same image provide the clearest basis for comparison.

If Resika encourages us to look for variations on a theme, he also shows us how to reduce an image to the simplest kind of drawing. Like Albers in the famous Homages to the Square, he pours his colors into a few flat shapes that can be outlined with a ruler. And in contrast to Cohen's deep space, he solves the problem of illusionistic perspective in the most direct way possible—by eliminating it. That is to say, he avoids the foreground/middle ground/distance thrust into space by lining up solid objects along the horizon, and treating sky and water as flat shapes. There is one notable exception—the foreground mast in *Moon on the Bay*. However, this is treated as an abstract, Mondrian-like stripe rather than as a dimensional pole anchored in space.

Finally, let's see what we can learn from Resika's handling of color. In studying the three paintings shown on pages 91–94, we note that each canvas is divided into areas of illumination and shadow that provide a striking contrast of warm and cool hues. *Moon on the Bay* features warm brown-black shadows silhouetted against a cold blue light, while in the other two paintings, hot yellow-and-orange sunset tones are countered by cold purple shadows. We are also struck by the way these paintings run the gamut of chromatic extremes—from almost black to almost white, and from the nearly monochromatic scheme of *Moon on the Bay* to an explosion of color in *Red, Yellow, Blue*.

Above all, we discover in Paul Resika a colorist who is master of both structural color relationships and painterly nuances, of powerful design and almost invisibly subtle touches like a moon's reflection on blue water or the ghostly image of a sailboat mast floating in a sunset sky.

# 6 FIGURE/GROUND RELATIONSHIPS: MAKING SPACE WORK FOR YOU

*It is certain that all sorts of fine effects as yet
unexploited may be achieved on colored grounds.*

—*Max Doerner,* The Materials of the Artist

For the studio artist, color is like an electric current—a source of energy that must be brought to earth and "grounded." In contrast to the stage designer, who creates disembodied illusions with lights and slide projections, a painter must give material presence to colors by attaching them to canvas, paper, or some other physical "ground."

Technically, artists' grounds are the surfaces they paint on, and sometimes an unusual material such as velvet or metal adds a distinctive character to their work. Ninety-nine percent of the world's paintings, however, are still done on standard canvas or paper, and in an esthetic sense, we tend to think of painting grounds in terms of color. Rembrandt worked on a brown ground, Uccello on a greenish one, and I would guess that half the pictures you see today are done on colored surfaces. Watercolorists almost always prefer white rag stock, but pastelists use tinted papers, and while some oil painters like blank canvas, others can't get started until they have covered its glaring whiteness with a more evocative ground color.

## COLORED GROUNDS

In any case, the function of this foundation tone is to establish an immediate sense of space and atmosphere that will bring the separate elements of the composition into harmony. Typically, the ground color is a

JANE PIPER, detail, *Untitled*
(page 119)

FRANK GALUZKA, *Drift* (early stage showing ground color), courtesy the artist.

FRANK GALUSZKA, *Drift*, 1987. Oil on canvas, 68 × 72″ (172.7 × 182.9 cm), courtesy More Gallery, Philadelphia.

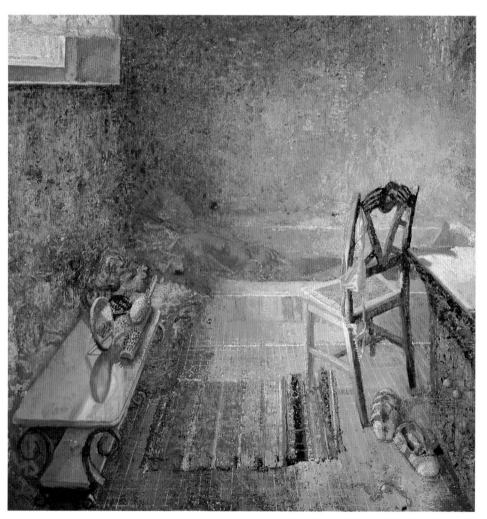

thin veil of pigment, suggestive rather than definite in hue and transparent enough to permit the luminosity of the canvas to shine through. Its color is usually determined by the subject, although artists have individual preferences.

The Philadelphia painter Frank Galuszka, for instance, says he likes manganese violet because "it makes the canvas look like space," whereas traditional ochre and red earth grounds "look like substance and seem impenetrable."[1] In his canvas *Drift*, shown here in both the final and an early state, we see how painting "into" a suggestive ground color can be a strategy for releasing the imagination. Though he has a strong feeling for structure, Galuszka is, above all, an intuitive painter who finds his images during the painting process rather than working them out in advance. Thus he likes to cover his first sketch with an impressionistic veil of color through which he can visualize figures and objects as if in a luminous fog. Then, as bits and pieces of the picture are brought to life, the fog gradually lifts upon a scene that may very well offer visual surprises.

A comparison of the early and final states of *Drift* reveals the dynamics of this process. At the outset, Galuszka establishes a very general idea— that this is to be a shadowy room lighted by a tiny attic window. He does so with a violet wash that covers the canvas except for a blank white rectangle in the upper left corner. Next, since the room is in cool shadow, a warm light is imagined, and a dialogue of complementary violet and gold touches evolves throughout the painting. Soon objects begin to appear—a chair, a dressing table, the ghost of a sunken bathtub in the back. And we note that the artist paints a foreground rug more boldly than the rest— perhaps because, with vivid stripes drawn to a vanishing point near the top of the space, it is a key to both the picture's perspective and its color scheme.

Galuszka not only finds inspiration in a stream-of-consciousness approach, he also makes it visible in the finished work. His subjects emerge from, or disappear into, a pervasive atmosphere; the viewer is simultaneously aware of the image on the canvas and the hardening or melting process that has brought it about. Look at the rag rug in the two versions of *Drift* and you will see what I mean. At first it is indicated with aggressive stripes. Later, as an amber spotlight picks out a table with mirror and toiletries on the left, the rug is pushed back into the twilight with an overpainting of flickering lights and shadows. Even without seeing the early version, I suspect you would sense immediately that *Drift* is about apparitions and metamorphoses rather than fixed objects.

Galuszka has a remarkable gift for transforming everyday events—getting supper, arranging flowers, sitting on the porch—into poetic images. Here, as the title suggests, a woman bathing in the sunken tub at stage center has "drifted" into a mood of Bonnard-like reverie; and her dream state is

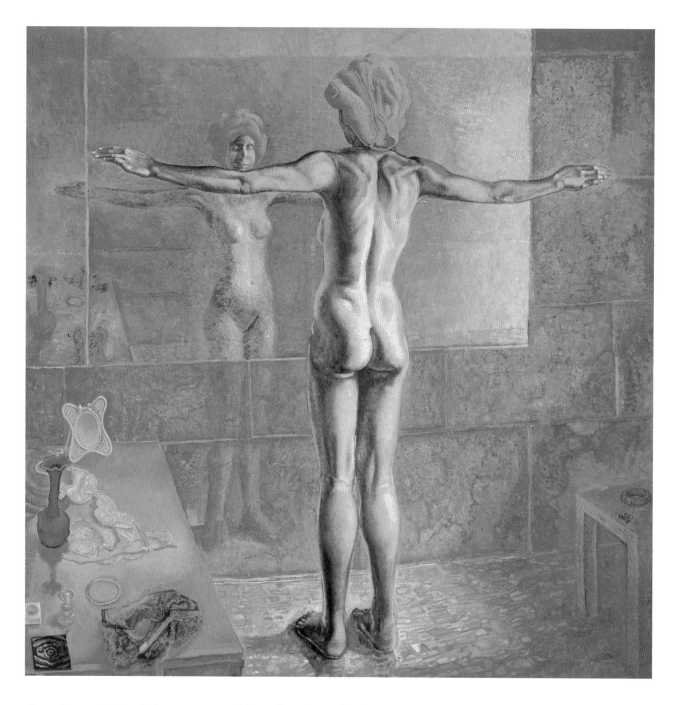

FRANK GALUSZKA, *Nude with Blue Turban*, 1981–82. Oil on canvas, 72 × 72″ (182.9 × 182.9 cm), courtesy More Gallery, Philadelphia.

conveyed by colors that also drift and shroud her body in mist. So much so, in fact, that when I first saw this picture on an exhibition poster, I admired it as a painting about space, not even recognizing the figure until later when I confronted the actual canvas.

*Nude with Blue Turban* represents an entirely different approach. Here, Galuszka employs an electric manganese blue ground color, not as a softening atmosphere, but as a dramatic contrast designed to set off the glistening, spotlighted anatomy of a nude woman preparing for a shower. The pose could be a modern dancer's, but it also has the Renaissance look of a Pollaiuolo athlete or a Botticelli Venus before her mirror. In any case, the lady's stance projects an aggressive rather than a "drifting" mood that

calls for a clear distinction between active figure and reflective background. Accordingly, Galuszka maintains an overall blueness throughout the picture that serves as a foil for the bather's golden physique and glittering reflection. The blue headdress is a particularly nice touch, since it ties the figure, which might otherwise have been too much of a silhouette, into the space.

## TONAL GROUNDS

Painting on a vividly colored ground can be exciting. But the traditional, and still most widely used, foundation for oil paintings is a tonal ground prepared with one of the more subdued earth colors. Instead of starting with brilliance, the idea here is to visualize an image dimly at first, as if in shadow, and then gradually pull bright colors into the light. The warmth and richness of ochres, siennas, and other earth pigments make them ideal for this purpose, and they come in a variety of reddish-brown, greenish-brown, tan, and terra-cotta tones.

I almost always begin an oil or acrylic painting with a ground tone—in part to establish an immediate sense of space, and also for the practical reason that, no matter how solid your brushstrokes, there are always nooks and crannies where the canvas shows through. If these spots are left white, the continuity of the paint "skin" is interrupted as if by facial blemishes, and touch-ups are awkward. A ground color, spread evenly over the canvas before you start, entirely avoids the problem.

Choosing the right color for this underlayer, of course, depends on your subject. For *Picnic on the Roof*, I used a fairly light mixture of yellow ochre and Venetian red to suggest a sun-bleached Moroccan locale. Although an interior/exterior format, mixing still life with landscape seen through a window, is fairly common, this picture is unusual in combining the two genres in a single, unified outdoor setting. Accordingly, the shapes of the distant city of Rabat, reconstructed from snapshots, and those of a still life observed in the studio, had to be brought together by a carefully planned design of interlocking planes and alternating warm and cool colors.

Developing a painting this way is a lot like developing a photograph from the first faint image that appears in the darkroom to the point where it is strong enough to be called "finished." I think you can visualize here— particularly in the distant architecture—how the facets of the composition have been built up with colors that relate to, yet modify, the underlying ground tone. Some planes have been darkened, some lightened; some have been given a warm orange or yellow cast, others a cool blue or violet tint. And in the process, the overpainting has been kept thin enough to let the ground tone show through and bind these separate colors into a harmonious chord.

To dramatize the space, I have emphasized the transition from thinly brushed background to solidly painted foreground by placing a wall between the two zones. This large, abstract rectangle is an area of unmodified background color. It is brought forward, however, and given physical presence by a roughly scrubbed texture against which the leaves of a tropical plant can cast convincing shadows.

In contrast to the tan underpainting in *Picnic on the Roof*, which conveys the sunbaked coloration of its Moroccan subject, the ground color I used for *Chinoiserie* has a quite different function. In this study of still life in an antique-shop window, a burnt sienna ground is keyed not to the colors of the objects themselves but to the dark shadows that surround them.

This is one of a group of paintings of window displays I did a few years ago. Growing tired of studio setups, I became interested in "found arrangements" and the idea of tackling subjects I hadn't dealt with before. My own still-life collection would never have included objets d'art like the Chinese vases, peacock feathers, and Oriental wallpaper shown here, yet

CHARLES LE CLAIR, *Picnic on the Roof*, 1987. Oil on canvas, 42 × 56″ (106.7 × 142.2 cm), collection of Mr. and Mrs. John V. Quinlan, Bingham, Mass.; courtesy Left Bank Gallery, Wellfleet, Mass.

the unusual shapes and textures of these curios were exciting to paint. Other studies were of flower shops, fruit stands, and gift stores, all with a profusion of incident. Indeed, one watercolor set some sort of record with a thousand small objects to be rendered—if you counted all the separate beads!

The special challenge, then, was to create order out of visual clutter. A dynamic perspective helps in *Chinoiserie*, but my main organizing device is a veil of brown shadow that tones down much of the middle ground and

background. Meanwhile, the space is energized by opposing light sources—cool daylight on the left and a dim interior bulb on the right. As in *Picnic on the Roof*, I have marked this contrast with a dividing point—this time the sharp edge of a Chinese vase with one side in bright light, the other in shade.

Look closely, and you will also observe an intriguing color exercise in which several passages had to be painted "normally" and then "transposed" to a darker or lighter key. The central vase, for instance, has a design of cerulean, cobalt, yellow, and amber on one face that is matched by shadow equivalents on the other side. And a vertical strip of window-glass reflections is painted from top to bottom with about twenty different mixtures that are cooler, paler versions of the colors of objects in the shop.

Although direct painters like Fish and Thiebaud usually work on white canvas, many well-known realists prefer a more spatially suggestive ground color. James Valerio, for example, paints on a thin, earth-colored acrylic-and-watercolor ground, and Jack Beal primes his canvases with a finishing coat of specially mixed gray-brown gesso that he swears by. Beal says painting on this dark, matte ground—the color of a French pastel paper he admires—is "totally different than starting on a white canvas." He outlines his subject in charcoal, and after blocking in a few key shapes in oil, he finds that it "looks like I have a half-finished painting when the work has barely begun."[2]

As a leader of the new realists, Beal became known during the seventies for portraits and still lifes of a florid, almost pop-art, brightness. His newer work, however, is characterized by the darkly dramatic, Caravaggiesque tonality we find in *The Sense of Sight*. There is some similarity here to my study of the antique shop—the same diagonal view of a crowded space with picture books and odd objects on a patterned floor, even the same cold light from the left. Instead of a neutral still life, however, Beal gives us an expressionistic vision of the human body as he sees it both symbolically and literally in the lens of his hi-tech magnifying glass. This last is a futuristic piece of equipment—an enlarging lens framed in a black ring mounted on the arm of a metal tripod. It is focused on the foot bones of a skeleton chart in the painting's upper left corner.

As the King of Siam would say, the painting is "a puzzlement!" But intentionally so, for it is a cubist collage of visual metaphors. Upon close examination, the black magnifying-glass frame also turns out to be the housing for a fluorescent light ring that has been turned inward to illuminate the space. Meanwhile, the center of the picture is filled with a mirror that reflects that light back into the viewer's eye—and by implication, into the eyes of the artist himself, who seems to be working where we are standing. Hence, Beal's face appears at the bottom of the mirror, surrounded by bones, muscles, a wooden manikin, a book of

JACK BEAL, *The Sense of Sight*,
1986–87. Oil on canvas,
66½ × 48½″ (168.9 × 123.2 cm),
courtesy Frumkin/Adams Gallery,
New York.

Rubensesque nude figures, and various objects symbolizing sight: a red flashlight, glasses, black binoculars, a beige magnifying glass, and camera equipment draped over a tripod.

The illusion of electric light in this canvas is a dazzling technical achievement that owes much to the artist's distinctive working methods. Whereas standard technique calls for a contrast between thick lights and thin, luminously transparent shadows, Beal reverses the principle. A heavy, opaque ground gives his dark tones unusual density, while light passages are painted rather thinly over areas of white acrylic, which are blocked in before he starts to work with oils.

Left: CAROLYN BRADY, *Dark Ground*, 1987. Watercolor, 44½ × 31″ (113.0 × 78.7 cm), courtesy Nancy Hoffman Gallery, New York.

Right: CAROLYN BRADY, *Red Ground*, 1987. Watercolor, 44½ × 31″ (113.0 × 78.7 cm), courtesy Nancy Hoffman Gallery, New York.

# FIGURE/GROUND RELATIONSHIPS

The use of an underlying ground color is one of the most effective ways of achieving spatial depth, because it provides an immediate backdrop for the artist's subject. As the painting progresses, thinly brushed colors that blend with the initial ground tone or permit it to show through will strike the eye as distant, whereas heavily painted contrasting colors will jump forward. Despite its advantages, however, this nuanced "indirect" technique is at

odds with the more immediate effects many contemporary artists are after. Hence, we turn now to the question of color dynamics in paintings done "directly" on plain white paper or canvas. Here, colors move forward, too, in what artists commonly speak of as figure/ground relationships.

The "figure/ground" concept harks back to Albers's experiments, and though the terminology is similar to "subject and background" or "foreground and distance," it has a more abstract frame of reference. Basically, the idea is that, in juxtaposing colors, one hue will always be perceived as being in front of the other—appearing as a positive "figure" against a negative (or recessive) "ground." Furthermore, in arrangements with many colors, closely related hues usually form aggressive or recessive clusters that work in much the same way.

This is the basis for Hans Hofmann's theory of "push and pull," which I shall have more to say about later. But for the moment, let's see how you would use the figure/ground principle in an everyday situation. Suppose, for example, you want to paint a still life of oranges on a blue compote. The colors of your subject (or "figure") are a given, since they are what caught your eye in the first place. However, the background wall (or "ground") could be almost any color, and your choice will depend upon the effect you are after. To cite a few possibilities: Cool violet or gray would make the oranges brighter; warm wine or rust would emphasize the blue compote; the blue and the orange would be equally potent on a (dramatic) black or (cheerful) white ground; and if you are into subtle shadings, a more neutral beige or bronze tone might be advisable.

Choosing just the right ground color is always a creative challenge. In watercolors of the same tulip-and-carnation bouquet, Carolyn Brady shows us two solutions to the figure/ground equation that yield diametrically opposed yet equally exciting results. Although Brady is a much-admired realist, these paintings reveal her as a person more interested in the abstract possibilities of a subject than in literal details. Having selected the pictures without checking labels, I was naturally pleased to find their titles—*Red Ground* and *Dark Ground*—so on target for this discussion.

The more dramatic of the two, *Dark Ground*, is as full-bodied a treatment of night shadows as you will find in watercolor. Although the medium has always been considered a small-scale, "thin" vehicle for sunny effects, there has been a recent movement, encouraged by the availability of huge new paper sizes, to give watercolors the scale and weight of paintings on canvas. For many leading watercolorists—Sondra Freckelton, Nancy Hagin, and Philip Pearlstein, for instance—this has meant an emphasis on workmanlike surfaces and an avoidance of flashy techniques. Brady, on the other hand, makes a virtue of the medium's traditional "wetness." Her work runs the gamut of values from purest white to darkest

dark, and these transitions are achieved with a virtuoso technique in which each passage is set down, once and for all, with a single sweep of the brush.

*Dark Ground* has the midnight illumination of a Caravaggio or Zurbarán, and we see here how a very dark ground will silhouette a positive image and push it forward. At the same time, extreme darks and lights must be bridged by transitional passages if the picture is to hold together. Accordingly, Brady enlivens the shadowy spaces of her watercolor with the echoing forms of a mirror reflection. *Red Ground* is a more direct interpretation of the subject—a picture about clear-cut local colors rather than color bleached by light or lost in shadow. Here, the bouquet is shown against a solid red tablecloth, the vase maintains its whiteness, leaves and stems read as a solid green shape, and the tulips are rendered as a flat mass, with only minimal modeling at the edges. Above all, this is a picture not about red tulips but about the *color* red, which Brady spreads in a bright

GEORGE FISCHER, *Deli 75¢*, 1988. Oil on board, 48 × 42¾″ (121.9 × 108.6 cm), courtesy Grand Central Art Galleries, New York.

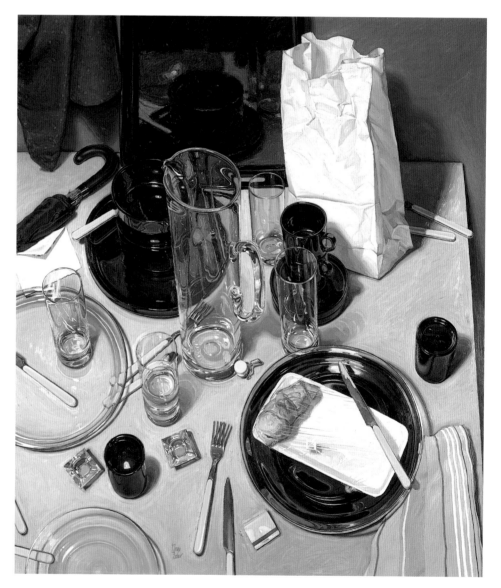

flood across the paper. She is particularly daring in "losing" the tulips, letting them melt into the background rather than featuring them as a more routine painter might do. She also plays a sophisticated game around the edges of the composition with small shapes—little sheets of paper, magazines, and wickerwork that move in and out like the elements in a collage.

George Fischer's canvas *Deli 75¢* is a more schematic composition. Though there is an impression of casualness, his plates, cups, and glasses are actually arranged in a calculated design of abstract circles countered by the rectangles of an envelope, paper bag, matchbook, and Styrofoam platter. The color is just as carefully worked out in an arbitrary plan designed to simplify the complicated subject. In contrast to Brady's full-scale palette, this young Chicago painter limits himself to neutral grays, plus black and white, and just one spectrum hue—yellow. But what is most interesting about Fischer's yellow-figure versus gray-ground scheme is that the bright color isn't attached to objects and the dull one to the background in the usual way. Instead, grayness invades every corner of the still life, and yellow is reserved for only a few key shapes.

In short, Fischer uses color in separate registers the way a composer assigns bright melodies for a pianist's right hand and dark chords for the left. And because just one spectrum hue is involved, we have an unusual opportunity to study the action of "positive" yellow shapes in relation to the "negative" ground color. In the center, for example, Fischer puts a tiny yellow bottle stopper at the foot of a tall glass pitcher. Yet such is the recessiveness of gray and black, and the aggressiveness of yellow, that the pitcher recedes into space, while the round bottle cap catches our eye like a blinking traffic light.

Finally, let's turn to Tony Vevers's *Emily's Book of Knowledge* as a reminder that realists and abstractionists are bound by the same color principles. Vevers is a very different kind of artist than Fischer—a creator of poetic images rather than an objective reporter. Here, six strips of paper from a child's exercise book provide one-word clues—*NOT, EMILY, I, YOU, GO,* and *WILL*—to a visual puzzle. There is also a larger black figure at the top that might be another *I* or the number *1*. From these artifacts, found on a Provincetown street and assembled on a ground of natural river sands, Vevers conjures up the mind of an imaginary child, Emily. And he arranges his clues around a center twist of red yarn that he explains as a "primary impulse," "nexus," "umbilicus," or perhaps "the center for Emily's rudimentary knowledge."

Despite obvious differences, however, Vevers's abstract collage has a lot in common with Fischer's naturalistic still life. They are both, in a sense, arrangements of found objects—discarded street scraps in the first instance,

Tony Vevers, *Emily's Book of Knowledge*, 1985. Collage and sand on canvas, 31 × 22" (78.7 × 55.9 cm), courtesy Long Point Gallery, Provincetown, Mass.

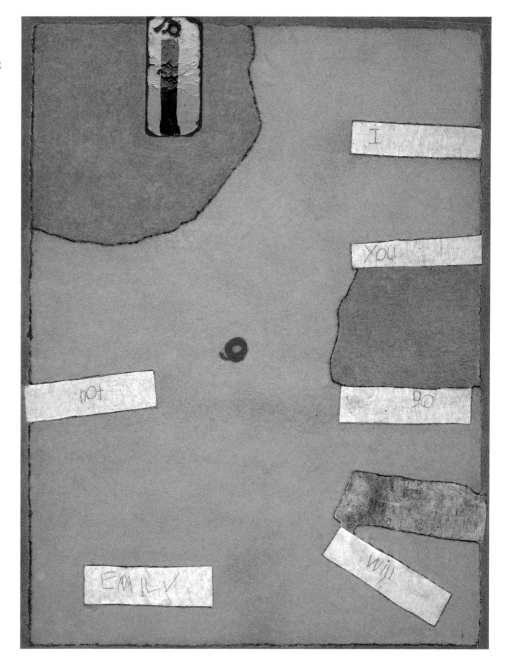

delicatessen takeout food in the second. Both have a dominant gray tonality. And in design, both feature a prominent central dot surrounded by narrow, striplike shapes.

There is a world of distance between the realist's bottle top and the abstractionist's metaphysical "nexus." Yet, in terms of color, the red and yellow dots function in the same way as positive figures on a gray ground. The major difference is that, whereas Fischer scatters yellow knives and forks around the table, Vevers saves his red for one bright touch. Indeed, this accent is so discreet that one might wonder why he bothers with color at all. If you think about it, though, you will see that something so rare is all the more important. Today's artists like to push ideas to an extreme position, and this red "nexus" is like a single diamond in a Tiffany window.

Even more important, it invites us to see the rest of the painting coloristically—as purplish-gray sand and ivory-gray paper strips rather than as a monochrome study.

## COLOR FIELDS

For anyone of my generation who began to exhibit in the forties, the greatest transformation in the art world—next to the incredible escalation of prices—has been the increased size of contemporary paintings. This was dramatized recently at New York's Whitney Museum in simultaneous exhibitions of Charles Demuth's lovely sketchbook-size watercolors and Julian Schnabel's paintings on gigantic nineteen-by-nineteen-foot tarpaulins.

The change in scale has implications for both artist and viewer. Old-time modernists like Braque and Klee liked to fill the canvas with a mosaic of small color spots that would destroy illusionistic depth. More recent painters, on the other hand, often present us with a spatial experience we can "walk into." As we approach work by the late Mark Rothko or such contemporaries as Diebenkorn and Frankenthaler, the edges of the picture disappear from our line of vision, and the canvas ground color becomes a kind of sky behind floating, cloudlike shapes.

The theory of "color-field" painting emerged during the period of abstract expressionism, and it became the rationale for a short-lived movement, led by Larry Poons and other stain painters, during the sixties. Basically, it postulates that modern art, having eliminated traditional railroad-track perspective into the distance, can create a new kind of space that spreads *outward* along the canvas surface rather than inward. Though the movement is long gone, the concept remains viable. Abstract painters continue to work with broad fields of color, and realists use the same strategy in what has now become a standard format, the "view from above."

The work of Harriet Shorr comes to mind most vividly in this connection. In addition to the paintings with multicolored drapes we saw in chapter 5, many of her still lifes show isolated objects floating against a uniform color field. Although these are ostensibly "floor pieces," the balloons, blossoms, and wobbly stripes seem weightless, and Shorr's backgrounds of rippling fabric give the illusion of a picture plane melting into the atmosphere.

The four canvases reproduced here give an idea of the variety and chromatic intensity of Shorr's ground colors. They also show how the usual figure/ground relationships are reversed in color-field thinking. Instead of serving as the backdrop for a positive image, the ground color itself becomes the dominant element and, in a sense, the artist's real subject. Not that the ground plane doesn't "go back," or represent negative space as before. But it becomes a compellingly colorful space in which positive

shapes, darting in and out like birds at sunset, play a supporting, rather than the dominant, role.

Shorr's airy paintings suggest two important guidelines for anyone interested in this approach. First, if the ground color is to sing out, solid forms must be used sparingly in a linear, rather than overlapping, pattern. Second, the colors of positive shapes must lead the eye away from, and then back into, the color field, instead of being merely silhouetted against it. The rhythms of *Summertime Swing* illustrate both principles. The vase of flowers twists like the body of a dancer with one knee bent and lavender arms upraised toward the band of rippling stripes on the right. These

HARRIET SHORR, *Summertime Swing*, 1981. Oil on canvas, 60 × 90″ (152.4 × 228.6 cm), courtesy Tatistcheff Gallery, New York.

HARRIET SHORR, *Red Fantasy*, 1982. Oil on canvas, 60 × 60″ (152.4 × 152.4 cm), courtesy Tatistcheff Gallery, New York.

HARRIET SHORR, *Christmas Memories*, 1986. Oil on canvas, 30 × 70″ (76.2 × 177.8 cm), courtesy Tatistcheff Gallery, New York.

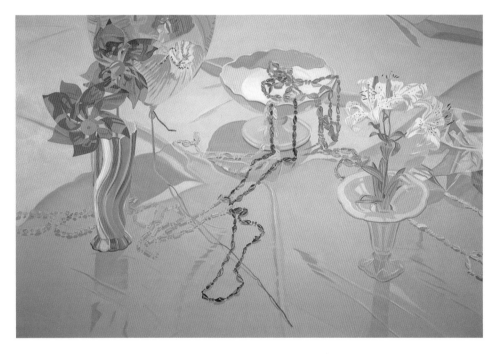

HARRIET SHORR, *Balloon at Noon*, 1986. Oil on canvas, 60 × 90″ (152.4 × 228.6 cm), courtesy Tatistcheff Gallery, New York.

linear movements along the surface of the canvas are then matched by the depthward ebb and flow of Shorr's colors—oranges and yellows projecting toward us, lavenders receding, and in the center of each "figure," a green stripe that pins it to the ground plane.

Similar color progressions are achieved in various ways in her other canvases. In *Red Fantasy*, contrasting values, rather than hues, create spatial movement as a *dark* fan motif presses inward and a *light* balloon drifts toward us. The transparency of the balloon's center, however, ties this floating object to the ground color, and the cellophanelike drapery in *Christmas Memories* is rendered with a similar "see-through" technique. *Balloon at Noon* features a more realistic treatment of highlights and shadows that moves yellow and green shapes in and out of an azure field.

WALTER DORRELL, *Still Life with Fruit and Shells*, 1988. Watercolor, 28 × 40″ (71.1 × 101.6 cm), collection of Louis and Barbara Conte, Washington, D.C.

The color-field principle is usually associated with radiant hues. But Harriet Shorr often uses very dark grounds, and as Walter Dorrell demonstrates in *Still Life with Fruit and Shells*, even a black ground can create a tremendous sense of depth. Dorrell is a Cape Cod watercolorist in the trompe-l'oeil tradition of William Harnett (1848–92) and John Peto (1854–1907), which combines detailed rendering with rather stylized setups of familiar objects. Here, bits of driftwood fastened to his studio easel serve as the framework for rows of fruit, flowers, shells, and an odd tennis ball. These crisscross wooden supports, together with objects set in boxes, form an overall image reminiscent of a Louise Nevelson bas-relief sculpture.

However, it is the use of a jet-black ground—veiling an everyday studio interior in spatially ambiguous darkness—that gives Dorrell's watercolor its special impact. This is a device of somewhat limited usefulness, but with an appropriate subject, the effect can be smashing. To avoid melodrama, though, the extremes of light figure versus dark ground need to be carefully modulated. Dorrell does this beautifully by staging his colors on several levels: a neutral driftwood grid linked to the background by cast shadows; rows of fruit in more aggressive primary hues; a sprinkling of white petals and shells that come all the way forward to the picture plane; and, finally, a midnight-blue vase that leads the eye back again into black shadows.

People often ask whether black is really a color. The answer, of course, is both yes and no. In light mixtures, black represents the "absence of color" we have all experienced in a power outage or stage "blackout." In pigment mixtures, on the other hand, black is the "sum of all colors"—a principle artists often prove by mixing their own blacks from other pigments. Thus black is very definitely a color for the painter. And it is one that has been a "signature" for such important figures past and present as Hals, Whistler, Mondrian, Motherwell, Franz Kline, and Ad Reinhardt.

## WHITE GROUND, WHITE SPACE

With the advent of open-air painting around 1850, artists discovered that working on white canvas instead of the traditional brown ground produced brighter, more "modern" colors. A little later, the impressionists popularized theories of prismatic colors and white light. And when scientists discovered that sunlight can kill germs, shuttered windows were thrown open, and interior decorators turned from Victorian richness to twentieth-century whites and pastels. In short, ours is an age of bright lights and bright spaces. Old masters may still be shown in darkened rooms with picture lamps attached to frames, but galleries the world over assure the contemporary artist of floodlights and white, or near-white, walls.

The overall lightness of modern decor functions mainly as a foil for the bold shapes and colors of the artworks or home furnishings displayed in it. At the same time, the concept of a "white space," so dear to architects, has also interested painters and sculptors. In the 1863 Salon des Refusés, Whistler set Paris on its ear with *Symphony in White No. 1: The White Girl*—a full-length portrait of his Irish mistress posed in a white gown, on a white bearskin rug, against a white curtain. In a 1919 Moscow exhibit, Malevich created similar shock waves with his painting *White Square on a White Background*. By now, of course, both the realistic still life of white eggs on a white cloth and the white-on-white abstraction, à la Agnes Martin, are commonly accepted formats.

Transparent watercolors are particularly appropriate for a "white" subject because of their delicacy, the pebbled beauty of the paper, and the positive use one can make of unpainted areas. These are qualities that attracted me to the medium, and though I currently work in a darker vein, I did a series of watercolors during the seventies in which the paper is visualized as white space. In each, a sheet of colored Plexiglas—like the violet rectangle in *Oranges against Violet*—becomes the mirror for objects shown in an all-white setting.

This is a spatial experience unique in our time, and as I sit in my white-walled studio writing at a white Formica table, on a pale-gray typewriter,

with a rectangular computer screen dominating an otherwise bleached-out space, the real-life image is almost identical with that in the watercolor. I am also struck by the fact that this modern scheme of dark rectangle versus light ground is simply the opposite of the familiar interior/exterior format that Randall Exon handles so beautifully in *Autumn*, a canvas from his Four Seasons suite. Here, his dark/light pattern is the opposite of mine, but our compositional devices are similar. In both paintings the forward thrust of a colorful rectangle is countered by the distant scene pictured within it.

CHARLES LE CLAIR, *Oranges against Violet*, 1978. Watercolor, 38 × 25″ (96.5 × 63.5 cm), courtesy More Gallery, Philadelphia.

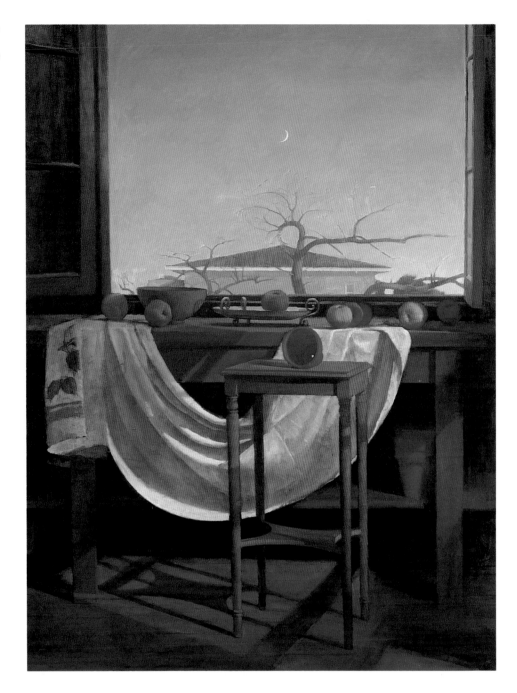

And in both, overlapping forms at the bottom of the rectangle link it with the surrounding environment: In my painting, a bottle carries the white ground color into a violet mirror; in Exon's, a tree branch extends the dark ground tone upward into a bright window.

Actually, there is very little untouched paper in my watercolors, since, as in *Oranges against Violet*, I like to develop white spaces illusionistically with planes of cool blue shadow and almost invisible yellow sunshine. On the other hand, *Still Life with Dragon*, by the Cleveland watercolorist Phyllis Sloane, shows how far you can go in the other direction. Instead of the soft glow of my tinted whites, Sloane creates a dazzling white light with small islands of color on a sea of blank paper.

The result is a technical tour de force achieved with a cleverly worked out design: first, the development of open spaces with white-on-white objects—a cardboard box, open book, and spread-out napkin—that dissolve in light and are visible only in the shadows; then, a sprinkling of sharp accents in black, brown, and the three primary colors; and finally, the introduction of more complex patterned areas—a rampant dragon on a cocktail napkin, a piece of boldly decorated Indian pottery, and, as an amusing touch, several red-and-white-striped peppermints.

Among oil painters known for their whites, Jane Piper comes immediately to mind because of her superb mastery of a light palette and her career-long devotion to it. The spaces in her paintings are almost always white, creamy, or dove gray; and in canvases like the *Untitled* still life reproduced here, she emphasizes a white ground tone in much the same way that Sloane does in watercolor. But Piper's is the more abstract approach, and the idiom of open white spaces, so natural on paper, is much more difficult to manage effectively in oils. The reason is that blank white canvas usually sticks out like a sore thumb. In an oil painting, therefore, whites have to be put in instead of left out, and opaque whites tend to be the coldest of pigments—chalky or just plain heavy unless they are handled very carefully.

Piper solves the problem with loose, joyous brushwork that interweaves thickly painted whites, in warm and cool tones, with bits of untouched

PHYLLIS SLOANE, *Still Life with Dragon*, 1984. Watercolor, 24 × 38⅝″ (61.0 × 98.11 cm), courtesy the artist.

JANE PIPER, *Untitled*, 1988. Oil on canvas, 36 × 46″ (91.4 × 116.8 cm), courtesy Mangel Gallery, Philadelphia.

canvas in an overall texture. She always starts from nature, but since space is her main interest, she says this pushes her toward more and more simplification as the picture progresses. A distinguished colorist, Piper paints lively oranges, pinks, and violets that are clearly in the French tradition, and posters in homage to artists like Gauguin and Matisse often turn up as subjects in her still lifes.

Above all, Piper is a painter whose life and art are as one. To see her work in her own home is to understand that the flowers, vases, and Matisse posters she paints are synonymous with the colorful and beautifully shaped objects she lives with. And to restate a point made earlier, the white spaces in the canvases that hang on her sunny white living room walls are, in a very real sense, a mirror of the bright environment she, and indeed most of us, enjoy today.

1. Frank Galuszka, interview with the author, October 1988.
2. John Arthur, *Realists at Work* (New York: Watson-Guptill Publications, 1983), 12.

# 7 BASIC COLOR HARMONIES: STRIKING THE RIGHT CHORD

*The principles of color interaction I use are quite simple.
They are those which can somehow make a color sing,
make a color (or two colors) look their jazziest best. . . .
Many painters, including those who teach, claim their
knowledge of color interaction is intuitive; however,
I had to learn it.*

—*Robert Keyser*

Color is almost always thought of more subjectively than other pictorial elements. Anatomy, perspective, and design may be carefully studied, but when it comes to color, most artists like to lose themselves in a freewheeling, intuitive experience. This is as it should be, since picture-making typically involves hundreds of quick responses to light, space, and subject matter that are best achieved with relaxed, spontaneous brushwork.

Such a painterly handling of color seldom "works," however, unless it is wedded to an underlying design of larger shapes. Earlier we saw how images can be reduced to basic color blocks. In this chapter, we shall consider another aspect of the organizing process—the need to orchestrate the colors of these basic shapes and mold them into a harmonious "chord."

## INTEGRATING COLOR AND IMAGE

Robert Keyser writes of "jazzy" color that "sings."[1] Other painters talk of "bounce" or "zing." But we are all after the same thing—colors that come together with a magical rightness. When in the grip of a color problem, I

ROBERT RAUSCHENBERG, detail,
*Artesian Gusher* (page 141)

often visit the studio before going to bed, first studying my picture in darkness, and then turning up the lights suddenly. If there is an instant emotional "lift," I know that, like Eliza in *My Fair Lady*, I've "got it." If not, of course, I simply start over again, and ultimately the impersonal laws of optical color theory will have a lot to do with success or failure. For just as the composer must convey passion, angst, or humor with the notes of a predetermined scale, so the painter is bound by a logical color vocabulary: the analogous and complementary relationships of the color wheel.

Developing a scheme that is both true to your subject and optically effective is by no means an academic exercise. It is a major hurdle for beginners, who must learn to leave out certain hues and heighten others for a unified color impact. And for an experienced painter, the problem of finding just the right color harmony never quite goes away. My struggle with *Banana Grove*—a canvas that had to be put through four color-change operations before things fell into place—is a case in point.

Here, the problem was to find the right ground color for a rather complicated positive image. As you see, the foreground is dense, with only small, shardlike openings in a jungle thicket. Yet the color of the sky is crucial and my initial choice of cadmium yellow proved dead wrong. Yellow's bright aggressiveness failed to provide either spatial depth or the

CHARLES LE CLAIR, *Banana Grove*, 1986. Oil on canvas, 50 × 72″ (127.0 × 182.9 cm), courtesy More Gallery, Philadelphia.

lush tropical mood I sought. In desperation, I tried two more experiments that were equally unsuccessful—a blue that proved much too shrill and a Venetian red that looked like shadows in the foliage rather than sky.

A Disney animator might have resolved matters quickly by putting my jungle on transparent film and testing various skies behind it. With oils, however, I was stuck with the tedium of painting each new color into countless disconnected small openings before an overall effect could be judged. Fortunately, my fourth choice—a deep red sky shading to ochre at the horizon—finally worked. Here, the value is at last deep enough to set off the dramatic lighting of the banana trees. More important, the red background establishes a clarifying red-versus-green polarity for the many colors in my jungle. There isn't a lot of red here, or much true green. Yet once the dominant notes in a "chord" are struck, other colors are perceived in relation to them. Thus the colors in this final version of *Banana Grove* move in a rhythmic arc: in the foreground, from green to yellow-green to beige; then, upward in the sky, from ochre to orange to the opposite polarity, red.

## COMPLEMENTARY HARMONIES

Like sex, color is sparked by an attraction of opposites—warm to cool, light to dark, dull tones to bright ones. And in this equation, complementary hues, representing opposing halves of the spectrum, are the most dynamic of partners.

There are three basic complementary relationships: red/green, blue/orange, and yellow/violet. They may be varied by pairing a vivid version of one color with a muted tone of the other, or by using "off" hues like greenish blue or orange-red instead of exact complements. Yet even when complements are substantially modified, we respond to them as elemental polarities in the same way that we think of Caucasian, Asian, or Native American complexions despite the infinite variety of individual cases.

It is also important to remember that complementary colors have tremendous psychological importance. They touch upon deep-seated, universal experiences. In even the most abstract art, green reminds us of nature's greenery, red, of its flowers. And blue will forever stand for sea and sky, orange for fire, purple for royalty, and yellow for the sun.

**Red and Green.** The red/green color chord is especially useful, since the green of trees and plants is the subject of so much representational work, and red is its natural foil. Nor is it an accident that red and green are Santa Claus's colors, because these are the warmest of the complements and hence the most cheerful. You see, both orange/blue and yellow/violet are

warm versus cool opposites. Red and green, on the other hand, are evenly matched partners. Both are warm, and both are of a firm middle value—qualities that set up a vibration, or optical glitter, when they touch.

In contrast to the subtle red/green polarity in *Banana Grove*, another of my paintings, *Green Dahlia*, is based on a more straightforward complementary format. Though the drawing of interlaced leaves and branches is elaborate, my color plan is simplicity itself: a circle of green on

CHARLES LE CLAIR, *Green Dahlia*, 1989. Oil on linen, 58 × 40″ (147.3 × 101.6 cm), courtesy More Gallery, Philadelphia.

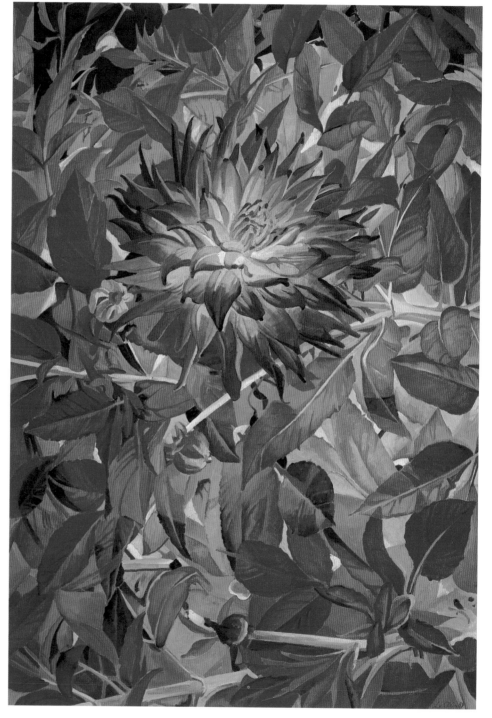

a shallow red ground, with a triangle of dark purple in one corner to suggest deeper space beyond.

The image is unusual in one respect, however, since it is based on an experiment with color reversals. If you have ever looked at a photographic negative, you will recall that the blacks of the positive print show up as white, while white objects are black, and vivid colors appear as their complements. Having long admired such abstract effects in my photographic negatives, I decided to do a series of paintings based on these chromatic opposites. Accordingly, in *Green Dahlia* an ordinary red flower on a green bush becomes an exotic jade blossom in an autumnal setting.

As you can see, the experiment also demonstrates how evenly balanced the red/green partnership is. Despite the reversal, a sense of natural growth and sunshine is maintained. And red, which is normally the more aggressive hue, slips comfortably into the role of ground color while green takes over as the positive image.

**Blue and Orange.** *Hotter*, a small canvas by Fritz Bultman (1919–85), is an archetypal orange-and-blue painting. A distinguished Provincetown artist and close associate of Hans Hofmann, Bultman worked with motifs—such as a curling rope, a floating bird, or a dancing foot—that he drew from nature and then distilled into abstract images. Abstraction was a spiritual language for this artist, and he would have abhorred too literal an interpretation of a painting like *Hotter*. Yet the title does give us a clear idea of Bultman's general intent, and there is nothing hotter in the spectrum than the yellow- and red-oranges he uses here in leaping, flamelike shapes. Nor is there a colder color than the blue with which he controls the blaze.

Figure/ground relationships are also interesting here, since orange and blue don't lend themselves as easily as red and green to reversed roles. Blue is stubbornly recessive, and Bultman's use of it in two horizontal bands establishes the architecture of a distant sky and sea. Within these cool boundaries, the various hot oranges, heightened by white, move forward and backward in a whirling, volcanic space.

Still another characteristic of blue is its power, beyond that of any other color, to suggest infinity. Howard Buchwald takes striking advantage of this spatial thrust in *Elizabeth's Ticket*, a huge, ten-foot-wide canvas on which mustard-colored shapes cavort against a bright cobalt "sky." Or on second thought, perhaps this blue expanse might better be described as a watery pool, its rectangular bottom outlined in black, and the darting shapes as eels and minnows.

These are metaphors, of course, rather than interpretations to be taken literally, since Buchwald is an essentially nonobjective painter. Unlike

FRITZ BULTMAN, *Hotter,* 1962. Oil on canvas, 30 × 24″ (76.2 × 61.0 cm), courtesy Long Point Gallery, Provincetown, Mass.

HOWARD BUCHWALD, *Elizabeth's Ticket,* 1985. Oil on linen, 98½ × 123½″ (250.2 × 313.7 cm), courtesy Nancy Hoffman Gallery, New York.

Bultman, whose abstractions often have figurative references, Buchwald focuses on purely formal relationships. I say this even though literary allusions are currently in vogue, and Buchwald's pictures often have elaborately descriptive titles. These are mere word clues in an esthetic game plan, however. They do spark our interest, and the thought of *Elizabeth's Ticket* as the diagram of a child's circus ticket caught in a gust of wind crosses one's mind. Still, this is a mere Rorschach suggestion, and Buchwald's painting is to be experienced primarily as an arrangement of line and color.

At this point you may well ask how *Elizabeth's Ticket* fits into our discussion of blue-and-orange schemes when there isn't a true orange in the picture. The answer is that painters visualize dull tones, which most people consider brown or gray, as low-key versions of the spectrum hues. Accordingly, khaki is dull yellow, maroon a muted red, and Buchwald's mustard mixture a low-intensity orange. You can check out this principle yourself by putting an orange or tangerine on a sunny windowsill. Look closely, and you will find that, although the fruit's edges are bright, its shadowy backside is a dark brownish color. Actually, Buchwald depicts his wiggly shapes in much the same way—as shadowy marks silhouetted against the light, with highlighted edges. Although these highlights aren't a direct orange, they are painted with alternate touches of yellow and red— "parent" colors that mix in the eye to create an optical orange effect when the painting is looked at suddenly in a bright light.

If you have visited Santa Fe and Taos, you will recognize blue skies and orange sunlight on adobe walls as a standard format in the art of the Southwest. In general, however, orange and blue don't go together as smoothly as red and green, and large expanses of these complements tend to be "obvious," or even garish, unless they are cleverly handled. On the other hand, discreet areas of orange and blue can be used to handsome effect as accents in compositions dominated by neutral tones. They are particularly striking when conceived, in the Renaissance manner, as light colors shining out of surrounding darkness.

Joseph Raffael and Frank Galuszka take this approach in paintings where oranges and blues are keyed to contrasting zones of warm and cool illumination. In the Raffael watercolor *Shadow Light*, for instance, orange appears in the upper half of the paper as the climactic gleam of an Oriental carp swimming in warm, brown-black "shadow," while the lower half is dominated by a cold, watery blue "light."

Galuszka's *Greta in the Kitchen* has a similar but more complicated color plan. Here, the artist announces his scheme with an orange circle in the exact center of the canvas and a blue square in the lower right corner. These abstract shapes are then explained figuratively as an orange piggy

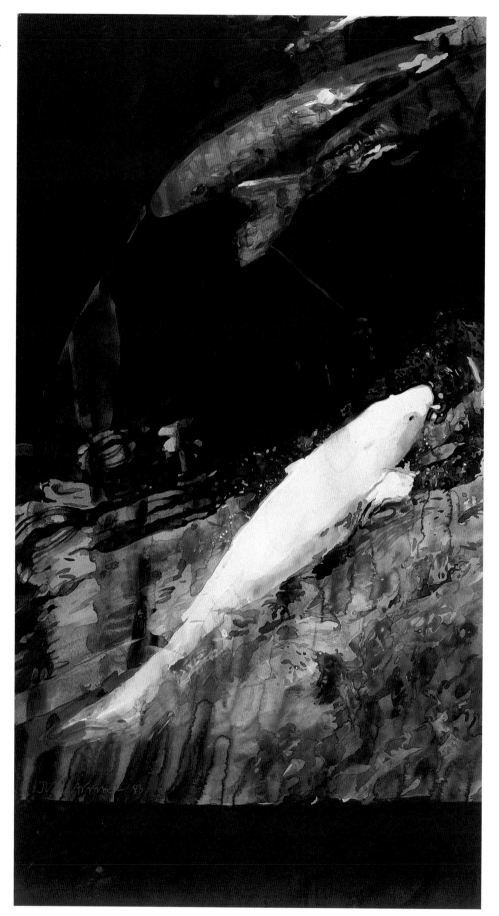

Joseph Raffael, *Shadow Light*,
1984. Watercolor, 58¼ × 32½″
(148.0 × 82.6 cm), courtesy Nancy
Hoffman Gallery, New York.

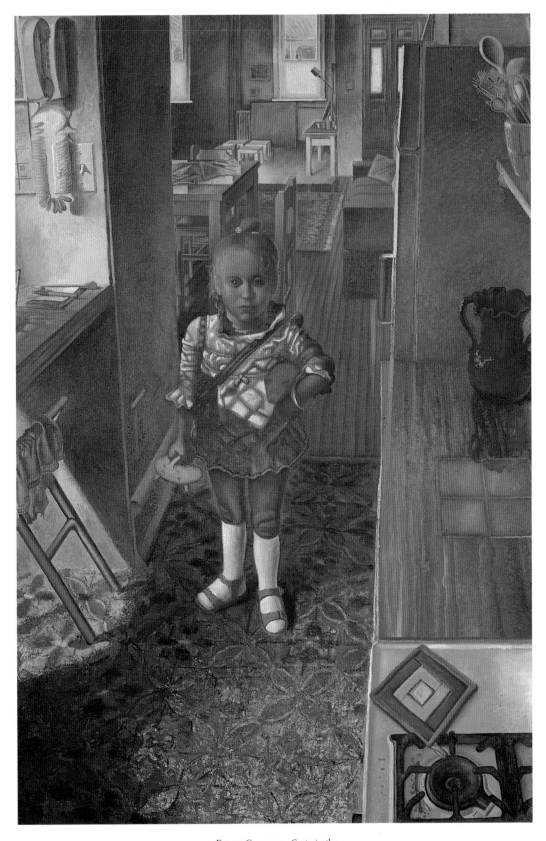

FRANK GALUSZKA, *Greta in the Kitchen,* 1981. Oil on canvas, 72 × 48″ (182.9 × 121.9 cm), courtesy More Gallery, Philadelphia.

bank in the hands of his small daughter Greta, and a bluish reflection on the kitchen stove. Within this framework, Galuszka shows us the wonderful silvery and tawny mixtures one can make with these basic colors, and the way such in-between tones can suggest the play of light. A walnut-colored shadow envelops Greta's figure, brightening into an orange-brown as it spreads outward toward the stove. The cold blue light on the stovetop, in turn, flows over the carpet and up toward the little girl, while—in a countermovement—warm sunlight shines down from the upper left, touching her shirt with amber.

**Yellow and Violet.** The yellow/violet harmony can be summed up in a single word—exotic. For while red/green reminds us of trees and flowers, and orange/blue of earth and sky, the yellow/violet chord has little connection with everyday experience. Instead, we find it in rare butterflies, tropical birds, unearthly sunsets, costumes of the Far East, and the trappings of royalty.

It is no wonder, then, that in gathering material for this book, I found very few yellow/violet paintings. Still, such major figures as Monet, Redon, and Munch have done marvelous things with lavenders and yellows, and

Left: JOSEPH RAFFAEL, *Iris*, 1986. Oil on canvas, 16½ × 10¾″ (41.9 × 27.3 cm), courtesy Nancy Hoffman Gallery, New York.

Right: JOSEPH RAFFAEL, *Untitled* (Iris), 1988. Watercolor, 44½ × 32¾″ (113.0 × 83.2 cm), courtesy Nancy Hoffman Gallery, New York.

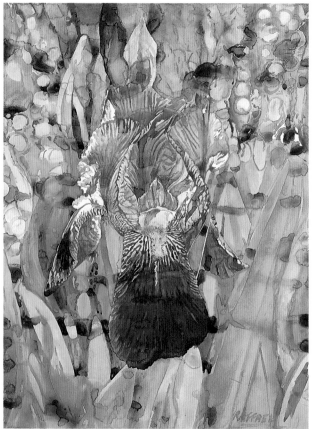

there are at least two situations in which this "exotic" combination is especially effective.

The first is the time-honored icon format—the presentation of a ceremonial image on a stylized ground. Medieval saints were shown on panels of "celestial" gold leaf, and this solemn approach has been revived over and over again in modern art—think of Rivera's Mexican peasants, Rouault's biblical kings, Walt Kuhn's clowns, and most recently, Chuck Close's photorealist portraits. Nowadays the backgrounds are usually painted rather than gilded, and they can be of any color. Yellow is still a natural choice, however, as a stand-in for gold.

Joseph Raffael's *Iris* is a rather modest example of the genre, yet it makes handsome use of yellow and violet, and it also shows how even the most unheroic of subjects can be monumentalized. A comparison of this stylized canvas with a more realistic watercolor of the same subject is particularly enlightening. In contrast to the watercolor's busy garden setting, the oil painting isolates a single flower stalk on a flat, golden-yellow ground. Where the one is casually drawn, the other is architecturally shaped—the iris scaled to dominate the space, side petals raised like arms, lower petal lengthened into a block, the stem a ruler-straight column.

Above all, this is an object lesson in the way color can be heightened by a decisive color scheme. The watercolor is charming, but its colors are diffuse. By avoiding naturalistic greens in the oil painting and focusing on the purple and yellow of the flower itself, Raffael makes a much more potent statement.

A second, quite different, role for yellow and violet is to be found in the nineteenth-century impressionist tradition of radiant light. For Monet and Pissarro, lemon and lavender often represented sunlight and shadow in an overall vision of "open-air" luminosity. In *The Yellow Square*, Wolf Kahn shows us how the impressionist spectrum palette can be updated with contemporary wit and intelligence. One of our most respected landscape painters, Kahn uses a typical Monet harmony, and he has a similar concern for the atmosphere of a special time of day. Here he captures the moment when daylight begins to fade by painting his barn in shadow, with a low-lying sun half hidden behind it.

At the same time, Kahn's abstractly composed, six-and-a-half-foot canvas is a far cry from the informal sketches we usually associate with impressionism. The subtlety of his color is also extreme. Indeed, the violet barn, blue sky, and green grass are so delicately tinted as to be almost indistinguishable against areas of sudden darkness—dusky trees, a barn door, the long line of a projecting roof. Kahn's most imaginative touch, however, is the small yellow square of the picture's title. Framed in a dark rectangle, this bright shape—representing a sunlit window on the far side of the barn's shadowy interior—has the severity of a Mondrian design.

The main thing to note here is that, given the right emphasis, a single touch of color is sufficient to set up a complementary polarity. In this case, one spot of bright yellow in a doorway is balanced by a vast expanse of pale violet on the side of a barn. Indeed, this yellow square is so insistent that we are forced to judge all the other colors against it. Put a finger over the yellow, and the picture suddenly loses its pep. Remove your finger, and it comes to life. The shape of an outer sliding door, which had been almost subliminal, now appears as a chartreuse afterglow of the warm yellow light source, while the other colors all take on energy as cool chromatic opposites.

In her watercolor *Pima Point II*, Susan Shatter uses a similar scheme but with a more full-bodied palette—deep yellows shot with lime and orange, and violets tinged with magenta. These intense mixtures, set down with impassioned brushstrokes, evoke a hot afternoon light in the Grand Canyon that is in sharp contrast to the cool New England atmosphere conveyed by Kahn's paler colors. Shatter also creates a more dimensional effect with yellows on the sunny side of her mountains and purples on the shady side.

This is an artist who balances a delight in scenic wonders—the Maine coast, Mexico, the Cycladic Islands, the American Southwest—with a feeling for modernist structure. Working with both oils on canvas and watercolors on huge sheets of industrial paper, Shatter translates on-site sketches into panoramic images that have the look of topographical relief

WOLF KAHN, *The Yellow Square*, 1980. Oil on canvas, 44 × 78″ (111.8 × 198.1 cm), courtesy Grace Borgenicht Gallery, New York.

SUSAN SHATTER, *Pima Point II*, 1982.
Watercolor, 48 × 96″
(121.9 × 243.8 cm), courtesy
Fischbach Gallery, New York.

maps seen from above. Her work is also much admired for a structural quality that takes its cue from the repetitive forms of Cézanne's late landscapes. Thus the rock formations in *Pima Point II*, for all their specificity, set up rhythms that read as pure abstraction if you look at them disinterestedly. Just turn this picture upside down, and you will see what I mean.

## ANALOGOUS SEQUENCES

We turn now from complementary colors, and relationships across the color wheel, to a consideration of close harmonies among neighboring, or analogous, hues. These are the golds, oranges, and russets of autumn leaves; the greens and blues of a mountain landscape; the indigo, turquoise, and lavender of tropical waters—in short, pleasantly harmonious colors rather than dynamic opposites.

For studio artists, these are everyday combinations to be described in nontechnical terms. Instead of "analogous harmonies," we speak of "closely related" colors or simply of working with reds or greens or blues. Hence, when we refer to Picasso's "blue" period, it isn't with the thought of a truly monochromatic scheme but of a generally bluish harmony. Such a blue color chord would typically range from green to violet, with a true blue at the center of the sequence.

Milton Avery's *Woman in Red* illustrates this approach, its title obviously referring to the artist's color scheme rather than the lady's gown, which is actually orange. It is a painting done in what artists think of as reds, but that a theorist might fairly describe as an analogous orange/red/violet

chord—orange evident in the dress, red in the background, and violet tones in both the sofa and the lady's feet.

Avery (1885–1965) was a marvelously inventive colorist with a talent for integrating color and subject matter. Here, the contemplative mood of a lady stretched out reading the paper is conveyed by a richly subdued palette. Like many first-generation American modernists, Avery emulated the simplified color areas of Matisse and the Fauves. And since it is a first principle of this style that every part of the picture be brought to life by color, Avery saves his most intense red for the negative spaces around the figure rather than for the positive image of the lady herself.

In his *Still Life in Red Room*, Warren Brandt puts a somewhat jazzier contemporary spin on the Matisse/Fauve tradition with a violet floor, chartreuse couch, and yellow flowers, plus assorted blues and magentas. Obviously, with this many hues, we no longer have an analogous chord with a dominant center. Instead, Brandt uses an entirely different system based on *sequential* relationships—that is to say, the linear movement of hues *around* the color wheel. Thus when a yellow/orange sequence appears, we expect red to follow; when yellow/orange/red is shown, we expect violet to be next; and the longer the color chain, the tighter the linkage.

This logic is similar to that of a musical scale. When do, re, and mi are sounded, we anticipate fa, sol, la, ti, do. In practice, however, there is a big difference, since composers work with a fixed keyboard, while painters do not. Whereas scientific color charts show regular chromatic intervals, artists have traditionally blurred these distinctions with "painterly" techniques. Many modernists, on the other hand, have reaffirmed the

importance of abstract relationships by developing their own color systems, or "scales." Seurat worked with "divisionist" dots, Mondrian with primary colors, Klee with six or seven values of a single color, and Matisse—like Brandt in his *Red Room* still life—with the full circle of hues around the color wheel.

To be perceived as a sequence, colors must be set down as separate "notes" rather than blended, and in a pattern with a rhythmic beat. Thus the stripes in Brandt's still life are a dead giveaway of the artist's intentions. And although there are complementary touches like the orange slits between blue stripes in a background drape, the main emphasis is upon sequential motifs. A central spray of yellow flowers fans out toward a yellow-orange pillow and chartreuse couch cover. Bands of yellow, orange, and magenta on one pillow relate to a violet floor, while lemon and green stripes on another cushion connect with chartreuse and blue blankets. Even the walls of Brandt's "red" room, instead of being solid, are painted as a sequence of magenta, dusty rose, and ochre panels.

WARREN BRANDT, *Still Life in Red Room,* 1972. Oil on canvas, 50 × 60″ (127.0 × 152.4 cm), courtesy Fischbach Gallery, New York.

Brandt's color has freshness and charm. Edna Andrade uses a similar sequential scheme more systematically in *Moon Game*, a nonobjective canvas divided into evenly spaced vertical stripes. On this grid Andrade plays the color game of her title, interrupting the stripes with round "moons" and "half-moons" of various sizes. The object of the game? Clearly, to use colors that will give each circle a visual "bounce" as it hits the stripes like a ball on a spinning roulette wheel. Beginning at the left, stripes #1 and #2 are painted yellow and greenish-beige tones that bring out the overlaid turquoise and lavender circles; stripes #3 and #4 are painted deeper shades of violet as a foil for yellow half-circles; and so on. Note, too, that while Andrade includes some complementary hues, she keeps the yellow- and violet-dominated segments of the spectrum on different spatial levels—analogous yellows and oranges moving across the foreground, sequences of grayed violet in the background.

If this sounds complicated, it is more so in the telling than in the color game itself, which is a lot of fun. The main thing to remember, in any case, is the distinction between working with spectrum *opposites* and with relationships *around* the color wheel. We have seen how complementary mixtures can create velvety shadows in representational painting.

EDNA ANDRADE, *Moon Game,* 1983. Acrylic on canvas, 50 × 50" (127.0 × 127.0 cm), collection of Mr. Richard Kirschner, Washington, D.C.; courtesy Marian Locks Gallery, Philadelphia.

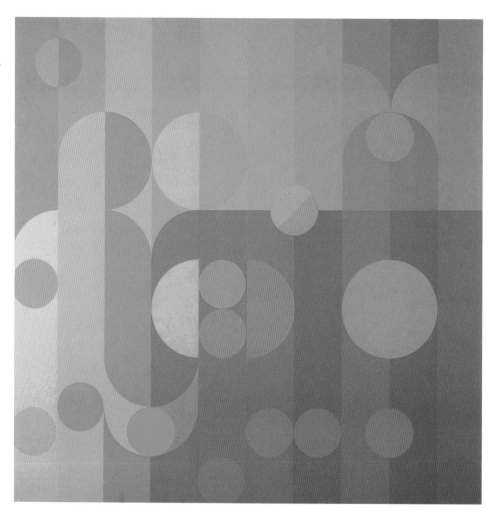

Analogous schemes, on the other hand, are most effective in stylized or abstract work, where colors are uniformly bright, and where there are enough of them to convey the idea of a chromatic sequence to the eye.

## STATIONARY RELATIONSHIPS

The schemes we have considered thus far have one thing in common: They all involve transitions and progressions—movement from one complement to another, from hue to neighboring hue, from dark to light or warm to cool. In a very real sense, to be a colorist is to be sensitive to precisely this kind of relativity—what Albers called the "interaction of colors."

At the same time, colors have certain fixed associations for us. Conceptually, roses are red, even though a Monet might paint them orange and violet. And along with the emphasis on elaboration in modern art, there has always been a countertrend toward simplicity—the search for elemental rather than transitory relationships. Even as the early modernists pursued "advanced" optical theories, they recognized the honesty of Henri Rousseau's "naive" red apples, green leaves, and pink people. Later the Bauhaus took "Less is more" as its motto, and Mondrian developed a reductive painting vocabulary of red, yellow, blue, black, and white.

Although there's a lot of color interaction in his late works, the classic Mondrian image is of large, stationary color blocks in a black-and-white space. This format, much imitated by later artists, replaces the usual concept of color movement with that of "stationary" colors around which other elements flow. In Roy Lichtenstein's *Cubist Still Life*, for example, a great deal of black-and-white movement is pinned down by red and yellow spots as if by thumbtacks. And in Sidney Goodman's *Woman on Air Mattress*, an apocalyptic gray-black atmosphere swirls behind solid blocks of yellow, white, and red. The difference between color here and in the work we saw earlier is the difference between a Calder mobile and stabile. Or if you are into horticulture, think of it as the difference between an English and a Japanese garden, the former free-flowing, the latter articulated by a few selectively placed rocks and plants.

The Goodman and Lichtenstein comparison is particularly interesting as an example of the way different kinds of art involve the same basic principles. Seemingly, no two painters could be more dissimilar. Lichtenstein is a pop-art star whose *Cubist Still Life* is one of a series of canvases in which "fine art" idioms like expressionism, futurism, and surrealism are presented or, if you will, parodied, in a "commercial art" style. Thus Lichtenstein's blacks and whites have the mechanical precision of a poster, and his yellows and reds the raw look of a colored comic strip. Goodman, on the other hand, is a realist whose work has moved toward increasing moodiness and expressionism. Where Lichtenstein is into

Roy Lichtenstein, *Cubist Still Life,*
1974. Oil and magna on canvas,
90 × 68 1/16″ (228.6 × 172.9 cm),
National Gallery of Art,
Washington, D.C., Gift of
Lila Acheson Wallace.

SIDNEY GOODMAN, *Woman on Air Mattress*, 1987–89. Oil on linen, 50 × 68″ (127.0 × 172.7 cm).

popular art *styles*, Goodman paints pop *subjects*—like this woman sunning herself on an inflated air mattress—but in a heroic, Renaissance manner.

There is irony in both approaches, for where pop art mocks the artifacts of modern life—lipsticks, clothespins, soup cans, air mattresses—Goodman makes them into Orwellian symbols of a sinister world. Thus, though his heroine seems to be protecting her eyes, we can't be sure it's from the sun. Perhaps there is an imminent explosion or atomic blast. Or perhaps she is already a victim laid out on a white stretcher.

In any event, Goodman's sulphurous brown-black shadows are a far cry from Lichtenstein's black-and-white harlequin patterns. Yet both artists are powerful draftsmen, and each in his own way works with a dark/light scheme punctuated by discreet areas of color. Lichtenstein gives his *Cubist Still Life* the look of a crisp graphic design, whereas Goodman is, above all, a master of sculptural form. His *Woman on Air Mattress* has the heroic symmetry of a classical pediment. In this context, the separateness of the colors, particularly of the intense yellow and white shapes, is a device for heightening the roundness of the volumes. Indeed, the ancient Greeks painted the costumes of their marble gods with bright colors in much the same way.

# CINEMATIC COLOR

Back in the fifties, Arnold Hauser wrote a book called *The Social History of Art*, whose message has proved prophetic. Hauser argued that whereas sculpture was the dominant art form in the ancient world and painting in the Renaissance, ours is the age of cinema. Not only do movies involve the most money and widest audience, he reasoned, but also their visual style has conditioned the other arts. Cinematic close-ups, montages, dissolves, and overlapping images are to be found in everything from advertising and comic strips to fine-art idioms like futurism, surrealism, and cubist collage.

The argument has even more substance in today's world of Cinerama-scale canvases, performance art, and installations. A Red Grooms installation offers as many special effects as a Steven Spielberg movie, and nowadays actual photographs, transferred to paper or canvas, are a major resource for the painter. Witness Andy Warhol's artfully touched-up photo-portraits of Liz, Marilyn, and Mao.

Within the realm of traditional picture-making—i.e., two-dimensional work of a size that can still be hung in a gallery or collector's home—Robert Rauschenberg has pioneered a particularly cinematic idea. This is the notion that paintings no longer should have "unitary" meaning. Instead, he argues, we should see a painting like his *Artesian Gusher* as a progression of changeable colors and images. In Hollywood terms, this is the difference between a still and a moving picture.

*Artesian Gusher* is one of the artist's recent Urban Bourbon series of nine paintings in which evocative yet seemingly disconnected photographic subjects are screen-printed on brilliantly colored aluminum panels. Machinery, lamp shades, garbage cans, horses, even the rear end of an elephant appear and disappear before our eyes in works with such fanciful labels as *Nocturnal Splash*, *Canary Frostbite*, and *Rodeo Olympics Glut*. Presumably, Rauschenberg's concept has to do with the totality of experience, and perhaps his name for the series, Urban Bourbon, is a metaphor for solids and liquids. Certainly, the title *Artesian Gusher* has an obvious liquid reference that is confirmed by pictures of a pump, what seems to be a yellow riverbed, and a gooey white splash. The urban/solid motif also appears here in references to a storefront and a barely visible green rubber tire.

If Rauschenberg's images are on the move, his color also has a dynamism that is new in our time—new because it involves a walking experience through a series of color sensations that is only possible in the oversize artworks museums feature today. The basic idea involves a sequence of panels, each separate and with its own color scheme, yet with overlapping elements that lead to the next "frame." In *Artesian Gusher*, the panels form a dark-to-light progression from deep violet through mid-value blue and red to a strip of white. Meanwhile, disparate color chords shine forth

ROBERT RAUSCHENBERG, *Artesian Gusher*, 1988. Acrylic on enameled aluminum, 120¾ × 144¾" (306.7 × 367.7 cm), courtesy M. Knoedler & Co., New York.

and fade out like lantern-slide projections—a yellow/violet harmony in the upper left, a red/green chord in the center, and at the bottom, a splash of white against patriotic red, white, and blue panels.

*Artesian Gusher* is only a modest example of the kind of "cinematic" color experience I am talking about. After all, it is only twelve feet wide, and Rauschenberg often extends his continuous grid system to much greater lengths, sometimes with projecting screens or movable parts.

Still more significant, I think, is the interest of many of our newer stars in creating shows rather than individual works. Thus at an exhibit by Kiefer, Rosenquist, Schnabel, or Rauschenberg, we are caught up in a total color environment. And sometimes the progressive color harmonies we experience in time, during a walk through one of these big shows, can be as meaningful as the fixed color relationships in any of the separate paintings.

1. Robert Keyser, letter to the author, November 21, 1989.

# 8  COLOR AS GESTURE

*Each gesture is an intuitively calibrated response to the previous mark and a question posed to the mark which follows. . . . Within this action of building up and filling out, there lies an unprecedentedly concrete record of a creator extending himself through his chosen medium . . .*

—*Stephen Westfall,* about Milton Resnick

Most painters think of color primarily in terms of shapes—either the pieces of blue sky, green grass, and red dresses that fit together in a figurative image, or the more arbitrary planes, circles, and triangles of an abstraction. Hence the emphasis in this book on what I have called "structural color."

Still, there is an altogether different kind of artist to be considered: the action painter, for whom color means movement and flux instead of fixed relationships. Although action painting is a 1950s term referring to the method of the abstract expressionists, it also reminds us of the dynamism of historic figures like Tintoretto, Rubens, and Delacroix. There is a big difference, however, since the brush marks of a contemporary Milton Resnick or Joan Mitchell stand alone, whereas the gestural flourishes of earlier painters were tied to representational images. This is even true of the first modernists. For all the energy of van Gogh's brushwork, for instance, his rivers of paint still flow within solid-color boundaries, and we perceive his starry skies as blue and his cypresses as green despite the tangle of subordinate colors within each area.

Thus Milton Resnick's 1959 *Horn of Plenty* represents a new phenomenon that suddenly appeared after World War II—the painting composed, on a grand scale, entirely of nonreferential gestural marks. To be sure, Kandinsky had invented free-form abstraction by 1910, and Soutine and Kokoschka had taken gestural distortions to great lengths. But we must remember that except for special projects like Monet's Water Lilies series or Picasso's *Guernica,* the pioneer modernists worked on a scale that would be considered intimate today. The Resnick and Mitchell canvases shown here, on the other hand, are six and a half and nine feet high. They are also painted with unprecedented emphasis on body language—the athletic gestures of arm and shoulders rather than hand and fingers as in the past.

MILTON RESNICK, detail, *Horn of Plenty* (page 144)

Physical energy is a decisive factor here because the esthetic of action painting is very much like that of the dance. As we respond to the picture's in-and-out, left-right, up-down, forward-and-back brush marks, we sense the presence of a muscular force behind them. Because of the larger scale of their canvases, many action painters also began to work on the floor, moving around the four sides of the picture, back bent and arms outstretched, in a dancelike physical workout. Legend has it that Jackson

MILTON RESNICK, *Horn of Plenty*, 1959. Oil on canvas, 78 × 53″ (198.1 × 134.6 cm), courtesy Robert Miller Gallery, New York.

Pollock even went so far as to pattern his rhythmic paint splashes after the ritual sand-painting dances of the Southwest American Indians.

# GESTURAL ABSTRACTION

As in a scientific experiment, artists like to isolate a particular phenomenon and see what can be done with it. Seurat was excited by dots, the cubists by faceted planes, the abstract expressionists by gestural marks. Of all the modernist idioms, however, gestural abstraction—that is to say, action painting without the figurative elements de Kooning and some others brought to it—is the most baffling for the general public. Most people feel they can respond to geometric abstraction at least on the level of design and color. But all too often gestural abstraction remains something of a mystery, a style that seems murky and formless, despite the reverential attitude of critics and admirers.

So let me offer a few clues that may help dispel the mystery. For starters, it should be understood that paintings like Mitchell's *Before, Again II* and Resnick's *Horn of Plenty* are the closest thing to music you will find in the visual arts. I have referred to music before, but this time the analogy is more precise because it involves the element of time. In action paintings, one feels the artist's brush gesturing to a rhythmic pulse that is like the beat of a conductor's baton. Although there is no beginning or end to this movement as in music, time is implied by the urgency of the brushstrokes and by overlappings that reveal their sequence. Doubtless it is with this idea of recurring rhythms that Mitchell chooses the words *before* and *again* for her title.

Thus on one level these paintings are "frozen music," and by looking at them in this way, you will find that color and line press the same emotional buttons that harmony and melody do. Mitchell's picture is cheerful, painted in an even tempo, with vivid colors and vigorous strokes—musically, an allegro con moto composition in a major key with bright orchestration. By contrast, the Resnick is a somber canvas, painted with tortuous strokes in darkly glittering colors. Musically, I would imagine it as a brooding tone poem, molto agitato, with woodwinds and cellos sounding minor chords.

On another level, action paintings often may be interpreted as representing elemental forces of nature—wind, rain, sunshine, storm—even when there is no concrete imagery. In this respect abstract expressionism differs from pure abstraction in that it is based on "organic" forms associated with nature rather than on impersonal geometry. Thus it is abstract in the sense of being very generalized without being strictly nonobjective.

Twisting marks inevitably remind us of growing things, and when these marks are in color, the associations are even more distinct. Thus,

JOAN MITCHELL, *Before, Again II*, 1985. Oil on canvas, 110 × 78¾" (279.4 × 200.0 cm), courtesy Robert Miller Gallery, New York.

confronting Joan Mitchell's canvas is like looking at a pool of blue water enlivened by rippling yellow and gold reflections. And whatever one's personal response to the picture, there shouldn't be any mystery about its frame of reference. We don't need to know that this American artist loves nature, or that she lives outside Paris in a house on the Seine that Monet once owned, to appreciate the fact that her painting is about light and atmosphere. We know this because the vocabulary of art speaks for itself, even without explicit imagery. A field of blue will always suggest sky or water, yellow is obviously the color of the sun, and rippling marks are a perennial shorthand for wind and waves.

Finally, action painting should be understood as a novel approach to space. The spatial concept of earlier modernists like Cézanne and Picasso had been a shallow shadow box echoing the picture plane. In place of this, the abstract expressionists envisioned a cosmic space reaching toward the stars—a space alive with pulsating forces plunging into depth rather than sliding blandly across the surface. As a second-generation abstract expressionist, Joan Mitchell achieves this openness with confident, briskly animated marks and fresh, bright colors.

Resnick, on the other hand, is a pioneer action painter whose *Horn of Plenty* is a record of exploration and struggle. Like de Kooning and Franz Kline, his goal was raw emotional power rather than charm. Accordingly, he paints here with a mixture of thick and thin pigments, smeared and scumbled brushstrokes, and contradictory rhythms. Short zigzag marks on the left, for instance, are overlaid with long, stringlike vertical scratches. His color is equally turbulent as flashes of golden light tangle with purple-black thunderclouds that, in turn, are shrouded in a milky veil of graffitilike whitish marks.

As you see, there is an inherent conflict between color and mark in Resnick's approach, since each new layer of brushwork in a sense "kills" the color underneath. In more recent paintings, the artist carries this "cancellation" process to the ultimate extreme. His *Red O*, for example, is so encrusted with interwoven marks that from a distance it appears to be a minimalist, uniformly colored, terrazzo-like panel. Yet upon close examination swirling brushstrokes and tiny flecks of pink, green, and vermilion reveal a world of excitement beneath the enigmatic surface.

Clearly, this cool *Red O* is at a far remove from Resnick's initial impassioned abstract expressionism. It is based on the same gestural rhythms, however, and you can see for yourself how one thing led to another by drawing something on a scratch pad and then scribbling over it until the image almost disappears. In much the same way, Resnick's action painting has come to be about "erasing" colors rather than stating them positively as before. Similar techniques of "obliteration" are widely practiced today in the thought that a partially revealed image can be more provocative than an explicit one. Jasper Johns's use of a hot iron to melt down his encaustic images is a well-known example of the strategy.

Although the heyday of abstract expressionism is long past, gestural abstraction remains a viable idiom, particularly in small-scale, highly personal work like Bill Scott's. As you see in the two pastels shown here, this young Philadelphia artist employs an action painter's vocabulary of lunging marks and layered colors, but with joie de vivre rather than muscular vehemence. The work also owes much to French impressionism, which Scott fell in love with early in his career. Subsequently, Scott studied with Joan Mitchell in Paris, and in the dual role of art critic and

curator, he has become a leading expert on the work of the nineteenth-century French painter Berthe Morisot. Like Mitchell and Morisot, he is inspired by landscape themes—not with the thought of painting particular places but of expressing elemental moods and emotions.

In contrast to the solemn tone of much action painting, Scott's work has a lively, sketchlike immediacy. Instead of all-over brushstrokes, certain clusters of marks are emphasized, with much of the background left untouched. As a result, one feels the artist's hand swinging across the page, and there is the sense of an image hidden in the piled-up chalk strokes. This is the case even where the marks are totally abstract, as in *Migraine,* but sometimes Scott provides clues to his subject. *Spring's Fluster,* for instance, reminds me of the poetry of Gerard Manley Hopkins, both in the evocative sound of its title—"cluster," "bluster," "fluster"—and in the associative character of its lines and colors. A band of crisscross strokes creates a distant horizon at the top of the picture, while a flurry of stemlike marks suggests a field of flowers and foliage below. This landscape image is further clarified by identifiable local colors—black and gray-green for plant stalks, red blobs for flowers, and star-shaped greenish-white strokes to suggest leaf clusters.

While gestural rhythms are especially compatible with the irregular forms of nature, they are sometimes applied to the human figure as well. One thinks of the scribbled drawings of Giacometti, for instance, or of de Kooning's fiercely distorted paintings of women. More recently, Hannah Wilke has done a series of watercolor self-portraits that are notable for the way they balance gestural purity and representation.

These new works are a surprising development in the career of an artist known for sculpture based on female symbols, photographs of her nude body in startling situations, and both performance art and essays heralding the idea of "physical and emotional self-exposure as esthetic process."[1] As always, however, Wilke sees the project as an adventure in self-discovery. Her familiar folded sculptures and posed photographs are essentially gestural statements, and in the new work each watercolor brush mark, tracing the contours of her face, becomes the vehicle for a continuing involvement with movement.

The new watercolors are also interesting technically. Like the May 13, 1988, version shown on the next page, each painting was done in a single day on giant, seventy-six-inch paper stretched out on the floor. Although the work may look spontaneous, it is actually quite the opposite. In a watercolor this size each foot-long mark has to be deliberately

Left: BILL SCOTT, *Migraine,* 1987. Pastel, 30 × 22″ (76.2 × 55.9 cm), collection of Mr. William M. Shea, Wilmington, Del.

Right: BILL SCOTT, *Spring's Fluster,* 1988. Pastel and lithograph, 30 × 22″ (76.2 × 55.9 cm), courtesy Mangel Gallery, Philadelphia.

choreographed, often with hours of waiting between strokes while puddles from a four-inch brush dry out. Look closely and you will see how each mark is designed to move in and out of facial hollows with a calculated wet-to-dry, dark-to-light shading. You will also note that Wilke builds her portrait, like a color-separated photograph, in carefully planned layers: first, a stratum of pale yellow marks; then a round of mid-value green marks that overlap the yellow ones, forming areas of yellow-green; and finally, a top layer of wine-red brushstrokes that, in the transparent watercolor medium, create various see-through mixtures with the colors underneath.

Thus Wilke's work, however devoted to gestural marks, has none of the free-flowing quality of action painting in either its original sense or in the sense in which Mitchell, Scott, and others are practicing it today. Instead, hers is a postmodernist approach to gesture based on a formal rearrangement of certain elements from the earlier style. The current "in" word for this strategy is *deconstruction*.

## ACTION PAINTING REVISITED

Howard Buchwald's work is representative of the newer attitudes in the art world of the nineties. Like other up-and-coming New York painters, he is identified with a stylistic family tree that is duly noted by critics and a sophisticated gallery-going public. In Barbara Rose's *American Painting: The Twentieth Century*, he is placed as a descendant of abstract expressionism, and he further defines himself as carrying forward the ideas of Jackson Pollock. Thus, in contrast to the pioneer modernists who drew upon such remote sources as Japanese prints and African masks, today's *post*modernists turn to the styles of the immediate past, reshaping them in a spirit of intellectual refinement rather than first-time discovery.

The current vogue for deconstruction sums up the change. Although you won't find it in a standard dictionary, this term refers to the reduction of a well-known style like cubism or expressionism into constituent elements that can be dealt with separately or reassembled in a new way. This is Buchwald's strategy in *First Steps*, a handsome abstract painting in which Pollock's furious gestural style is reduced to even-handed rhythms. Where Pollock dribbled housepaint with continuous, dancelike gestures, Buchwald works with controlled bands of color. And as in Hannah Wilke's watercolors, the technical expertise required for making such smooth, wide marks on a large surface is considerable. Oil paint is a stubborn medium that won't flow evenly unless expertly diluted, and here the problem is compounded by a secondary pattern of parallel, threadlike drips. Achieving such an effect is like skipping a stone on water: Your paint has to be just liquid enough and the brushstroke just fast enough to permit tiny runs without messy blotches. Clearly, this is action painting with a difference, a version based on stylized rhythms far removed from the naturalness of the original idiom.

If a certain emotional impact is lost in this translation, there is, on the other hand, a significant gain in clarity—a greater sense of the strong, clean way in which line, color, and texture interact. This feeling of a "perfected" image that is at once lively yet frozen—the way a photographer stops the action of a dancer in midair—is particularly striking in Buchwald's *Picturing Vision I* and *II*. In the two versions, we find the artist working as a printmaker with a design that can be repeated with variable

HOWARD BUCHWALD, *First Steps,*
1988. Oil on linen, 82 × 72″
(208.3 × 182.9 cm), courtesy
Nancy Hoffman Gallery, New York.

HOWARD BUCHWALD, *Picturing Vision
I*, 1984. Oil on linen, 90 × 84″
(228.6 × 213.4 cm), courtesy
Nancy Hoffman Gallery, New York.

HOWARD BUCHWALD, *Picturing Vision
II*, 1985. Oil on linen, 90 × 84″
(228.6 × 213.4 cm), courtesy
Nancy Hoffman Gallery, New York.

color schemes and changeable subordinate motifs. Here, the main image is one of large, looping lines against which smaller improvised marks form a playful counterpoint. Yet although these "key" lines have a terrific gestural swing, we see at once that they aren't freehand marks at all. Indeed, they are so perfectly matched in the two paintings that they might have been stenciled in. And the endings of these marks are punctuated by circular cutouts—holes in the surface of board-mounted canvases that further emphasize the architectural character of their design.

Buchwald's framing device also helps to structure his image by creating the illusion of a shadow box. Thus our eye is caught by the spatial ambiguity of an inner square that can be read either as a window in the canvas or as an object suspended in front of it. Buchwald's title strongly suggests the latter, however, and I see the square in version *I* as a bright positive image against a dark background—perhaps literally a picture hanging on the studio wall. The center square in version *II*, on the other hand, seems much more transparent. Here, the image might be a sheet of picture glass, drawn in brown with patches of blue and black showing through from underneath.

In any case, these are stunning paintings, and much of their snap and crackle derives from an assured painting strategy. Buchwald explains that his work is about "drawing with color" rather than "painting" in the usual sense. To implement this concept, he has also formulated the following guidelines for himself based on an analysis of Pollock's achievement: *first*, working with linear distribution patterns rather than focused images; *second*, avoidance of solid color areas that might read as "shapes"; *third*, emphasis on maximum color saturation; and *fourth*, the use of black throughout the composition.[2]

From the standpoint of color, the most striking thing about this approach is the emphasis on movement. Instead of working with solid shapes, Buchwald builds color relationships with gestural lines. Hence, his colors are not only scattered airily in space, but they also take on the directional thrust of the strokes they are made with. In *First Steps*, for example, a surging river of brush marks flows from the bottom of the canvas toward the upper right corner, the direction of each stroke announced by a little kite's tail of drips at its starting point. Thus we perceive the colors as sliding upward and into each other—yellow running into red, red tangling with black and green, and in front of everything else, lines of blue and rose-violet that look like carnival streamers against a sunset sky.

*Behind the Curtain* is equally dynamic, but this time the movement is angular rather than fluid, with straight lines piled up like sticks in a dimensional crisscross design. As the title suggests, the action is revealed

by a white curtain drawn back on the right. Whether it opens onto a stage or a picture window is unclear, and the dark vision beyond might be anything from city traffic to storm-tossed trees or even bent-over figures. But it is in any event a wildly expressionistic image that, like Edvard Munch's work, "screams" with color. Black outlines give the red, yellow, and pinkish-violet stripes a stained-glass brilliance. And Buchwald sets his lines of color in motion by drawing them to a series of perspective points, each of which is marked by one of his distinctive circular cutouts. It is intriguing to speculate about effects that might be achieved by hanging this painting against variously colored backgrounds. But in the standard gallery situation shown here, spotlights give these cutouts special emphasis by surrounding each opening onto a snow-white wall with dark cast shadows.

# GESTURAL REALISM

In figurative work, gestural rhythms can't be quite as ebullient as in abstract art because they must conform to recognizable shapes. Nevertheless, dynamic brushwork is a key element in the work of many of our contemporary realists.

Susan Shatter and Neil Welliver come to mind here, and it is perhaps no accident that they are both landscapists, since this is the least inhibiting of the representational genres. Still lifes, interiors, and cityscapes must observe a certain architectural logic; figure paintings, a degree of anatomical accuracy. On the other hand, the shapes of clouds, waves, hills, and foliage flow easily from an artist's brush, and their contours are so irregular in nature that they may be bent and twisted into expressive patterns without loss of believability.

Shatter's *Study for Indian Point* shows how smoothly a gestural style can be adapted to a landscape theme. This is a tiny on-site watercolor of the Maine coast whose subject is not so much sea and rocks as the swirling rhythms that unite them—in short, an image of movement appropriately expressed here in a linear design of gestural brush marks. Some of Shatter's marks maintain their first-time crispness; others are modified by additional washes that set up a movement of colors comparable to the directional thrust of the brushstrokes. Thus the warm tones of foreground rocks are overlaid with blues that slide in from the sea, while the inky sea, in turn, is washed with pink.

Much of the charm of a small watercolor like this derives from the way images can be created with a blob or squiggle of the brush. It is difficult to maintain a purely gestural approach, however, in large-scale work where

SUSAN SHATTER, *Study for Indian Point,* 1981. Watercolor, 7 × 11″ (17.8 × 27.9 cm), courtesy Fischbach Gallery, New York.

greater realism is called for and separate marks are lost in a lengthy painting process. As a result, artists often treat small studies and large canvases differently. For Shatter, the on-site watercolor is a lively shorthand outline for a composition to be developed on a grand scale in the studio. As we shall see in the next chapter, her finished versions follow the small sketches closely, but with linear rhythms translated into solidly built up sculptural volumes.

In this respect, Neil Welliver is unusual in bringing a consistent gestural style to both king-size canvases and small watercolors and prints. Since he is also a leading exponent of the new-realist view that paintings done from life can (and should) have the formal structure of abstract art, I was pleased to find paintings of his that, when compared with Buchwald's *Picturing Vision I* and *II* (page 153), would seem to prove the point. Like Buchwald, Welliver gives us two interpretations of the same subject, *Ledge and Brook* and *Thawed Ledge and Brook*. And despite diametrically opposed styles, the realist and the abstractionist clearly have a lot in common. They are both not only gestural painters; they also follow similar, intellectually conceived strategies.

Like Buchwald's twin abstractions, Welliver's landscapes are based on the idea of theme and variations. And again as in Buchwald's work, variations of color, texture, and subordinate motifs are imposed on an underlying design that remains constant. Welliver's rationale for change is more obvious, of course—here, ostensibly the contrast between verdant spring and icy winter. However, there is an esthetic agenda, too, since these aren't casual impressions of the weather but abstractly formulated images based on a distilled drawing that has been proportionally transferred to canvases of unequal dimensions. At first glance, the underlying grid is somewhat obscured by snow in the one and greenery in the other. But examine the two pictures closely and you will find a uniform topography with nearly every tree and rock in place.

Thus the broad outlines of Welliver's composition are, in a sense, frozen. Like Buchwald's calligraphy, however, they are frozen into distinctly gestural rhythms. Except for a narrow band of trees at the top, all of the lines are shaped with long, swinging, diagonally intersecting curves that— particularly in the winter scene—bear an uncanny resemblance to Buchwald's abstract motifs.

Within this carefully structured overall design, Welliver develops his pictures with more spontaneous rhythms. After transferring the drawing, and guided by a color sketch, the artist starts painting at the top of the canvas and continues to the bottom edge without ever going back. Along the way, he works with exuberant strokes of a heavily loaded brush, alternately creating and destroying the initial drawing with smears of

NEIL WELLIVER, *Ledge and Brook*, 1988. Oil on canvas, 72 × 72″ (182.9 × 182.9 cm), courtesy Marlborough Gallery, New York.

pigment. In contrast to the studied curves of the underlying shapes, these smaller marks follow impulsive gestural rhythms that have a life of their own as paint.

This is "action" painting, then, on two levels: carefully shaped lines that set the stage, followed by an exuberant dance of gestural marks within boundaries. Welliver's motivation for this process, he says, is an overriding concern for light. He explains further that his interest isn't the usual one of light falling on objects; instead, he has a vision of "light in the air, flashing and moving like a flow of energy through space."[3] This concept of energy flow, as you will see, speaks directly to the theme of this chapter—color as *gesture*—since it proposes a fusion of linear and color rhythms that move together in conveying the flow of light.

We see Welliver's principle at work in the springtime version of *Ledge and Brook*, for instance, as waves of chartreuse and salmon-pink brush marks slide diagonally into the picture from the upper left, turn into larger grass-green marks headed in the other direction, and then splash downward like green spray over gray and black rocks. The winter version has fewer gestural flourishes, but it illustrates another important aspect of

the artist's work: his simplified palette. You will find only six or eight colors here—warm white and pale blue-violet for the snow, medium-value neutrals that range from greenish gray to rusty gray for the rocks, and a luminous black for shadows and dark water. There are a few more colors in the spring scene—perhaps ten or twelve—but, again, these are preconceived colors used uniformly throughout the painting.

Thus it is Welliver's thought that in order to see colors in motion—as agents of light—we must identify them as *colors* rather than as *objects.* Accordingly, he has systematically eliminated the separate building blocks of local color most painters rely on. You won't find red roses, yellow forsythia, or blue-jeaned figures in a Welliver canvas. His colors *do* refer to grass, rocks, and snow, of course, but they are treated as generalized tones spotted throughout the picture rather than as the hues of static objects.

1. Joanna Frueh, "Hannah Wilke," in *Hannah Wilke: A Retrospective* (Columbia, Mo.: University of Missouri Press, 1989, exhibition catalogue), 15.

2. Howard Buchwald, conversation with the author, October 1988.

3. John Arthur, *Realists at Work* (New York: Watson-Guptill Publications, 1983), 150.

# 9 COLOR AND LIGHT

*I remember one time Paul Resika was here and I showed
him a brook that is a sea of boulders. He walked in and
said, 'A feast of planes.' . . . For me there were no planes
at all. Instead, I was seeing a great energy flow of light,
fragments of light whistling through the total volume we
were looking into. . . . That's what my paintings
are about.*

—Neil Welliver

Light is an important consideration for any figurative painter. Yet it often
plays a subordinate role, since artists usually start with the shapes and
colors of a particular subject, which are then modified by lighting effects.
A pink wall may be pushed back by shadows or a blue dress caught by the
sun, but we recognize the basic colors as those of the objects being
represented. This chapter, however, is about a different kind of artist—
the painter who sees light and atmosphere rather than physical description
as the real subject of the picture.

Historically, this attitude first emerged around 1500. Ancient frescoes,
medieval altarpieces, and early Renaissance tempera paintings were all
done with a cheery general illumination that made each face and costume
equally visible. But later artists like Leonardo, Giorgione, and Titian,
working with deeper oil colors, discovered the poetry of darkened rooms
and crepuscular landscapes. By the seventeenth century the portrayal of
light had become a dominant theme in baroque painting. Rembrandt was
known for his golden glow, Caravaggio for midnight shadows, Rubens
for a rosy ambience, and Georges de la Tour for his marvelous illusion of
candlelight.

## CHIAROSCURO

The method of the old masters was to darken the canvas with a brown or
red-earth ground and then pull gleaming lights out of the gloom with
touches of thick oil paint. The technique is called *chiaroscuro*, a term
meaning "light out of darkness." And while modern art has generally
moved toward brighter colors, the drama of shadowy spaces lit by shafts of
light continues to attract some of our most imaginative painters.

WOLF KAHN, detail, *Golden Shore*
(page 168)

In *Grand Studio*, for example, James McGarrell creates a dramatic indoor/outdoor space where neon blues and golds glitter among rust and purple shadows. As our eyes adjust to the gloom, we recognize the scene as a sculpture studio—the artist, back toward us, on the left; a female torso at stage center; a male torso on the right; and various other clay figures circling the room on turntables. In short, a mundane subject, but one glorified by light in much the same way that Rembrandt transformed his drab models into biblical kings.

With studios both here and in Italy, McGarrell brings Italianate imagery and style to work that has many levels of meaning. His basic strategy is to lift everyday events to the level of allegory. Thus in *Grand Studio* he uses the literal subject of a sculptor at work to express a much grander theme: the transcendence of artistic imagination. This is conveyed by a bright apparition of tropical plants and turbulent skies that frames the darkened figures in the studio. And although light is the main actor here, the romantic mood is heightened by old-world imagery—vaulted arches, checkered marble floor, sunbaked walls, orange trees, and country fruits and vegetables scattered everywhere. Always the modernist, however, McGarrell also puts a telephone in the lower right corner. Like cinema auteur Fellini, he likes the symbolism of old and new.

If chiaroscuro dominates the scene, McGarrell achieves it with a thoroughly modern technique. In place of old-master umbers and siennas—what the impressionists derided as "brown gravy"—he underpaints with vivid colors like alizarin, olive green, Indian yellow, ultramarine, and manganese blue. Using these pigments as a transparent palette, he paints the whole picture freely, almost as if it were a watercolor, on white canvas. This dark yet brilliant start is then followed by an overpainting in which the artist refines and accents forms, this time with opaque colors mixed with white.

Opaque/transparent contrasts of this kind are a key principle in chiaroscuro technique. They take advantage of the fact that thin colors absorb light, while thick colors reflect it back into our eyes. As a result, we see "into" transparencies with a sense of spatial depth, whereas opaque passages jump out at us. Playing with this duality, McGarrell has developed a virtuoso technique in which thinly painted darks are encrusted with a finely wrought embroidery of opaque lights. His treatment of the male torso on the right is a particularly striking example, its somber musculature highlighted by glittering, sequinlike touches of red, pink, green, lavender, and white.

*Grand Studio* is typical of McGarrell's work, and I can think of a few other contemporaries, such as Alfred Leslie, Sidney Goodman, Leonard Baskin, and Andrew Wyeth, whose images have a comparable moodiness.

JAMES McGARRELL, *Grand Studio*, 1987. Oil on canvas, 60 × 78″ (152.4 × 198.1 cm), courtesy Frumkin/Adams Gallery, New York.

Most of today's artists, however, see chiaroscuro as just one of many available color approaches to be used, or not used, depending on the subject. Joseph Raffael, for instance, is known for iridescent visions of tropical birds, fish, flowers, and landscapes. Yet in some recent portraits, he has turned to subdued colors and dramatic dark/light contrasts. Indeed, the lighting in *Joseph and Reuben*, a study of the artist and his son, is so extreme as to suggest a night scene with figures caught in the glare of automobile headlights. We are reminded of Caravaggio's theatrics, yet there is pop-art irony in the obvious snapshot source: the figures self-consciously posed, eyes turned toward us, as the camera shutter clicks.

The main thing to observe here is the color scheme—warm yellow heightened with white versus cool violet deepened with black. These are the colors of light and shadow rather than of the figures themselves. Except for the man's hand, there isn't a true skin color, nor can we make out the color of the background wall or the stripes in the father's sweater. In short, *Joseph and Reuben* is a perfect example of the way in which light rather than substance can become the dominant element in a painting.

JOSEPH RAFFAEL, *Joseph and Reuben,*
1984. Oil on canvas, 84¼ × 72¼″
(214.0 × 183.5 cm), courtesy
Nancy Hoffman Gallery, New York.

One doesn't often associate lights and shadows with abstract painting. Most abstractions are too solidly hard-edged or laden with paint to be thought of as in any way "atmospheric." Yet there is an exception to the rule, a technique called stain painting in which thin, wet-looking tones run together and dissolve like dyes. As you can see in two of Helen Frankenthaler's canvases, *Ashes and Embers* and *Casanova*, it is the nature of such liquid passages to suggest clouds, atmosphere, and light.

Stain painting emerged during the fifties in response to the abstract expressionists' goal of making pictures large enough to create spaces the viewer could "walk into." To achieve this scale, Jackson Pollock began to work on the floor with unstretched canvas, while Mark Rothko, Adolph Gottlieb, and others discovered the advantages of thinned-out paint in creating huge bursts of color. It was Frankenthaler, however, who developed a complete system for soaking, staining, and controlling the movement of liquid colors on raw, unprimed canvas. Her 1952 *Mountains and Sea* was a landmark that converted Morris Louis and Kenneth Noland to her method and launched it as an important style. In the sixties the movement was further encouraged by the introduction of acrylic paint, a quick-drying, water-based medium far more suitable for stain painting than oils.

For forty years Frankenthaler has mined the possibilities of staining, always coming up with new variations on an idiom critics refer to as "abstract landscapes." Locales aren't specific, but her titles often relate to nature, and the rhythm of sky, sea, and mountains is conveyed by her colors and shapes. Like Raffael, Frankenthaler is a brilliant colorist, yet in recent canvases she, too, has experimented with chiaroscuro. Of the paintings shown here, *Casanova* has a format one often sees in her work— a long, narrow shape suggesting tall trees and cliffs in a vertical composition, or low-lying landscape formations when used horizontally, as here. In *Casanova*, a yellow strip running the length of the painting establishes an obvious ground plane, while a black thundercloud overhead sends down tornadolike funnels that might be trees or columns.

*Ashes and Embers* has similar black/white contrasts, but in a squarer frame and with rectangular motifs suggestive of architecture rather than landscape. In both paintings, however, space is articulated by the airy movement of red or pink spots—"embers" in the one canvas, and perhaps fireflies or magic lanterns in the other. In any case, these are wonderfully rich and evocative canvases. And although Frankenthaler is widely heralded as the inventor of stain painting, we should remember that her more important contribution, as Barbara Rose suggests, is the use of this technique to create an "art of pure and vibrant light and color."[1]

Top: HELEN FRANKENTHALER, *Ashes and Embers*, 1988. Acrylic on canvas, 59½ × 90½″ (151.1 × 229.9 cm), courtesy André Emmerich Gallery, New York.

Bottom: HELEN FRANKENTHALER, *Casanova*, 1988. Acrylic on canvas, 71 × 141½″ (180.3 × 359.4 cm), courtesy André Emmerich Gallery, New York.

# IMPRESSIONISM

Art history can provide valuable insights, but one must be wary of the chronological fallacy—the notion that art movements become extinct as new ideas take center stage. The fact is that, like old generals, old art styles never die. They may retire to the wings, but they continue to have followers, and there is often a second life in a revisionist movement or revival. Take the case of impressionism. Monet led the movement from its inception in the 1870s until his death in 1926, and we must visualize this great man quietly painting water lilies at Giverny while the art world was rocked by such noisy avant-garde explosions as fauvism, cubism, and dada.

Since then, impressionism has enjoyed both widespread popularity as a style and continued ideological relevance. The 1960s op-art movement drew upon impressionist theories of spectrum color mixtures, new realists of the seventies revived the "direct painting" techniques of Boudin and Monet, and the current attention to Monet's "serialism" is yet another case in point. This last is the idea of sequential pictures in which the light on a given subject is recorded at systematic intervals. Thus the traditional picture of Monet as "only an eye, but what an eye" has been upgraded in the nineties to that of "conceptual artist."

If you walk through the galleries of any major museum, moving from the sober images of the old masters to the bright world of Monet, Pissarro, Renoir, and Morisot, you will see that impressionism marked the sudden end of a centuries-old tradition and the beginning of our modern era. Yet this was a quiet revolution, achieved in the most natural way, by painters who simply wanted to paint outdoors so that they could capture the light of the sun. Today it is hard to imagine this as a radical step, but the truth is that, while earlier artists had made sketches and watercolors outdoors, finished paintings had always been done in the studio.

In the sunshine, studio grays and browns all but disappeared. And where the chiaroscuro tradition had centered in darkness, the impressionists envisioned light in its purest form without the support of surrounding darks. We see this in the overall radiance of *Golden Shore*, a painting by the contemporary impressionist Wolf Kahn. Like Monet and Sisley, Kahn works with a palette of spectrum hues applied with hundreds of small strokes that create a visual dazzle, or optical vibration. The blues of sky and water are intermingled with pink, rust, and lime. The "golden" shore is flecked with green and orange. And although a wedge-shaped shadow hovers over the land, it is created by color contrasts rather than darkness.

One of the reasons impressionism has been so influential is the variety of its theoretical and practical possibilities. The spectrum palette, initially rather pale, could be deepened by later painters like van Gogh and Matisse. The technique of separate brush marks could be rendered either freely or with the precision of a Seurat. Above all, the famous light and atmosphere

of impressionism could be put to the service of either realism or visual poetry. Monet's own work ran the gamut of these polarities, moving from early scenes of everyday life, complete with factories and smokestacks, to idealized images of cathedrals and water lilies bathed in symphonies of light.

It is the possibility for personal interpretation that most interests Wolf Kahn. In his *Golden Shore*, light casts a luminous veil over the scene, the shapes are as abstract as Frankenthaler's, and the mood they evoke is of a scene remembered rather than observed. Here, I am reminded of another impressionist, Monet's contemporary, the composer Claude Debussy. In pieces like "Clouds" and "Sunken Cathedral," Debussy casts a similar spell with bright harmonies and clusters of separately struck notes that hang in the air like Kahn's web of blue and gold brush marks.

Rose Naftulin's work represents the more objective potential of impressionism. Her paintings also "cast a lovely light," but it is the descriptive light of a particular place and time of day. *Spreading Garden* captures the warmth of a summer afternoon with a palette of yellow and chartreuse lights and fuchsia and moss-green shadows. *Still Life and Snow* has a quite different, yet equally specific, color scheme that contrasts the cold blue-violet light of a winter landscape at dusk with the hot reds and pinks of an interior still life.

Rose Naftulin, *Spreading Garden*,
1985. Oil on canvas, 40 × 50″
(101.6 × 127.0 cm), courtesy
Gross-McCleaf Gallery,
Philadelphia.

Rose Naftulin, *Still Life and Snow*,
1987. Oil on canvas, 36 × 42″
(91.4 × 106.7 cm), courtesy Gross-
McCleaf Gallery, Philadelphia.

If the impressionists' color was a historic breakthrough, their technique of "broken" brushstrokes was equally revolutionary. In Monet's work the painter's "mark" began to take on a life of its own, quite apart from its representational function, and this sense of an image broken into particles soon became a hallmark of modernism. Cézanne shaped impressionist marks into small structural motifs, van Gogh twisted them into nervous lines, and pointillism and cubism carried the fragmentation process still further. A case can even be made for Jackson Pollock's paint spatters as the ultimate extension of this idea.

One should remember, however, that the average "impressionist," then as now, is interested primarily in a quick-sketch approach—an attempt to capture the moment as Monet did in the famous *Sunrise—An Impression*, which gave the movement its name. In this context, brush marks tend to be spontaneous rather than systematic. An early development that encouraged this approach was the shift from unitary subjects to panoramic views offering scattered images that could be matched by equally scattered paint strokes. Street scenes with crowds and sun-dappled trees were a popular 1870s subject, and today, Rose Naftulin takes a similar approach in paintings that involve a wealth of incident and many small shapes. In *Spreading Garden*, for instance, she translates blossoms, leaves, trees, and bits of architecture into gaily rendered color spots that float toward us in a shimmering wave of light.

Impressionism also inspired another kind of mark: the small, repetitive "point" or "touch" that artists of an analytical temperament often use as an organizing principle. You will find it in Wolf Kahn's *Golden Shore*, where, as in many of Monet's landscapes, large areas of sky and sea are animated by hundreds of separate strokes. The theory that variously colored dots would blend in the eye was promoted by the 1880s pointillists (see chapter 3). But oddly enough, it was the stippling of the *marks* rather than the interaction of *colors* that has had the more enduring influence. Although Seurat's divisionist color theories were too specialized to attract many followers, artists discovered that the staccato repetition of small brush marks is sufficient in itself to create a palpitating, luminous atmosphere. You can even do it with black and white.

Frank Galuszka's *Domain of the Lamp* is a striking illustration of this principle. As the title suggests, this is a painting about light and the way it can envelop the tangible world in its radiance. To convey this idea, the artist proposes a solidly detailed subject and then "loses" it in a flurry of overlaid brush marks. For the viewer, the effect is a little like coming upon half-buried objects on the beach—mysterious artifacts of someone's life all but lost under a shower of sand.

Here the stage is set by a tubular-shaded lamp that shines on a wrought-iron table littered with glass and porcelain bric-a-brac—a cat, rabbit,

several dogs, a crystal bowl of after-dinner mints (slightly to the right of the lamp), and a yellow ballerina (on the far right). In short, an elaborate image that is obliterated and then reconstituted by an even more elaborate technique. A hail of purple, brown, and hot-pink marks creates a broad nimbus of light spreading outward into shadows. In the original, one sees that these atmospheric marks, ironically, have a solid, collagelike presence. Actually, I have never seen anything quite like Galuszka's paint surface. It is layered with acrylic and Day-Glow vinyl blobs applied with tweezers, knives, and fingers. Still other marks are attached indirectly—"cultivated," as it were, on another surface, scraped off by a dentist's scalpel, and then pressed into wet paint on this canvas. Furthermore, flecks of raw canvas are visible throughout, and where these "sparkles" are insufficient, Galuszka takes the extraordinary step of gluing on tiny canvas cutouts.

As a study in night shadows, *Domain of the Lamp* might well have been included in our earlier discussion of chiaroscuro rather than here. Yet it is well to remember that Renoir, Manet, and Degas were as fascinated by gaslit cabarets and theaters as Monet was by the sun. Galuszka's painting is an extraordinary summation of the ultimate impressionist theme: the supremacy of light (and the world of the imagination) over substance (and mundane reality).

# STRATEGIES FOR CAPTURING LIGHT

In my experience there are two kinds of colorists: those who think of color in relation to objects and those who see it as a manifestation of light.

There is no right or wrong in these attitudes. But to the extent that they are encouraged by training, I think it fair to say that today's art students have far more opportunities to work with "local" than with "atmospheric" colors. Despite the discoveries of impressionism, local colors have been the painter's historic vocabulary, and this pattern has been reinforced by the literalism of recent trends like pop art and photorealism. Furthermore, we naturally associate colors with objects in everyday life. Children point to "yellow" bird and "brown" bear, adults to a "red" or "blue" car without really seeing the other colors reflected on its hood.

Thus to become an interpreter of light and atmosphere rather than material reality takes both an effort of will and considerable practice. Sketching outdoors, as the first impressionists did, can be helpful. But all-weather landscape painting isn't for everyone, and the limitations of a gloomy gaslit studio that drove Monet outdoors no longer apply. Hence, for today's painters the study of still-life and figure setups under controlled lighting conditions is the best road to take. So let's look at some of the strategies and techniques to be explored along the way.

CHARLES LE CLAIR, *Still Life with Landscape Elements*, 1985. Watercolor, 29 × 41½″ (73.7 × 105.4 cm), courtesy More Gallery, Philadelphia.

CHARLES LE CLAIR, *Pommery*, 1977.
Acrylic on canvas, 44 × 50″
(111.8 × 127.0 cm), courtesy
More Gallery, Philadelphia.

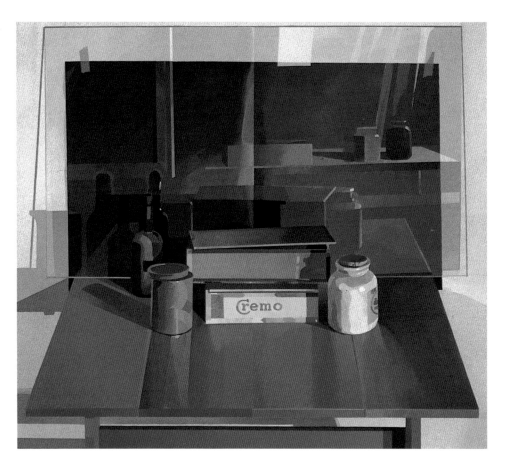

**Working with Reflective Surfaces.** Like air and water, light is transparent—something we can see through that must be represented by fluid rather than solidly massed colors. One of the best ways to achieve this is to work with reflective surfaces that bounce colors around. All sorts of things will do: china plates, silver bowls, plastics, aluminum foil, or, as in my *Still Life with Landscape Elements*, a shiny Formica tabletop. Here, the blue and white color chord is quite simple. But the beauty of the reflective setup is that it creates a movement of different blues throughout the space: light, dark, bright, dull, cerulean, ultramarine, indigo—you name it. It is precisely this changeability that is so essential in portraying light.

Most figurative painters use reflections in one way or another. The reflective object is typically either white or silver, but it can be any color, and I find semireflective surfaces, which echo objects without mirroring them exactly, particularly intriguing. The smoky background in my still life *Pommery*, for instance, is created by a piece of black construction paper taped to a white wall and then covered with a sheet of clear Plexiglas. The title, incidentally, refers to the jar of French mustard that is featured along with a cigar box and a pantyhose container. These objects—in primary red, yellow, and blue—are then reflected both forward onto a teakwood table and backward against the black construction paper.

This is a more elaborate arrangement than most people would want to attempt. But the more usual strategy of using one of the central objects

rather than the background as the reflective surface is quite simple. In his
little study *Cherries*, Wayne Thiebaud demonstrates the principle by
focusing on a china bowl that has very little character in itself, but whose
surface is a sensitive mirror of the environment. In bright sunlight the
bowl is dissolved by greenish and sky-blue reflections, and it seems less
substantial than its vivid purple shadow. Very much the impressionist here,
Thiebaud renders the cherries with a similar sensitivity to light, showing
them against the sun and shaping each globe with blue, rust, or purple
shadows rather than an obvious red. Even the smallest touches are radiant.
Highlights sparkle with lavender and yellow instead of pure white, and the
cherry stems, which most painters would see as brown, are touched with
luminous color.

**Exploring the White-on-White Subject.** Since the days of Malevich, the
white-on-white abstraction has been seen as the acme of simplicity and
refinement. Figurative painters from Whistler to Thiebaud have also been
attracted to the white subject, both for these qualities and for the unique
opportunities it provides for observing light. In contrast to the usual
situation in which one paints the light on something that is already
pigmented, the colors that meet the eye with a white subject are the colors
of light itself! Thus the study of eggs on a white tablecloth, or of a lady in
white against a white wall, is an almost obligatory exercise for any painter
interested in optical effects.

Wayne Thiebaud's *Twin Cakes* is an amusing example of the genre, with echoes of both Malevich's geometry and Whistler's realistic textures. Unlike the artist's studies of cherries and pears, *Twin Cakes* is a fully considered statement. As such, it illustrates a typical Thiebaud theme—a banal pop-art image as the subject of a serious, essentially abstract composition. Here, two lushly frosted, strawberry-topped bakeshop cakes are presented as monumental sculptural volumes. And while the frosting looks good enough to eat, there is an ironic formal detachment in the mechanical precision of these cylindrical forms.

To capture light on white objects, a painter like Thiebaud works not with dead white but with a palette of warm and cool whites lightly tinted with complementary hues—pinkish- versus greenish-white, amber- versus mauve-white, and so on. Sometimes the mixtures are so subtle as to seem colorless; sometimes they are vividly chromatic. In Thiebaud's *Cherries*, for instance, the "white" table is a pale yellow-orange in the sunlight and a bright blue in the shade. And while we know his *Twin Cakes* are white in real life, we enjoy the painting itself as a colorful study in yellow and violet. Needless to say, dark/light contrasts are as important as color in painting a white subject, and Thiebaud models his cakes with careful attention to values, shading from *light* yellow on the outside of each cylinder to *dark* violet in the center and deep purple in the shadows.

WAYNE THIEBAUD, *Twin Cakes*, 1980. Pastel, 16 × 23″ (40.6 × 58.4 cm), courtesy Allan Stone Gallery, New York.

Scott Fraser's *Notable Landings* is a quite different treatment of the white theme—a trompe l'oeil painting whose gritty realism prohibits any chromatic flourishes of the kind Thiebaud has such fun with. Nevertheless, the search for luminous color lies at the heart of the white-on-white adventure, and despite the subtlety of Fraser's tonal effects, I can't think of a more dedicated colorist than this young Colorado artist.

What is so extraordinary about *Notable Landings* is the richness of observation, technique, and esthetic awareness that went into it. Fraser sees his "assemblage" of familiar objects as a kind of family portrait—paper airplanes made from his wife's sheet music, the collapsible ruler his grandfather let him play with as a child, a feather from the family's cockatoo, scissors from his wife's primary-school class. He has arranged these things lovingly on a sheet of worn and wrinkled paper in a gamelike composition that is at once playful in tone yet metaphysical in its suggestion of time, measurement, and movement.

Commenting on his goals, Fraser says, "I paint my still lifes from life so I can see deep into them. This piece was set up for months while I observed the changing light on it. Sometimes in the beginning it is difficult to see the depth of color in a piece, but it becomes stronger to my eye in the different stages of construction."[2]

Ultimately, the viewer of the finished painting has much the same experience. When I first saw *Notable Landings* in the window of a Manhattan gallery, it seemed almost monochrome. But on close inspection I began to make out distinct hues, as I think you will too, despite the

SCOTT FRASER, *Notable Landings*, 1989. Oil on panel, 25½ × 43″ (64.8 × 109.2 cm), courtesy Grand Central Art Galleries, New York.

greatly reduced scale of our illustration. On the upper right, for instance, the airplane's lower edges are haloed with orange; also on the right, the curled-up edge of the large piece of paper is yellow-white; the table cover behind it has a distinct mauve cast; and on the opposite side of the canvas, the darkest of the airplanes has a glowing orange light at its center. As Fraser says, "You can actually be pretty daring packing color into white just as long as you complement it with another equally strong color."

**Modeling with Spectrum Colors.** I generally advise students to think of color in terms of basic shapes rather than rendering techniques. This is important both for the positive value of a structural approach and because the study of shading and modeling tends to lead away from color toward issues of dark and light. The old masters even treated form and color as separate functions, first developing the shading of anatomy and costumes in a monochrome underpainting, and later glazing over these areas with blocks of local color—pink for skin, red for a vest, green for sleeves, and so on. And to some extent this tradition is maintained today by the separation of drawing and painting courses in our art schools.

However, attention must also be paid to the interaction of form and color, particularly in contemporary work where forms are modeled with spectrum hues instead of neutrals. Wayne Thiebaud, for example, has done numerous studies of small still-life objects under dramatic lighting conditions that combine traditional chiaroscuro with modernist optical color. In *Pears* he sets his fruit on a windowsill between a blazing sun and a pitch-dark interior, yet even the most extreme darks are loaded with color. His *Untitled* pastel of a pear and a strawberry is spotlighted from above with cast shadows that are shaded in a glissando of rainbow colors—blue, green, and lime with an orange line around the edges. If you look carefully at the skin of the pear, you will see that he models it with touches of at least twelve different hues—lemon, warm yellow, orange, lime, ochre, green, violet, indigo—all this in a space less than three inches high!

Pastel is an ideal vehicle for modeling with color because it permits the identity of separate chalks to be maintained even as colors flow into one another. Degas is the historic master of this hatching technique in a medium that, until recently, was limited to small studies. Its possibilities have been greatly expanded, however, by the introduction of modern oversize fine-art papers and the innovative medium of oil pastels, which combines the linear character of pastel with the richness and permanence of oils. An oil-pastel mark looks very much like a dry pastel stroke, but the pigment is oily rather than powdery and doesn't dust off or require fixative.

Oil pastel has been a godsend for artists like Susan Moore who do large-scale figurative work. Moore's paintings focus on the human figure in tightly cropped close-up views like that in *With No Visible Sign*. These are

WAYNE THIEBAUD, *Pears,* 1984.
Pastel, courtesy Allan Stone Gallery,
New York.

WAYNE THIEBAUD, *Untitled* (pear and
strawberry), 1984. Pastel and
pencil, 4½ × 5⅞″ (11.4 × 14.9
cm), courtesy Allan Stone Gallery,
New York.

Susan Moore, *With No Visible Sign,*
1988. Oil pastel on paper, 74 × 67″
(188.0 × 170.2 cm), courtesy
More Gallery, Philadelphia.

monumental rather than realistic images in which features and clothing have a weight and frontal solemnity reminiscent of archaic Greek sculpture. At the same time, they are psychological portraits, and the overall mood is one of contemporary angst. Moore explains the lady in *With No Visible Sign*, for instance, as an outwardly passive person— someone whose pose and features give "no visible sign" of her thoughts. Yet the artist senses an inner excitement in her subject, which she conveys with an "eruption" of aggressive colors on the right side of the head and shoulders.

In contrast to Thiebaud's little still-life studies, Moore's giant portraits are built up slowly over a period of weeks or months. Yet these artists rely on the same basic discipline—the modeling of forms with prismatic colors. In *With No Visible Sign*, Moore achieves sculptural roundness by caressing each feature with rhythmic strokes that trace the flow of light. Yellow tones on the right cheek, for example, blend into blue, blue into salmon pink, and then at the nose, into an orange-ochre shadow. The hatching of separate marks is especially noticeable on the fold at the base of the neck, where an electric blue has been layered with strokes of pale blue, ivory, and rose-violet.

**Experimenting with Cast Shadows.** Cast shadows often play a secondary role in painting, since they are an indirect rather than a direct reference to the subject. Yet in special situations, and for artists of a certain temperament, they can be wonderfully exciting. Dali's surrealist visions feature lengthening shadows. De Chirico conveys a Proustian sense of times past with the shadows of towers and colonnades. Edward Hopper evokes the clarity of Cape Cod light with clean-cut shadows. And on the current scene, the names of three artists who do interesting work in this vein come immediately to mind.

The first, Paul Wonner, is a San Francisco realist who captured attention a few years ago with a novel still-life format. In the manner of the seventeenth-century Dutch "little masters," he scatters pots, cans, and vases of flowers around the floor, along with assorted household furnishings and pets. His early setups were shown in an aerial view from above, against a bright light, with the dark shadows of many small objects snaking downward toward the viewer. *Tulips* represents a more recent experiment with side lighting in which random objects are arranged against a dark background with deep-blue shadows cast horizontally across the floor. In any case, it is the quirkily shaped shadows rather than the objects themselves that hold our interest in Wonner's work. Here, the complicated shadow pattern on the lower right—with its echoes of chair slats, tangled leaves, and twittering songbirds—is especially intriguing.

PAUL WONNER, *Tulips*, 1988. Acrylic on canvas, 48 × 48″ (121.9 × 121.9 cm), courtesy John Berggruen Gallery, San Francisco.

The second of these artists, David Ligare, is a Los Angeles painter who works with an exquisitely detailed technique that is quite different from Wonner's broad, Manet-like style. In a recent exhibit he showed a dozen or so small still lifes of different subjects in an identical setting—an elegant gray shadow box, with the sun on the right, the featured object in the center, its cast shadow on the left, and a deep blue sea and sky in the background. Where Wonner's helter-skelter setups appear "realistically" casual, Ligare's selective arrangements are charged with emotion and symbolism. The Greco-Roman head in *Still Life with Bust and Roses* is an obvious classical reference; another of his paintings depicts a Winged

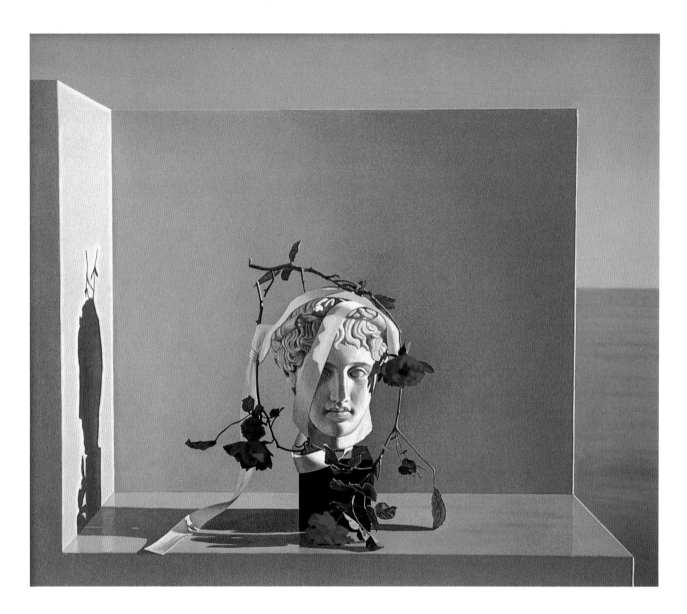

DAVID LIGARE, *Still Life with Bust and Roses,* 1989. Oil on canvas, 20 × 24″ (50.8 × 61.0 cm), collection of Mr. and Mrs. Richard L. Boger, Atlanta; courtesy Robert Schoelkopf Gallery, New York.

Victory effigy made of sticks and a dead bird's wing; and still other images are based on the Christian symbolism of bread and wine or loaves and fishes. In each case Ligare's subject is dramatized by a distinctively contoured, Dali-like shadow that runs like a sheer silk stocking along the floor and up the left wall.

Although cast shadows usually describe objects, they may also be used to create broad architectural patterns of light and shade. The third of our artists, Flagg Waltermire, explores this idea in paintings of empty rooms that are reminiscent of Edward Hopper's deserted storefronts and lonely bedrooms. The inspiration for the series was an on-site painting in an abandoned hotel he and his wife discovered while vacationing in New Hampshire. The strategy of combining a bare and shadowy foreground with a lively landscape background immediately suggested other exciting compositional possibilities. It also appealed to Waltermire as an approach in which realistic material from informal sketching trips could be reworked into more abstractly structured studio paintings.

The four canvases reproduced below and on the next two pages indicate the range of Waltermire's variations on this theme. As you see, the shadows are soft and tonal rather than vivid, since there is less opportunity for chromaticism in painting a room space like this than in dealing with the shadows of specific objects. Yet Waltermire makes the most of shadow shapes, and the way in which he dramatizes each canvas with a distinctive leitmotif is fascinating. In *Interior IV*, for instance, the great curving line of an upward-thrusting mountaintop is carried down into the empty room by a shaft of light on the left wall. *Cape Cod Interior*, on the other hand, is composed of many small horizontal and vertical shapes as the forms of sand and beach-grass clumps in the distance are paralleled by a mazelike shadow pattern in the foreground. *Interior I* introduces yet another motif— this time, triangular shards of light around an open door that take on a ghostly stage presence in Waltermire's deserted room. Here, too, there are matching shapes in the landscape—a wedge of blue water on the left, triangular patches of sand on the right.

In some ways *Western Painting* is the most interesting of the series, as odd bits of furniture—a battered trunk, a black chair, a white table, and a looking glass—add human interest and a touch of fantasy. Here, the shapes

FLAGG WALTERMIRE, *Interior IV*, 1987. Oil on canvas, 36 × 48″ (91.4 × 121.9 cm), courtesy the artist.

FLAGG WALTERMIRE, *Cape Cod Interior,* 1987. Oil on canvas, 36 × 48″ (91.4 × 121.9 cm), collection of the artist.

FLAGG WALTERMIRE, *Interior I,* 1987. Oil on canvas, 24 × 30″ (61.0 × 76.2 cm), courtesy the artist.

FLAGG WALTERMIRE, *Western Painting*, 1987. Oil on canvas, 36 × 48″ (91.4 × 121.9 cm), collection of the artist.

of chair back and trunk are echoed in the rock formations immediately above them, and the overall arrangement of interior objects comes to a peak in much the same way as the mountain outside. Color is also especially well handled, as Waltermire reduces this image to an economical pale-blue and rusty-orange chord.

Finally, let me say a word about Waltermire's working method. Theoretically, his device of a window wall will produce, like a kaleidoscope, an endless array of shadow patterns. I say "theoretically," however, because in real life you can't control the sun or clouds or rain, and there is nothing more maddening than trying to chart the angles of an architectural cast shadow. Draftsmen can do it with T squares and mathematical ratios. But if you work from direct observation, the shadow will have either changed its angle or disappeared altogether before you have time to reach for a brush. Waltermire says he struggled with this problem in his first interiors. Eventually, though, he "got smart" and turned to cardboard models that can be photographed at various experimental angles. After leafing through a batch of test photographs, he then projects the most promising one onto the canvas as a guide for his compositional drawing.

1. Barbara Rose, *American Painting: The Twentieth Century*, rev. ed. (New York: Rizzoli International Publications, 1986), 110.
2. Scott Fraser, letter to the author, October 19, 1989.
3. *Ibid.*

# 10 EXPRESSIONISM

*I was tired and ill . . . the sun was setting—the clouds
were colored red—like blood—I felt as though a
scream went through nature . . . I painted this picture—
painted the clouds like real blood. The colors
were screaming.*

—Edvard Munch

People often think of impressionism and expressionism as complementary
movements, the one focusing on the outer world, the other on inner
emotion. Although there's some truth in this view, the terms aren't as
parallel as their spelling would suggest. You see, impressionism is a Johnny-
come-lately movement of the 1870s, an offshoot of realism, defined largely
by style and technique. Expressionism, on the other hand, has a broader
connotation. While it can refer to a particular early twentieth-century
movement, the term is also used more generally to describe a permanent
tendency or attitude that runs throughout art history.

This is a view of art in which traditional ideas of naturalism are
abandoned in favor of urgently expressed personal emotion. Hence, though
we find certain recurring stylistic qualities, expressionist art is defined
primarily by its emotional thrust. Mood and atmosphere take precedence
over other elements in an emotional spectrum that includes horror,
passion, melancholy, and mysticism as well as a lighter vein of fantasy
and whimsy.

## HISTORY

The expressionist impulse can be traced to the Greek cult of Dionysus,
and it is evident in both medieval art and the work of such northern
Renaissance painters as Dürer, Bosch, and Grünewald. Historically, the
expressionist has often been a lonely figure like the American visionary
Albert Pinkham Ryder, or the Dutch painter Rembrandt, who slid from
fame to obscurity when patrons saw his work as too moodily introspective.
With the advent of modern art, however, private passions have become a
mainstay of public art. Van Gogh and Gauguin set the stage for a full-scale
expressionist movement that flourished in northern Europe after the turn of

MALCOLM MORLEY, detail, *Michael's
Cathedral* (page 202)

the century. Munch, Ensor, Nolde, and Kokoschka were a few of the leaders, and a bit later, during the Great Depression, the movement was embraced by the Mexican muralists Orozco and Siqueiros and socially conscious Americans like Ben Shahn and Jack Levine.

Since then, there have been two important revivals. Under the banner of abstract expressionism, Pollock, Rothko, Motherwell, and other New York School painters of the 1950s advocated an emotional art based

FRANK HYDER, *The Newborn*, 1987. Oil on carved wood panel, 72 × 48″ (182.9 × 121.9 cm), courtesy More Gallery, Philadelphia.

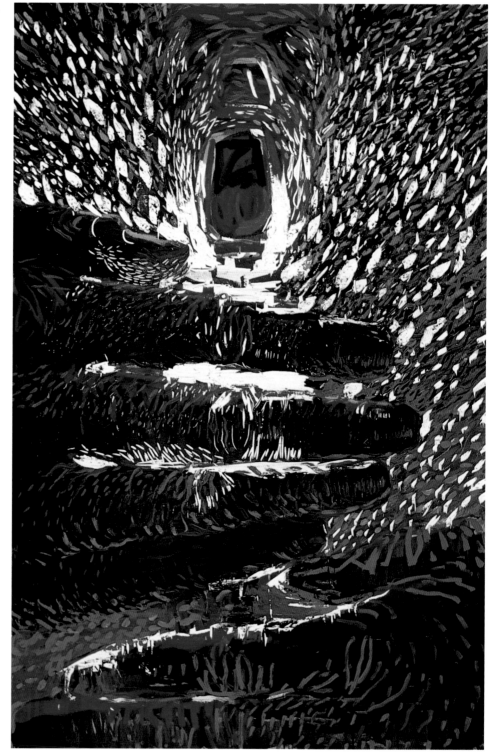

on nonobjective rather than figurative devices (see chapter 8). Again, during the 1980s we saw yet another resurgence of expressionism—this time a worldwide interest that appeared in various forms under the catchall label of neo-expressionism. Francesco Clemente in Italy, Anselm Kiefer in Germany, and the Americans Jonathan Borofsky and Julian Schnabel are a few of the names associated with this ongoing movement.

# FIGURATIVE DISTORTION

In 1893 the Norwegian artist Edvard Munch painted *The Scream*, a picture that has been described as "the most famous image of neurosis in Western art."[1] And over the years, the scream, whether as sound or image, has been a perennial expressionist device—an effect immortalized by Laurence Olivier as the blinded Oedipus, by the film director Alfred Hitchcock, and by painters from Siqueiros to Francis Bacon.

Munch's protagonist is a man standing on a bridge over a fjord, isolated from nature, deserted by friends, and crying to the heavens. In Frank Hyder's contemporary version, a newborn child is shown screaming with pain or excitement, but in the protective hands of a more welcoming world. It is a powerful image that, with its bloody splashes of red, can be seen either literally as a graphic description of childbirth or symbolically as a metaphor for the pain of artistic creation.

Hyder is a Philadelphia artist whose work springs from the tradition of Munch, Soutine, and Nolde. This is both the original and the most natural form of expressionism, since it depends largely on an exaggeration of normal figurative images. Thus in *Night Spirit* Hyder creates a sinister mood by lighting the scene from underneath, as if by theater footlights, and by exaggerating spatial distances. Giant faces are held aloft in the foreground like masks in the fingers of a cosmic puppeteer, while progressively smaller figures of a naked woman and a man reaching for the stars are shown in the middle and extreme distance. In *The Newborn* there is an even greater contrast between a close-up of enormous hands and the long shot of a screaming head hurtling backward like a creature from outer space.

Despite traditional roots, Hyder's brand of expressionism is boldly contemporary in feeling—oversize rather than intimate in scale and crafted with unconventional materials. Like many current neo-expressionists, he prefers dimensional techniques to traditional oil on canvas. Where Schnabel paints on broken dishes and Kiefer on a terrain of sand, straw, and lead, Hyder works on carved wooden panels that are sometimes combined into folding triptychs or screens. The artist's hand-carved marks, dug through a dark painted surface into light wood, produce dimensional gouges that catch the light. In *The Newborn* the effect suggests pointillist

FRANK HYDER, *Night Spirit*, 1987.
Oil on carved wood panel,
72 × 96″ (182.9 × 243.8 cm),
courtesy More Gallery,
Philadelphia.

FRANK HYDER, *The Promise*, 1987.
Oil on carved wood panel,
48 × 48″ (121.9 × 121.9 cm),
courtesy More Gallery,
Philadelphia.

dots; in *Night Spirit*, the whirling constellations in a van Gogh sky. The dimensionality of Hyder's surfaces is further reinforced by dozens of studlike projections—scraps of gouged-out wood that have been reattached with nails and glue and then highlighted in vibrant colors.

Another contemporary aspect of Hyder's work is its graphic quality. In contrast to the exuberant painterly style of the pioneer expressionists, much neo-expressionism has an underlying sobriety. Anselm Kiefer's lead-encrusted canvases, for instance, are developed from drawings, prints, and altered black-and-white photographs, and in an exhibit of his work, images flow from one medium to another. In a similar spirit, Hyder tackles a six-by-eight-foot plywood panel the way he would a six-by-eight-inch woodcut. Though the engraving tools are larger, the basic procedure is the same— a black India ink drawing with the background cut away. Later Hyder adds layers of overpainting in oils or acrylics; but even so, the feeling remains that these are giant woodcuts rather than easel paintings in the traditional sense.

## SYMBOLIC COLOR

When the curtain rises on a kitchen with dishes in the sink, we expect a realistic theater performance. When actors perform in pantomime without benefit of props, we assume the author has abstract thoughts in mind. And when the scenery consists of a pile of sand and one purple tree, it is fair warning of the play's expressionistic, *Waiting for Godot*–like style.

In painting there are similar clues to an artist's intention. As we have seen, figural distortion is one indication of an expressionistic approach; color symbolism is another. Hyder uses both devices, and although his colors follow the logic of warm and cool light, they are chosen primarily for emotional impact. Working as a printmaker would, with a limited scheme of black and two or three set colors, he builds each composition around a dominant, mood-enhancing hue. In *The Newborn* the key color is blood red; in *Night Spirit*, moonlight yellow; and in a painting called *The Promise*, the violet of an evening sky. Hyder pairs each of these key colors with a complement or near complement that will enhance its brilliance. Accordingly, his red baby appears in an aura of blue stipples, the golden tones of *Night Spirit* are countered by a lavender shadow on the face at the left, and the magenta sky in *The Promise* is lit by a lemon-yellow moon.

Sidney Goodman brings a similar mix of graphic imagery and heightened color to work that is notable for its somber, apocalyptic mood. A well-known realist whose paintings can be almost clinically factual at times, Goodman has become increasingly fascinated with symbolism and metaphor. In a major cycle of five paintings, for example, he depicts the elements of fire, earth, air, and water supervised by the hovering figure of a

female archangel. He also likes to work with more enigmatic personal symbols—Goya-like mutilated or headless figures, images of separate body parts, as in *A Man's Arm* or *Head with Red*, and scenes of urban violence, as in *Burning Vehicles*.

A master of dramatic chiaroscuro, Goodman is most at home with the black tones of a charcoal drawing that can be smudged, erased, and moved across the paper like storm clouds in the sky. While many of the drawings stand alone, others are also source material for his paintings. Thus, like Hyder, Goodman works with a graphic artist's instinct for color separation—a dark black or brown to establish the basic image and a few bright hues to give it local color and atmosphere.

Sometimes Goodman heightens the symbolism still further by focusing on just one emotionally suggestive color and using it in an arbitrary design. At first glance, for example, the intense red in *A Man's Arm* might be seen as simply the color of a background drape. Yet in association with the image of a Christ-like arm, it becomes a metaphor for bloody death and its rectangular shape a reference to the Cross. In *Burning Vehicles* a blazing jeep on the left is shown in collision with a smoldering truck at stage center, while vaguely shaped bodies burn in the foreground. This time the key color is a fiery yellow, and although there is again a literal basis for the choice, Goodman heightens the symbolism by focusing on one explosive yellow shape and drawing the rest of the picture in black and white.

SIDNEY GOODMAN, *Head with Red*, 1988. Charcoal and pastel, 65¾ × 60″ (167.0 × 152.4 cm).

SIDNEY GOODMAN, *Burning Vehicles*, 1979. Pastel, 35 × 57″ (88.9 × 144.8 cm), collection of Mr. Malcolm Holtzman, New York.

Finally, in *Head with Red* even the title conveys the idea of two separate elements playing against each other—a representational image versus a symbolic color. The drawing is a marvelously imposing self-portrait in the form of a classical bust that might be of an emperor or a famous composer. Shown in dramatic perspective from below, the head stands on an ancient column against the sky. The drama of this black-and-white visage is then heightened by a single, arbitrary band of rust-colored chalk drawn like a blindfold across the brow. We can't be sure of its meaning, but the color is an earth red rather than a spectrum red, with the dust of antiquity in it— in short, a color that links this contemporary portrait with the great traditions of the past.

## NARRATIVE IMAGERY

Goodman and Hyder represent the traditional face of expressionism, an impulse commonly associated with powerful images and emotions of Wagnerian intensity. Rouault's biblical kings, Kokoschka's lovers in the storm, even Francis Bacon's latter-day images of corruption and addiction are all in this grand manner.

But there is another, quite different vein of expressionism devoted to livelier, less heroic emotions. Paul Klee's quirky watercolors were the model for a kind of small-scale personal statement that has flourished ever since. It is an expressionist idiom that thrives on storytelling, social commentary, and moods ranging from humor to bitterness. And stylistically, it draws strength from "primitive" directness—the language of child art, paper cutouts, and graffiti—rather than conventional rendering.

After World War I, the German expressionists turned to caustic political imagery that Hitler ultimately banned as "degenerate art." During the depression years in the United States, Roosevelt's New Deal created a more favorable climate for social comment. While the WPA supported regionalist murals in praise of motherhood and apple pie, it also encouraged Ben Shahn's *Passion of Sacco and Vanzetti*, William Gropper's caricatures of venial bankers, and Philip Evergood's scenes of slum and factory life. From today's perspective, it is interesting to note that a body of art devoted to black issues also emerged at this time. Robert Gwathmey, a concerned white artist, depicted the hardships of black sharecroppers in the South. Jacob Lawrence rose from a Harlem ghetto to become a spokesman for his people. And Romare Bearden (1911–88) took the first steps in a career that was to make him perhaps the most celebrated contemporary painter of the black experience.

His was a career of twists and turns, from social realism to abstraction to photomontage. Yet for his most deeply felt work, Bearden drew again and again upon memories of childhood in Mecklenburg County, North

Carolina. In one of his last works, *Sunrise for China Lamp*, most of the characters in this continuing series are present: black women, the center of family life; a guardian animal (often a cat or sacrificial cock, but here a barking dog); bare-bones props like the broom and stove; and for contrast with this austerity, a single item of hard-won extravagance—the china lamp.

This is narrative painting, of course, with the cutout shapes of figures and objects assembled like those in a cubist collage. For all the busyness of his magenta, vermilion, and purple shapes, however, Bearden is a master of large effects. Here, he contrasts pleasures of the night, symbolized by the china lamp, with the rigors of the day ahead, as black women rise at dawn to dress for the cotton fields. This theme is developed both by narrative incident and by a color scheme that pits lamplight against the sunrise. A zone of night light is established on the right by neutral tones, while on the left, bright sunshine throws the room into intense red-violet shadow.

Within this overall pattern Bearden explores some interesting devices. We note, for example, that whereas the lamp shines on a solid tan wall, sunlight is represented by prismatically fractured hues. The lighted window

is split into separate blocks of yellow and orange; the room's enveloping shadows, into different shades of magenta and purplish blue. Bearden's most curious color decision, however, is the central, kelly-green square. Although it sets up a lively vibration against the complementary red of the woman's shirt, this raw, thinly washed green hue clearly sticks out in a way that would seem awkward in more conventional work. But we must remember that effective color isn't always the most harmonious color, and Bearden is anything but a conventional artist. His subject is the harsh life of the underprivileged, and he has found colors that, for all their brilliance, have an appropriate harshness and vitality. Beyond this, it strikes me that his green square is also designed, like a theater spotlight, to focus attention on the story—the human drama of this naked woman stepping into her skirt and pulling on her shirt in preparation for the hard day ahead.

The pictures of another black artist, Paul Keene, are more disquieting because they deal with urban corruption rather than the hardships of agrarian life. Keene, too, looks back on his childhood, but he remembers growing up in an atmosphere of quiet beauty in North Philadelphia, an area he now sees as a Babylon of drugs, decay, and abject poverty. In paintings like *The Garden of Earthly Delights* he conveys the contrast between old and new, the distance between idealistic hopes and brutal

PAUL KEENE, *The Garden of Earthly Delights*, 1987. Acrylic on paper, 41½ × 29¾″ (105.4 × 75.6 cm), collection of the artist.

realities, with scenes of faceless bodies writhing in the streets while portraits of cultural heroes shine as icons in the sky.

As his title suggests, Keene pays homage here to Hieronymus Bosch's *Garden of Earthly Delights*, a sixteenth-century triptych famous for exquisitely detailed visions of sensual pleasure, obscenity, and religious heresy. Although Keene's modern version is more generalized, there is a similar emphasis on pale, intertwined bodies and the mingling of sinners and haloed saints. Keene, however, circles his heroes with bright rings of red, orange, and blue that also have the effect of spotlights or movie close-ups picking out certain faces in a crowd. Two figures further dramatize the human condition—an anonymous abstract personage on the lower left and a sad-faced boy who appears dimly, like a documentary image of poverty or hunger, in the upper right corner.

Although it is also composed like a collage, Keene's painting is more abstract than Bearden's. Despite its cubist patterning, *Sunrise for China Lamp* is about real people in an individualized setting. The space in *The Garden of Earthly Delights*, on the other hand, is cut through by an abstract, Cross-like shape that divides struggling humanity into zones of earth-red flesh and wan, bluish bodies. Presumably, the reddish tone represents licentiousness; the bluish-gray color, the pallor of the starving and dispossessed. The great virtue of this kind of generalized symbolism, in any case, is that it stirs the imagination. We can't be sure of details here, but the broad theme of embattled angels and demons is abundantly clear and deeply moving.

Carmen Cicero represents a different milieu. I think of him as a Woody Allen figure in the sense that he is such a dyed-in-the-wool New Yorker, such a committed jazz performer, and so adept at walking the thin line in his art between comedy and introspective drama. On one level his watercolor *Leisure* is a very funny picture, yet on another, it is a haunting image of Freudian desires and fears, as a sexy blonde dreams of faraway places while a shadowy male figure steals toward her in the night. Is our heroine a lady or a bimbo? Is this *her* dream of escape or *his* fantasy of seduction? Is the childlike drawing meant to suggest barroom melodrama or primitive desires? As in a Woody Allen movie, the answer to such questions about Cicero's work is, typically, "All of the above, and more!"

In contemporary art, figurative composition in a collage style (like Cicero's) or in actual collage technique (like Bearden's) is a basic strategy for dealing with subject matter in a nonliteral way. Both artists use bright, flat colors, primitive markings, and simplified cutout shapes. To these common devices, Cicero adds a few of his own. By setting the scene on a shadow-box stage he plays tricks with space, as his train zooms behind the proscenium and the lady's legs stick out in front of it. In another interesting effect, he tracks the movements of his male figure with a sequence of

cinematic dissolves. The ghostly intruder appears first in close-up on the right as a rust-colored profile with hooked nose, Dick Tracy jut jaw, and gangster hat. He then moves forward as a threatening figure in black, fades to violet near the heroine, and exits on the far left, once again in a close-up view.

## SPATIAL FANTASY

As an art of personal emotion, expressionism is most commonly associated with figural themes. But landscape, with its suggestion of cosmic forces and infinite space, is another important subject. Artists from van Gogh to Kokoschka have seen the heavens as a mirror of the soul, the darkness of night as a reflection of inner emotion. Dali's surrealist landscapes have this quality, as do Rothko's abstract spaces and Chagall's Russian skies afloat with cows, ladies, and upside-down villagers.

Look again at Carmen Cicero's *Leisure* and you will find that, for all the human drama, it is also a picture about the mysteriousness of the night. The dominant color is an inky blue, and Cicero's reclining lady gazes yearningly at a distant moon. In another Cicero painting, *Flower with Red*

CARMEN CICERO, *Leisure*, 1987. Watercolor, 22½ × 30" (57.2 × 76.2 cm), courtesy June Kelly Gallery, New York.

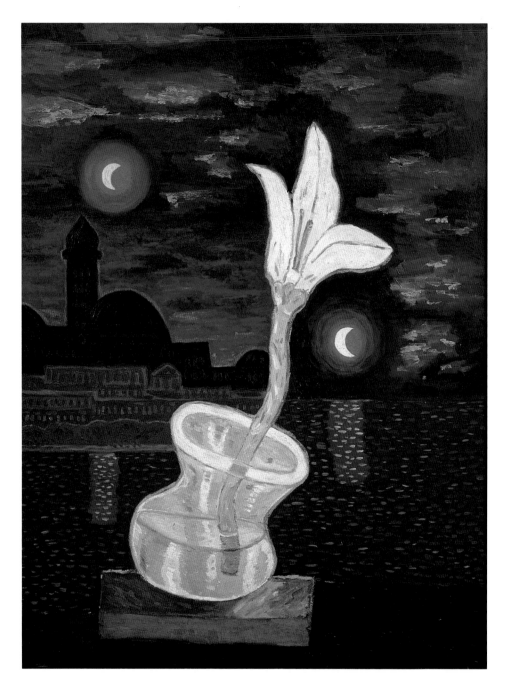

*Sunset*, we see the scene through the artist's eyes as he stands gazing at the night sky beyond his studio window. A single yellow flower writhes on the sill in a gesture of loneliness, and the mystical nature of the experience is announced by the presence of two moons and a fiery sunset.

In painting, there are two ways to treat color symbolically. The first is to use reasonable colors in unreasonable situations, as Cicero does with his normal dark blue sky lit by unlikely moons. The second is to take the opposite tack of painting ordinary scenes in extraordinary hues. Socrates Perakis's "skyscape" *Moon Apples* combines these principles, I suppose, since it is also about strange planets. However, the overall tone is representational, and the artist's basic strategy is to give symbolic overtones

to a realistically rendered sky by painting it an unexpected fiery red. Thus at first glance the image would seem to be a simple sunset. But as we look closer, the radiant hues—oranges, reds, and pinks shot with threads of blue and green—take on the iridescence of a fantasy world.

In recent years man's concept of space has expanded to visions of "star wars" and time travel. This sensibility is reflected not only in figurative work like Perakis's but also in abstract art, where an earlier obsession with flatness has given way to concerns about deep space. Today's abstract painters are also interested in referential imagery as never before. Ellen Wiener's *Untitled I*, for example, has the whirling movement of an early Kandinsky, yet where Kandinsky's great achievement was the elimination of subject matter, Wiener's work is fascinatingly allusive. Despite its abstract patterning her tiny painting conjures up a gigantic world of encrusted planets, moon glow, and starlit voids.

Technically, this talented New Yorker's collage paintings are remarkable for their small-scale refinement and the physicality of their surfaces. The artist works on a Renaissance gesso ground with thin oil or watercolor washes and attachments of wood, paper, and metal foil. In *Untitled I* you will find a wedge shape cut from a wooden cigar wrapper (on the upper left next to a white crescent); in *Untitled II*, a paper cutout from an etching that looks like fossils or prehistoric footprints. Space in the latter painting

is more compressed than in the first, but here, too, the images suggest a lunar landscape—in the foreground, a web of arclike forms sprouting branches; in the distance, a gray cone-shaped object gliding like a spaceship between golden moons.

Wiener's color is as subtle as her textures. Her muted palette harmonizes with the earthy and metallic tones of her collage materials, and she creates fascinating spatial contrasts by setting bits of raised collage or strangely textured painted passages against black or midnight-blue ground colors.

## THE HEROIC IMAGE

Expressionism cuts across every segment of today's art world, and there are good reasons for its current resurgence. By exalting sincerity over technique, it appeals to the sophisticated amateur as well as the professional. At a time of waning interest in realistic or purely abstract work, expressionism offers the excitement of startling imagery and unconventional materials. And most important, its emotional thrust is attuned to current ideologies; many of today's artists are "into" making narrative paintings of self-examination, while others are involved with politics of minority rights, feminism, sexual identity, AIDS, or environmental causes.

Meanwhile, the headliners of the 1980s neo-expressionist movement have been concerned with more exalted themes. Anselm Kiefer has painted

Left: ELLEN WIENER, *Untitled I*, 1988. Oil, watercolor, and collage on Masonite, 11¾ × 9⅞″ (29.9 × 25.1 cm), courtesy Marilyn Pearl Gallery, New York.

Right: ELLEN WIENER, *Untitled II*, 1989. Oil, watercolor, collage, and silver foil on Masonite, 12 × 10″ (30.5 × 25.4 cm), courtesy Marilyn Pearl Gallery, New York.

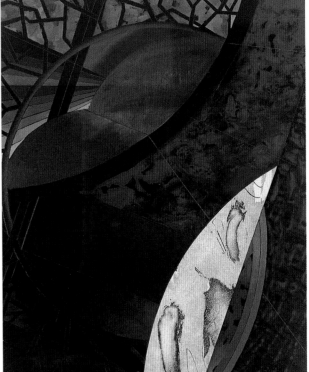

*Germany's Cultural Heroes*; Julian Schnabel has simulated religious altarpieces with mosaics of broken, paint-spattered crockery; Italy's Francesco Clemente has given us epic fantasies of death, birth, and sexual regeneration. Above all, these artists are masters of the heroic image—the big bang, the important statement.

Malcolm Morley, an Englishman who has lived in the United States since 1958, is one of the most impressive of these international stars. And in contrast to the somber tonality favored by many, he is a dazzling colorist. In *Michael's Cathedral* and other paintings of the eighties, he creates explosive effects that recall both the chromaticism of early twentieth-century expressionism and the gestural drips and splashes of the abstract expressionists.

MALCOLM MORLEY, *Michael's Cathedral*, 1988. Oil and wax on canvas, 70 × 78″ (177.8 × 198.1 cm), courtesy The Pace Gallery, New York.

Indeed, this canvas might well be mistaken for an abstraction if taken out of context. Yet in a one-man show we see that Morley's major paintings are distilled from a wealth of drawings and watercolors done from direct observation, typically during visits to such far-flung places as Greece, Kenya, Antigua, Egypt, and Spain. He mines this material for themes that range from beach scenes complete with lifeguards, sunbathers, and bobbing boats to images in which contemporary subjects are clothed in myth and legend.

Thus *Michael's Cathedral* should be perceived not as a separate effort but as one of many variations on a visual theme. Here, the subject is the facade of a Barcelona cathedral—not the famous Gaudí cathedral, but another one with three great spires, which Morley interprets less as architecture than as a crescendo of upward surging movement in a Spanish sunset. Although an earlier canvas depicts recognizable towers rising to a heavenly cross, *Michael's Cathedral* is a vision of pure line and color, with all specific references removed.

In a 1988 one-man show, Morley exhibited *Michael's Cathedral* along with a watercolor whose composition was almost identical. One saw at once that the painting, executed in oil and wax, is a "transcription" of the watercolor—a turning up of the volume, as it were, to a higher pitch. In contrast to the old idea of the canvas as a record of an artist's struggles and changes, precise enlargement of small studies to larger surfaces, often with the aid of a slide projector, is a technique more and more contemporary artists are adopting. This involves an initial action painting with splashes, splatters, and happy accidents in a fluid medium like watercolor, and a subsequent translation of each mark into the weightier and more stubborn medium of oil painting.

The brilliance, assurance, and physical presence achieved by this process of developing and editing an image is astounding. In the ultimate version of Morley's Cathedral series, shown here, horizontal bands of viscous, liquid color—green at the top melting into ochre, yellow, rust, and blue—pour through the framework of dark gestural marks like waves of molten lava. Every brush mark has a first-time freshness, set down once and for all in an alla prima technique—wet paint brushed into wet paint with bits of sparkling white canvas left untouched. And despite the ropy weight of pigment, there is an extraordinary transparency as greens and oranges are laid over underlayers of yellow that shine through in an effect of evening light.

1. Robert Hughes, *The Shock of the New* (New York: Alfred A. Knopf, 1981), 285.

# 11 ADVANCED COLOR GAMES: TRANSITION AND COUNTERPOINT

*It is in what [the subject] is transformed into and how it is accomplished that the mystery of painting occurs.*

—William Bailey

In the preceding chapters, we have reviewed basic color theories, styles, and painting strategies. But as in any creative area, there is a point where one's interest goes beyond the basics. In a four-star restaurant, we savor the sauces and soufflés of "haute" cuisine. In museums and galleries, we look for work of similar "high" quality—art that is exciting and out of the ordinary.

Therefore, these closing remarks are devoted to strategies that can make the difference between a "nice" painting and one that is visually compelling. The role of inspiration can't be discounted, of course, but it is also true that very often the tyro and the expert are simply playing different painting games. Where one artist has a single idea, the other makes a multilevel statement. And where one is involved with basic shapes and colors, the other is concerned with nuances.

Thus an intriguing painting is often the result of an ambitious game plan. And although the list could be longer, I have five "advanced" color strategies to suggest here. They are approaches that add a measure of difficulty to the painting process. But in art—as in bridge, chess, or any other game—the greater the challenge, the greater the fun.

## "DOUBLING" COLORS

On Sundays, my wife and I enjoy doing the *New York Times* puzzles. Fortunately, there is one for each of us, since she prefers the straightforward

JASPER JOHNS, detail, *Diver* (page 221)

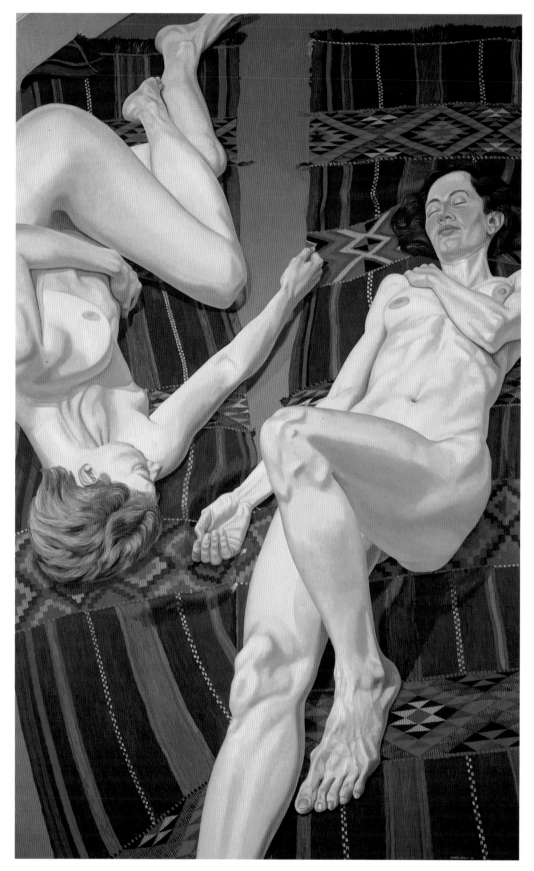

PHILIP PEARLSTEIN, *Models on a Bedouin Rug*, 1987. Oil on canvas, 96 × 60″ (243.8 × 152.4 cm), courtesy Hirschl & Adler Modern, New York.

crossword format, while I like the double crostics, which, though more elaborate in design, offer twice the number of clues. I am reminded of this here, because artists also have the choice of a straightforward or multileveled approach to color, and each mode has its rewards.

A comparison of paintings by Philip Pearlstein and Jack Beal—each with two figures in an actively patterned space—illustrates the point. The canvases are equally handsome, but in different ways. Pearlstein's *Models on a Bedouin Rug* is composed like a crossword puzzle, with each color defined by a single clue: *the color of the object itself*. Accordingly, flesh tints are a uniform beige modified only by anatomical shading, the floor is brown, and the orange/blue/black stripes on the rug are re-created on canvas as flat shapes. Beal's color in *Portrait of the Doyles*, by way of contrast, is

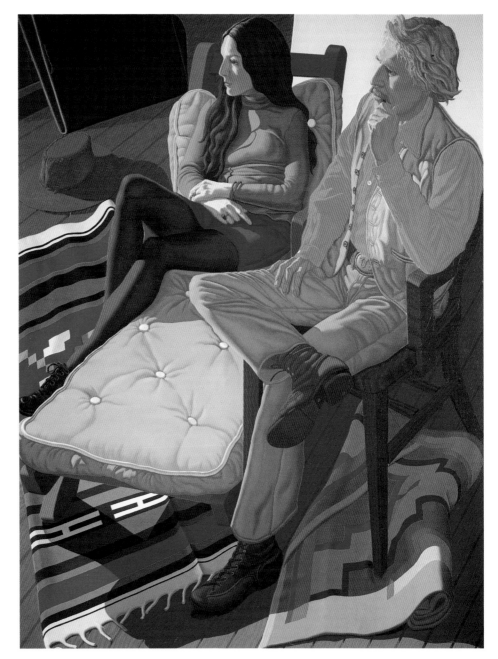

JACK BEAL, *Portrait of the Doyles*, 1970. Oil on canvas, 76¼ × 58⅛″ (193.7 × 147.6 cm), National Gallery of Art, Washington, D.C., Gift of Evelyn and Leonard Lauder.

structured like a double crostic with twin variables: *the color of the object in light* and *its distinctly different coloration in shadow.* Thus his portrait heads, far from being a uniform flesh tone, are painted with planes of contrasting hue. Working like a mosaicist with bits of colored tile, Beal chooses two colors for each area—pale ochre and burnt sienna for the lady's hands, kelly green and dull moss green for her sweater, aquamarine and teal gray for the chair mattress, and so on.

What I am suggesting, then, is that one artist composes with the basic color blocks we considered in chapter 5, while the other ups the ante, as it were, by "doubling" the colors in each block. This isn't a better way of working, but it is a more "coloristic" one that the ambitious painter would do well to explore. Where Pearlstein creates visual interest with linear and anatomical complexity, Beal does so with more intricate color patterns. His rug designs, for instance, are developed with two entirely different harmonies—crisp red, black, and gray stripes on the left, a tapestry of shadowy browns on the lower right.

Finally, it should be understood that this strategy is quite separate from the issue of dramatic lighting. A Raphael or Bronzino will paint a red satin gown from brilliant highlights to blackened shadows while maintaining the sense of its uniform redness. In this traditional approach, however, light is used to reveal an object's true color, while shadows gradually soften and dissolve it. Beal's colors, on the other hand, are faceted rather than blended, and colors seen in shadow are often as intense as those in light. This is particularly noticeable in the male figure whose jeans are most intensely blue on the dark side and whose face and hands are shadowed with a bright, ruddy pink.

## MODULATION

If heightened color can add visual interest, so can transitions and modulations. Chekhov is admired for quicksilver shifts from comedy to tragedy; Debussy, for airy harmonic progressions. And in the same vein, certain painters are masters of transition and nuance. Rembrandt is famous for his shadows; Turner, for iridescent atmospheres; Wyeth, for weathered and sun-bleached textures.

Among contemporary abstractionists, James Havard has a particularly fluid approach. His canvases feature broad planes of color that, though handsome, aren't unusual in themselves. What gives his work its special zing, on the other hand, is the remarkable ebb and flow surrounding these color blocks. And the most unusual aspect of his color modulations is the fact that they move in two directions—both up and down across the surface, and in and out of deep space, as key shapes appear to lift off the canvas and float toward the viewer.

In a typical painting like *Apache #716*, for example, movement along the surface is developed with a sequence of horizontal stripes—buttery bands of thick pigment whose edges melt into one another rather than being firmly separated as in a Hofmann or Albers abstraction. Lightly sketched lines, drips, and graffiti add to the fluidity of an overall image that suggests a night landscape under a black "sky." On the right, blacks move from the bottom edge of the canvas upward into grays and whites, while on the left, the progression is from black to pale cerulean and creamy yellow at the "horizon."

At the same time, Havard creates a countering depthward movement by treating a row of squares and several spaghettilike figures illusionistically. That is to say, he paints the squares as dimensional cubes, seemingly cut out of the gooey paint surface and pulled forward in order to cast shadows on it. And in a spectacular technique that has become a trademark, he transforms a rope of yellow acrylic paint, squeezed straight from the tube, into an airborne worm by underlining it with an airbrushed shadow. Other small motifs are handled in similar fashion, and there is a particularly nimble modulation of six of these surrealistic shapes, moving from light into darkness, on the upper right.

Although such modulations normally function as connective tissue between major shapes and colors, they can sometimes play the leading role. Robert Keyser, for example, bases his art on small, cryptic images connected by elaborate transitional passages that often take on as much, or even greater, importance than the image itself. In a typical work like *Cave, Freshet, Bush*, he presents an aerial view of a small island overlaid with frontal diagrams of a bell-shaped cave, a "freshet" of aquamarine water at its mouth, and a yellow cactuslike bush outlined in spiky dots. The image is certainly provocative. Yet in purely visual terms, it is the wonderfully modulated, richly brushed waves of color surrounding this central image that I, at least, find most memorable.

This is highly personal work that carries forward Paul Klee's ideas about recording irrational thoughts and fancies in a rational way. Using the principle of free association in accidental situations, Keyser often discovers his themes by playing with a deck of prepared "magic cards"—fifty-two notecards covered with writing, signs, watercolor sketches, and color notes. In a game of solitaire, Keyser says, "the overlaps can create new meaningful configurations, all formed by chance."[1] If the resultant images are enigmatic, they are also, as in Klee's work, typically arranged in a vast, richly modulated space. Sometimes it is a metaphysical space covered with writing or numbers. But very often, as in *Cave, Freshet, Bush*, it is a more tangible landscape or waterscape rendered with wavelike color gradations. Where Klee surrounded his mermaids, boats, and fish with as many as six or seven dark-to-light gradations, Keyser carries the technique even further.

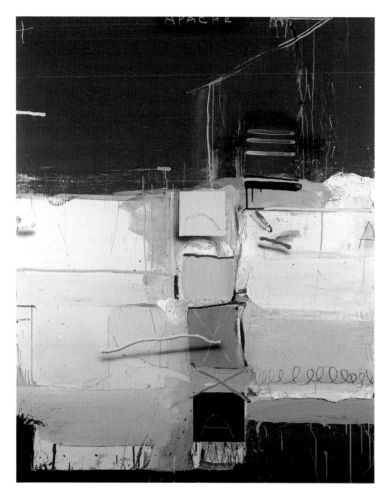

JAMES HAVARD, *Apache #716*, 1982.
Acrylic on canvas, 60 × 48″
(152.4 × 121.9 cm), courtesy
Marian Locks Gallery, Philadelphia.

ROBERT KEYSER, *Cave, Freshet, Bush*,
1986. Oil on canvas, 18 × 20″
(45.7 × 50.8 cm), courtesy
Dolan/Maxwell, Philadelphia and
New York.

In the waters around his little island, I count five bands of aquamarine and twelve warm-to-cool grays—seventeen gradations in all!

In art of this kind, the name of the game is the interaction of intuition and reason, of improvisation and plan. Thus we perceive the bands of color in Keyser's ocean—like the growth rings in a tree—as a logical diagram of an expanding universe. And we see at once that each ring must be the same thickness but painted a shade darker and in a wider arc. Yet, at the same time, we take pleasure in the artist's playful response to this logical configuration—squeezing out long snakelike marks with the casual grace of a pastry chef, running them together in places, creating interesting gaps elsewhere, and lifting his brush suddenly to make room for two little figures that might be the sun and moon or fishes in the sea.

Richard Cramer's *Redbank* represents another strategy altogether. Where Havard and Keyser are masters of the intimate personal touch, Cramer is inspired by the possibilities of scientifically precise color mixtures in large-scale nonobjective work. His compositions of rectangular color panels are arrived at intuitively. However, these basic shapes are then developed with an incredibly elaborate system of finely calibrated gradations that give the finished work a glistening, electronic-age presence.

RICHARD CRAMER, *Redbank*, 1975. Acrylic on canvas, 96 × 127" (243.8 × 322.6 cm), courtesy the artist.

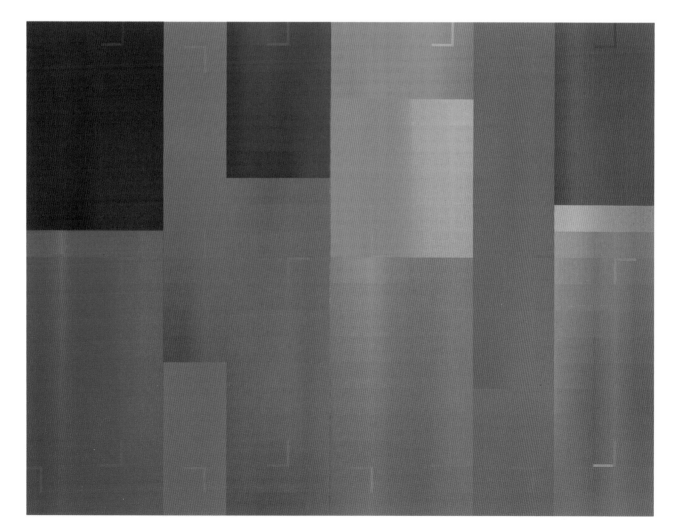

*Redbank* is typical of a period during the late 1970s when Cramer pushed the concept of fine-tuned color measurement further than perhaps any other American artist. Pursuing the idea of color perception at a threshold level of minimal change, he composed his paintings in either a very light or, as here, a very dark key. Within this general tonality, radiant colors were then mixed in extremely fine steps to the point of a barely noticeable difference. Look closely at *Redbank*, for instance, and you will see that the vertical panels are subdivided by nineteen horizontal bands that are the matrix for almost imperceptible color changes—twelve gradations in the green block, eleven in the red area, and so on. Then, as a further refinement, Cramer has rounded each column with a highlight in the center and subtle changes in hue. The violet panel, for example, shifts from a magenta tonality on the left to a lavender radiance on the right.

Ultimately, Cramer's five-year project involved the cataloguing of thirteen thousand color samples with the help of studio assistants trained to mix pigments with a medicine dropper. Thus having made his point, the artist has now moved on to new ideas. Nevertheless, this was an important experiment that suggests a number of creative possibilities for anyone working with abstract shapes and colors. On a less elaborate scale, Cramer's basic strategy is especially appropriate for geometric abstractions done with masking tape and acrylics. Gradations don't have to be scientifically accurate to be effective, a grid design can be made with a much simpler plan, and exciting color effects can be achieved with five or six modulations instead of ten or twelve.

## PATTERNING

Patterning is another important device for creating visual excitement. As we have seen, realists like Beal and Pearlstein like to animate their figure studies with patterned objects of all kinds: Navajo rugs, Oriental kimonos, floral wallpaper, wickerwork—you name it. In fact, Pearlstein has a whole storage floor of such props and furnishings adjacent to his studio.

Of all the genres, however, still-life painting is the most natural vehicle for this approach because of its small scale and the viewer's perception of it as a calculated arrangement. In P. S. Gordon's watercolor *The Captain's All Vegged Out*, for example, a patterned quilt is the dominant subject rather than a mere background element. Accordingly, the dimensional objects huddled in the center are, in a sense, absorbed into this flat checkerboard pattern—a ceramic "tomato" pitcher echoing a tomato-red design above it, a basket woven with quiltlike designs, a bunch of asparagus tied with a "cross-stitch" **X**-shaped ribbon, and so on.

This Oklahoma artist with the "postscript" initials has lots of fun with quirky subjects and titles. Here, a china rabbit nibbles in a garden of

P. S. GORDON, *The Captain's All Vegged Out*, 1982. Watercolor, 49 × 40″ (124.5 × 101.6 cm), collection of Becton, Dickinson & Co., Paramus, N.J.; courtesy Fischbach Gallery, New York.

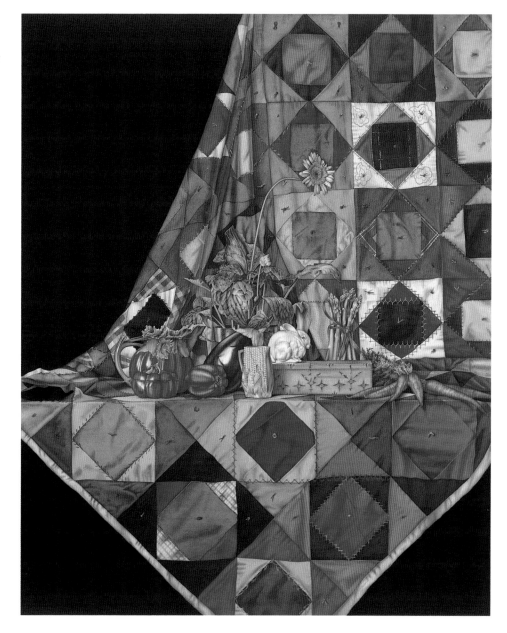

carrots, asparagus, tomatoes, and corn in which—as in *Alice's Adventures in Wonderland*—some of the objects are real and some are ceramic fakes. And like Lewis Carroll, Gordon creates his fantasies with a touch that is at once sophisticated and innocent. Each object is rendered with an elaborate "magic realist" technique, yet the overall design of squares, diamonds, and triangles has a folk-art simplicity.

Gordon's wall-relief format is the most direct expression of a patterned subject because, when objects are arranged on a shelf at eye level, depth perspective is minimized, and designs can be translated from wall to canvas without distortion. Thus it is an approach for beginners as well as experienced painters, and the introduction of repetitive shapes is a sure-fire way to develop richly interactive color relationships. In Gordon's watercolor, for example, there is a wonderful flow of leafy greens through the center

NANCY HAGIN, *Two Rugs*, 1986.
Watercolor, 30 × 42″
(76.2 × 106.7 cm), collection of
Cargill, Inc., Minneapolis; courtesy
Fischbach Gallery, New York.

CHARLES LE CLAIR, *Irises*, 1987.
Watercolor, 58 × 40″
(147.3 × 101.6 cm), courtesy
More Gallery, Philadelphia.

and a dramatic movement of blacks sliding in from the edges. Furthermore, if you study the path of any one color through the composition, say red, you will find that it rings all the basic color changes—turning dark in some squares and light in others, and moving from complementary red/green chords to analogous passages of rose and violet or red, orange, and yellow.

Nancy Hagin's tabletop setup in *Two Rugs* is an even better illustration of the kind of intricate color games we are discussing. In contrast to Gordon's forthright approach, Hagin plays tricks with foreshortening and mirror reflections. Where his "veggies" are lined up in profile, her jugs and pitchers are shown from above as overlapping volumes. And where Gordon is a master of trompe l'oeil rendering, Hagin "fools the eye," too, but in the sense of creating a visual puzzle. Although stripes on the upper right of her watercolor obviously represent a rug on the floor behind the still-life table, jazzy patterns on the left are purposely confusing. Ultimately, we discover they are reflections in a white-framed mirror—distant views of a chair leg and an Oriental rug on the other side of the room, and close-up reflections of a white pitcher and other objects in the still life itself. Despite this logic, however, the first impression is of arbitrary shapes, and clearly, the artist wants us to see her painting both ways—as abstraction *and* as realism.

Patterning is a dominant theme in my own work, too, though with a somewhat different twist. Because I am so tall, neither the standard view of still life against a flat wall nor the tabletop format of objects seen from above seems natural to me. Instead, I tend to see things in a boxlike space with equal areas of background wall and foreground tabletop or floor. There is often a dividing line between vertical and horizontal planes in the middle of the picture, and my special concern is the flow of patterning across the line and throughout the space.

In my small still lifes, this continuity is often achieved with mirrors or shiny tabletops that reflect patterns from above. But in larger works like *Irises*, I have been interested in more natural, less manipulated effects in which patterned motifs flow from one object to another rather than being exactly repeated. Instead of using my own setups, many of these paintings are based on "found" subjects—in this case, the dining room of a distinguished Philadelphia collector. It is a room space of extraordinary visual excitement, and I have tried to capture this energy in my painting.

The space is defined by a huge Lucas Samaras abstract quilt that hangs like a theatrical backdrop behind a transparent glass dining table. But what is most remarkable about this interior is the way all of its furnishings reflect Samaras's motifs. In his quilt, patches of op-art fabrics are outlined by a network of zigzag multicolored ribbons, and this ribbon motif is echoed in the elongated iris stalks and in narrow metal supports for the glass table. It is also picked up by bands of recessed ceiling lights that throw glittering blue stripes across the tabletop.

In trying to convey this sense of patterns moving through space, I found the chairs particularly interesting to work with. Their neat mahogany frames continue the ribbon motif, and by turning them a certain way I was able to repeat the trapezoidal shapes of the patchwork quilt. Furthermore, the diamond pattern of the upholstery—a design of yellow, orange, and red stripes around a purple center—has much the same optical energy as the polka-dot fabrics up above. And finally, the scene's depth perspective adds yet another visual complication as the chair pattern moves in progressively larger intervals from middle distance to foreground to a close-up view at the bottom of the picture.

# PENTIMENTO

When Lillian Hellman's memoir *Pentimento* hit the best-seller lists a few years ago, most of us had to look up the word. According to Webster, it refers to "the presence or emergence of earlier images, forms, or strokes that have been changed or painted over." Miss Hellman, of course, uses the word as a metaphor for half-forgotten memories. Nevertheless, this is a painting term, one that points to a widely accepted principle—namely, that a painting's underpinnings are an integral part of the finished work.

In contrast to the old masters' habit of repainting images to please their patrons—changing winter to spring or pagan gods to Christian saints— modern artists see painting as an organic process in which every brush mark contributes to a unified whole. If the goal is a clean-cut look, the technique must be immaculate. But in a more personal work, the sense of life beneath the surface is a positive enrichment, and we perceive first touches, later marks, changes, and erasures as a visual record of the artist's thought processes.

Paintings can also be "layered" more systematically, and a current avant-garde strategy is to arrange color sequences in depth rather than simply across the surface. We have seen this in the traditional technique of underpainting followed by transparent glazes. But instead of two layers, nowadays there are often four or five layers of wildly different colors arranged like piled-up pieces of stained glass. Rauschenberg's multiple photo images are transferred to metal panels in a variety of overlapping colors. Warhol's standard "portrait" format is a diptych designed to show contrasting colors layered over the same basic image. And David Salle likes to superimpose images in different styles as well as different colors—a realistic scene, for instance, might be overlaid with a line drawing, a bit of abstract design, and a top layer of collage, with each stratum keyed to a distinctive hue.

The most complete dedication to this strategy I know, however, is to be found in the work of the Philadelphia artist Warren Rohrer. His canvases

are not only executed with a detailed system of underlayers but also are infused with an almost mystical sense of hidden meanings. And it is this vision of mysteries below the surface that suggests the word *pentimento*. Whereas underpainting and layering are forthright technical terms we have met before, pentimento has connotations of antiquity, veiled meanings, and a kind of archaeological or psychological "dig."

In a Rohrer exhibit, the contrast between one's initial impression and later judgement after "digging" into the work is amazing. Executed in a format of Albers-like squares, the paintings seem at first to be of solid colors—yellow, green, rust, and violet abstract panels. Yet they are anything but minimal. Instead of smooth, flat paint, Rohrer gives us weighty surfaces with the look of crackled ceramic glazes on slabs of fired clay, an effect achieved by painting the main colors over contrasting undercolors, which show through in interesting ways. Violet over yellow is a typical combination, and in *Cipher* one sees flecks of turquoise under the dominant emerald hue at the top of the picture and speckles of deep ultramarine below. The bottom edge is also incised with V-shaped gouges that reveal further underlayers of white, yellow, and rust.

The sense of hidden depths becomes even more compelling when one suddenly realizes that these "abstractions" are actually landscapes. *Cipher*, as it turns out, was based on drawings of vegetation made during a sketching trip. The V-shaped plant motifs visible at the bottom were scratched in continuous rows across a "field" of thick paint and then filled in with a fluid green overlayer that blurs these strokes like water in a rice paddy. Thus the basic image is very much like a van Gogh wheatfield. But instead of indicating depth with perspective, Rohrer suggests it with veils of color.

In *Meridian* the landscape illusion is reinforced by another Rohrer device—a horizontal division that suggests land and sky. The distinction between these zones is typically so subtle as to be almost subliminal. Here, the upper band is an orange-yellow with speckles of red; the lower, an ochre-yellow with flecks of purple. Yet the fact that one barely sees the horizon line adds to the fascination, and the overall image has the delicacy of an Oriental print.

If Rohrer's color is subtle, it also has an extremely physical presence. The canvases are built up with an insistent energy that has invited comparison with another American visionary, Albert Pinkham Ryder.[2] A review of photographs taken during the development of *Meridian* will give you an idea of Rohrer's laborious technique and the role of "buried" colors in achieving his effects.

In its fourth state we see the picture after several preparatory steps. First, a layer of red pigment was applied with a painting knife and scraped smooth. Second, a "landscape" drawing was scratched into the thick wet

paint. Third, a band of white was added at the top, which hides the red color but not the relief pattern of incised marks. And fourth, the whole surface was brushed with yellow. Thin on top but settling into the scratches, this yellow glaze is vivid in the dark red zone but barely visible on the white strip. Next, in the fifth state, a layer of blue has been applied with an irregular scrubbing motion. This unifies the underlying colors and sets up a warm/cool atmospheric vibration. Mottled brushstrokes also create the dynamic color contrasts shown in a close-up detail—solid areas of thick blue paint alternating with thin patches where red and yellow show through.

Thus a richly textured ground is established, over which the artist can float still further veils of luminous, atmospheric color. In *Meridian* the final layer is sunset orange and gold; in *Cipher*, a malachite green shading to blue that suggests a pond with reeds rippling the surface. Though Rohrer's technique is arduous, this kind of scratched and "weathered" underpainting has significant advantages. For the artist, it produces color variations of a subtlety that can't be duplicated in any other way. And for the viewer, it offers hints of a subterranean world that is at once rather mysterious and convincingly solid.

WARREN ROHRER, *Cipher*, 1988. Oil on linen, 36⅛ × 36⅛″ (91.8 × 91.8 cm), courtesy Marian Locks Gallery, Philadelphia.

WARREN ROHRER, *Meridian*, 1988.
Oil on linen, 66¼ × 66¼″
(168.3 × 168.3 cm), courtesy
Marian Locks Gallery, Philadelphia.

WARREN ROHRER, *Meridian*, fourth
state, courtesy the artist.

WARREN ROHRER, *Meridian*, fifth
state, courtesy the artist.

WARREN ROHRER, *Meridian*, detail,
fifth state, courtesy the artist.

# VISUAL COUNTERPOINT

The strategies we have been discussing have one thing in common: They all involve an interplay of opposing forces. *Modulations* connect cool and warm or dark and light areas; *doubled colors* describe sunlight and shadow; *patterns* flow through different spatial zones; and Rohrer's concept of layered colors, or *pentimento*, explores such dichotomies as abstraction versus representation and surface versus depth.

In music the use of opposing themes is called *counterpoint*, and it is an important principle in painting as well. While unity and variety are standard virtues, the latter can be achieved in either of two ways—by variations on a single theme or by combining different ideas. In general, the pioneer modernists preferred singular motifs. Think of Seurat's insistent dots, or Cézanne's overlapping planes. Reacting against this kind of consistency, however, nowadays painters and sculptors like to combine dissimilar images, unlikely materials, and seemingly contradictory styles.

Jasper Johns's work is a classic illustration of this multilevel approach. Johns built his early reputation on impersonal images of flags, numbers, and alphabets painted in orderly stacks and rows. Later these public symbols were joined by more personal imagery, but in any case, what makes Johns's work unique is the way his intellectual schemes are altered by contradictory twists and turns during the painting process. As the work progresses, hard images melt, numbers and letters are transformed or erased by color, and flat shapes take on a curious dimensionality.

Nowhere is this visual "counterpoint" more daringly set forth than in *Diver*, a masterwork of the 1960s. Here, the artist starts with a format of vertical panels and a lineup of symbolic images—a half circle on the left

JASPER JOHNS, *Diver*, 1962. Oil on canvas with objects (5 panels), 90 × 170″ (228.6 × 431.8 cm), collection of Norman and Irma Braman, Miami Beach, Fla.

that is at once target and artist's color wheel; then a textbook chart of the black-and-white value scale; and on the right side, RED, YELLOW, and BLUE, the primary colors, stenciled in packing-box block letters. As you see, however, Johns contrasts this orderly framework with a wildly expressionistic backdrop of a diver plunging into a "sea" of color.

In this context the diver suggests artistic endeavor, but it is an image with many other associations. Diving has traditional connotations of sexual prowess and of plunging below the conscious level of the mind (as F. Scott Fitzgerald's hero Dick Diver does in the novel *Tender Is the Night*). Johns himself sees it as an "ambiguous" symbol "that can suggest either life or death,"[3] and while working on the painting, he made a charcoal drawing of its central figure that is as funereal as the canvas is animated and colorful. It has even been proposed that these works refer to the suicide of the poet Hart Crane, who leaped to his death from the stern of a ship.[4]

Johns disavows such specific intent, however, emphasizing instead his interest in enigmatic images that can be read in different ways. He also likes to hide a subject so that the viewer will have to hunt for it. *Diver* is an extreme case in which the swimmer is so lost in waves as to be almost invisible. But look closely, and you will see a central yellowish V shape that represents long arms splashing downward toward tiny hands at the bottom edge of the canvas. This isn't a singular image, however, but a composite of successive movements made during the execution of a swan dive. Thus the V-shaped arms can also be seen as pointing upward, with a second pair of hands at the other end. There are also vestigial footprints in the exact center of the top edge of the canvas, with small black spots marking the heel, metatarsus, and toes. All these images are sketchy translations of the actual imprints of his own hands and feet Johns used in the drawing.

As a major American painting about color, Johns's *Diver* is a fitting end piece for this book. Indeed, I can't think of another painting that makes a more convincing case for the importance of color and its knowledgeable use in contemporary picture-making. Johns pays homage to optical science with his value-scale chart and to historical precedent by using Mondrian's classic palette of black, white, gray, and the primary hues. Furthermore, his painting is an almost literal demonstration of Albers's theory of color relativity—the idea that color relationships depend on the context in which they are seen. Accordingly, Johns paints his block letters in colors that toy with the meaning of the words. BLUE is stenciled in blue. But RED is painted blue, too, and YELLOW is a contradictory red. The artist also emphasizes the spatial ambivalence of his colors. At the top of the picture, a blue wave splashes in front of a red one, thus contradicting the usual assumption that blue is the more recessive hue. And in another reversal, this same red wave runs behind the top of the gray-scale chart while oozing, like Silly Putty, in front of it at the bottom.

We see, then, that Johns conceives his picture as a series of ironies in which contradictions between literal and obscure meanings, neat and splashy brushwork, and flatness and spaciousness abound. The underwater scene gives an illusion of depth, for instance, while the value chart is flat, and several small objects fastened to the canvas add still another note of *real*, rather than painted, dimensionality. Strung along the edges of such a huge picture, these little attachments are hardly noticeable, yet they are very important conceptually. Look for the dark strip, really a wooden stretcher bar, suspended from the eye of the target; a thin yellow line along the bottom center edge that is a tape measure; and a blackish mark on the lower right that is actually a tiny silver knife-fork-and-spoon set.

# CONCLUSION

In bringing this discussion to a close, I would emphasize that—though we have examined any number of color concepts separately—you must look for multilevel approaches in much current art. Painting strategies are more complicated now than in Albers's time, when a purely esthetic order was the painter's goal. For many of today's artists, dissonance is more interesting than harmony, conflicts more exciting than neat resolutions, and work incorporating sculptural elements, words, and photographs more socially relevant than "pure" painting.

The twenty-first century will doubtless be marked by even more radical change as innovative materials, mediums, and technical processes are explored by a new generation of creative people. But as every good cook knows, no matter how "nouvelle" the recipe, the basic ingredients and culinary skills remain the same. And as one who has observed the passing art parade from the innocent thirties to the supersophisticated nineties, I can assure you that, despite shifting styles and attitudes, the fundamentals of line, form, and color have been, and will remain, constant.

I leave you, therefore, with every confidence that, having explored the ideas and strategies of the sixty-odd artists reviewed in these pages, you will be well prepared for any future shocks that may lie ahead. And it is my fervent hope that, like Johns's diver, you will want to plunge headlong into the turbulent but exhilarating currents of our ever-changing art world.

1. Robert Keyser, "Some Remarks and a Conversation," *Robert Keyser: Ten Years, 1977–1987* (Philadelphia: Temple University, 1987, exhibition catalogue), 7.

2. Howard Hussey, "Latitude (x) Radiance," *Warren Rohrer* (Philadelphia: Marian Locks Gallery, 1989, exhibition catalogue), 6.

3. Nan Rosenthal, "Drawing as Rereading," *The Drawings of Jasper Johns* (Washington, D.C.: National Gallery of Art, 1990), 28.

4. *Ibid.*

# INDEX